IMAGES
*of America*

# AFRICAN AMERICANS
## OF DAVIDSON COUNTY

**Dunbar**

# High School

**This Certifies that**

*Mattie Mae Davis*

Having completed the Course of Study prescribed by the Board of Education, is hereby declared a Graduate of Dunbar High School, and as an Honorable Testimonial of Excellence of Character and Scholarship, is entitled to this

**Diploma**

Given at Lexington, North Carolina, this 26th day of May, A. D., 1933.

_____
Principal

_____ President } Board of
_____ Clerk } Education

In the early 17th century, there was an intense debate regarding whether slaves should learn to read. Many slaveholders equated education with empowerment. But not even the threat of death quelled the thirst in African Americans for knowledge. Education and the tussle for the tassel will be something that black America continues to strive for, because only by being educated can people truly be free. This 1933 Dunbar High School diploma measures 14 inches by 17 inches in its original state. (Courtesy of Tonya Lanier.)

**ON THE COVER:** Attendees at a Masonic convention held at St. Stephen United Methodist Church around 1944 pose for local photographer H. Lee Waters. Being centrally located, Davidson County was chosen for many regional and national Masonic events. (Courtesy of H. Lee Waters Collection.)

IMAGES
*of America*

# AFRICAN AMERICANS
## OF DAVIDSON COUNTY

Tonya A. Lanier

ARCADIA
PUBLISHING

Published by Arcadia Publishing
Charleston SC, Chicago IL, Portsmouth NH, San Francisco CA

Library of Congress Control Number: 2010923694

For all general information contact Arcadia Publishing at:
Telephone 843-853-2070
Fax 843-853-0044
E-mail sales@arcadiapublishing.com
For customer service and orders:
Toll-Free 1-888-313-2665

Visit us on the Internet at www.arcadiapublishing.com

*This one is for my grandmothers, Lou Ida Edwards
Lanier and Jennie Lee Cross Wilson. Thanks for teaching
me the importance of family and memories.*

# CONTENTS

# ACKNOWLEDGMENTS

I am deeply indebted to all those who made this book possible. First, thanks to God for giving me the vision and the Holy Spirit for keeping me focused. Thanks to my husband, Robert Freeman, and my son, Tavon Lanier, for tolerating my mental and physical absence and for your love and support throughout this endeavor.

An eternal appreciation goes to Catherine Hoffmann and Gail Harrison at the Davidson County Historical Museum. These ladies provided technical assistance, critiquing services, working space, and logistical support that proved invaluable.

Very special thanks to the late H. Lee Waters for his priceless collection. Waters went into the African American community when it was not a popular thing. Of the 125 African American images currently housed at the Davidson County Historical Museum, I was fortunate to incorporate over 40 photographs from his collection. Catherine Hoffman, curator at the museum, says, "In 1926 H. Lee Waters (1903–1997) bought a photography studio on South Main Street in Lexington, North Carolina. The body of work he produced during his 60-year career is considered a timeless historical resource, quite literally a picture of a specific time and place. His inquisitive nature led him to document countless people, places, and events beyond his studio walls and gives evidence to an unusual range and innovative spirit during the most prolific years of his career. His still work is held in the H. Lee Waters Collection at the Davidson County Historical Museum in Lexington, North Carolina, and his independent film work (1936–1942) is being preserved by Duke University."

I was fortunate to find assistance in some way from friends at the Lexington Library, the Genealogical Society of Davidson County, and the *Chronicle* of Winston Salem.

This book could not exist without the cooperation of the 50-plus persons who graciously allowed me into their homes. They willingly shared memories, experiences, and, of course, precious photographs from their private collection. They receive photograph credit when their name appears in parentheses at the end of each caption, but that's not nearly enough thanks.

To my esteemed local history enthusiasts Charles Owens, Etta White, Robbie Cross, Louise Miller, Lena Perkins, Alberta Carter, Wayne Talbert, and Wanda Craven—just to name a few—thanks so much for sharing. The time I spent with you will be treasured. Your eagerness to chat and provide specifics for the book was a testament of your commitment to preserving our local history.

And to those who will make this book part of their private collection, thanks. I hope and pray that the names and faces scattered throughout these pages will always be remembered. May there be a better understanding of the contribution made by these, and others, to Davidson County. I hope this book serve as a community photo album and memory keeper. It should help sketch our history, relating a story of our people that should be read by everyone because the story of America is incomplete without it. Enjoy!

# INTRODUCTION

*I am not tragically colored. There is no great sorrow dammed up in my soul, nor lurking behind my eyes. . . . Even in the helter-skelter skirmish that is my life, I have seen that the world is to the strong regardless of a little pigmentation more or less. No, I do not weep at the world—I am too busy sharpening my oyster knife.*

— Zora Neale Hurston, *How It Feels to Be Colored Me*

There was a box, a huge box, nestled under the living room table pushed out of sight. It was full of photographs. Many of the faces staring back had no name. They were strangers to me. Since they were in my grandmother's Linwood Road home, I assumed that they were folks she knew or loved. Some had her nose or her walnut complexion. Some gathered at favorite family sites. A few had dates or sentiments scribbled on the back. Others held no clues at all. These people, I assumed, had some connection to my world, whether it be by blood, community, or ethnicity. And so the project began—the goal of preserving a little bit of history that is threatened with oblivion.

It is a great idea to try to grasp the full meaning of the past. By studying, we can sometimes understand just a snapshot of history. Pictures help us do that. Through pictures, we can be in the same room with Lance Crump, Oscar Hege, or Hattie Baldwin. We can look at the smiles of Ruth Thomas, Marie Carter, Fannie Albright, and Clara Staplefoot. Through photographs, we can honor unsung heroes and heroines like Theodore Crump, Willie Shoaf, Lucille Yarbrough, Leroy Pearson, and Helen Caple.

The names of prominent African Americans can be spouted off the lips of many. There is a list of rehearsed favorites that children often recite, especially during the month of February. We have our special list here in Davidson County. It isn't likely, however, that Robert Wilson's name will come up. I doubt that there will be a book that references Bo Carter or Sid Roan, yet these folks made a mark in our history. Will there be an anthology about Jettie Moore or Frances Hargrave? What about Minnie Payne or Maxine Reid? Where is the historical fact sheet on Martha Michael or Rev. F. D. Betts?

Not only are photographs of people essential to our history, there are buildings and structures that connect many historical gaps as well. There are images that capture the space of the educational system in Davidson County—from the Rosenwald schools to Dunbar High and so many educational sites in between. We have churches, old and new, that carved stones into our community, like Files Chapel, Ezekial African Methodist Episcopal (AME) Zion, Union Chapel, and Yadkin Star, to name a few. For recreational purposes, let's remember Big Will's, Clyde's, the Loose Booty, the Glass Castle, Bo Knott's, Scott's Place, and the Hole. Mainstream society was not waiting to teach our children how to swim, how to be a Scout, or what it took to run a business; our leaders saw a need and created. Someone asked why Fourth Street was such a booming area in the 1930s, 1940s, and 1950s. It was because no one else was providing these services for black

folk. In order to have a dry cleaner or grocery store or childcare, an auto repair shop or a café, they had to create it themselves. And they did.

It is important that our children are exposed to their rich heritage, whether physically or spiritually. For many young blacks, our history began and ended with slavery. A picture and a few words can help paint a more accurate account.

The labor of writing this book turned into a passion. It was a passion that immediately became a privilege. To recall the names of so many greats was mind-boggling and an impossible task. Several are still with us today, while others are precious memories. There was too much to tell. There wasn't enough space; there wasn't enough time. Each deserves a personal volume. But in capturing the few that we have, I hope it stimulates conversations and actions to preserve much more of our local history. Read on!

# One

# PIONEERING SPIRITS

Born in 1861 to a slave mother, Robert Baxter McRary became an outstanding community leader and extremely successful businessman. He owned valuable property in downtown Lexington. Baxter graduated from Lincoln University in Chester County, Pennsylvania, and the Berlitz School of Languages in Rome, Italy. Considered a cultured, wealthy, and prominent man, Baxter was active in educational and political movements in Davidson County. He served as principal of Reidsville High School and later as principal of the normal department of Livingstone College in Salisbury, North Carolina. He served six years as magistrate for Davidson County. He traveled extensively and was an exquisite dresser. In 1903, he was honored to be a lay delegate to the Methodist general conference. Baxter died on April 23, 1946, in Baltimore, Maryland. (Courtesy of Patsy Bush.)

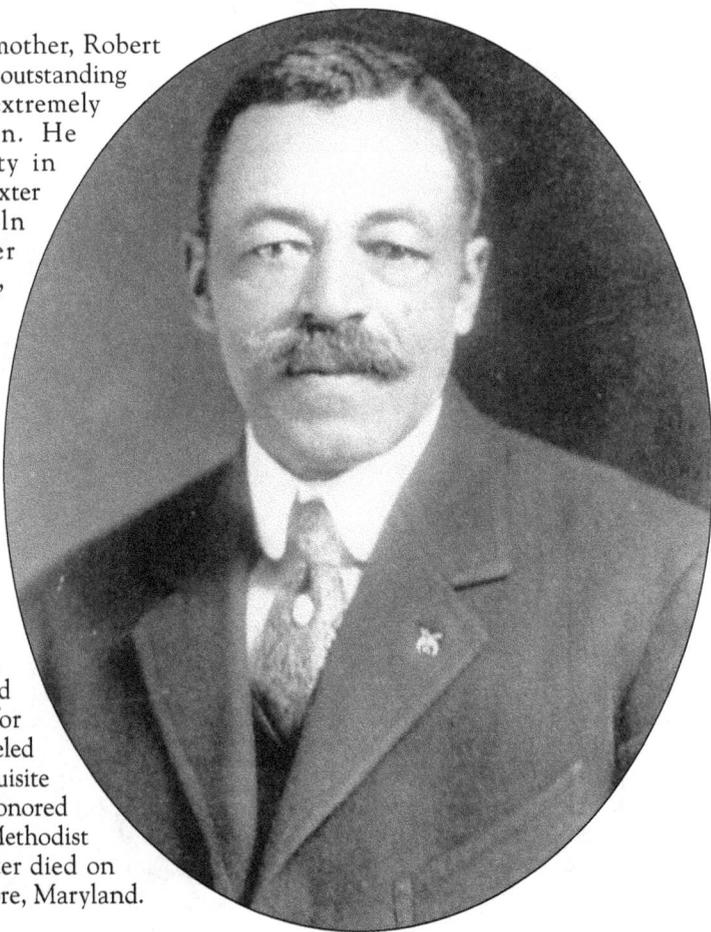

Julia Michael stands outside of her Heightstown home. She was the mother of Frank "Uncle Bud" Michael and grandmother to Etta, Lula, Ralph, Lewis, Shando, Wesley, and Cleo. An ornamental headstone for Julia rests at Chestnut Grove United Methodist Church in Reeds. (Courtesy of Lula Pittman.)

Luther Miller, a successful business owner, operated one of the largest concrete companies in the state. He was hired to pour driveways, walkways, city sidewalks, and decorative planters. His company was contracted to construct the swimming pool at Summerhill Baptist Church (now First Baptist) on Church Street. (Courtesy of Charles Owens.)

Charles "Coach" England began his teaching career in Tarboro, North Carolina. He accepted a position at Dunbar High School in 1958. When desegregation occurred, he moved to Lexington Senior High, where he had an illustrious career teaching, coaching, and touching the hearts of many students. He and his wife, Julia, had three children—Macon, Kaye, and Darren. (Courtesy of Julia England.)

In 1964, Jimmie Henderson, son of Harvey and Lottie Henderson, made history when he became the first African American student to attend the all-white Lexington city schools. Following a federal court ruling, Jimmie and eight other students were transferred peacefully. He would become an outstanding athlete and exceptional student at Lexington Senior High. (Courtesy of Faye Henderson.)

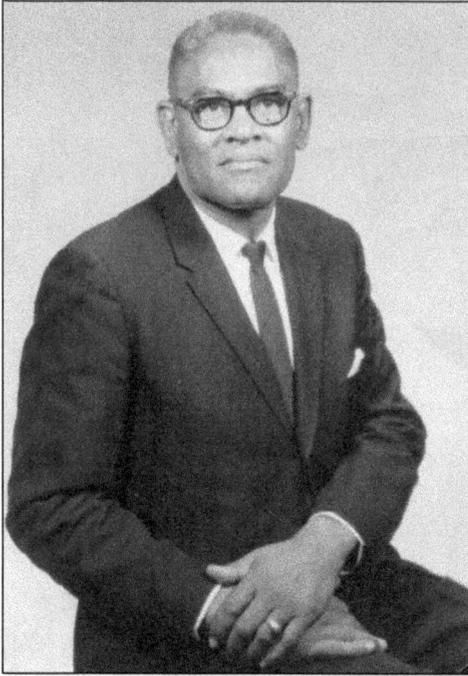

Arthur B. Bingham served from 1934 to 1967 as the fifth principal of Dunbar High School. A momentous development in the history of public education was evident under his leadership. Bingham's tenure saw growth in the faculty, the facility, and the curriculum. Dr. Bingham was determined to prepare young minds for the real world. His wife, Lucille Bitting Bingham, accepted a teacher-librarian position at Dunbar. (Courtesy of Charles Owens.)

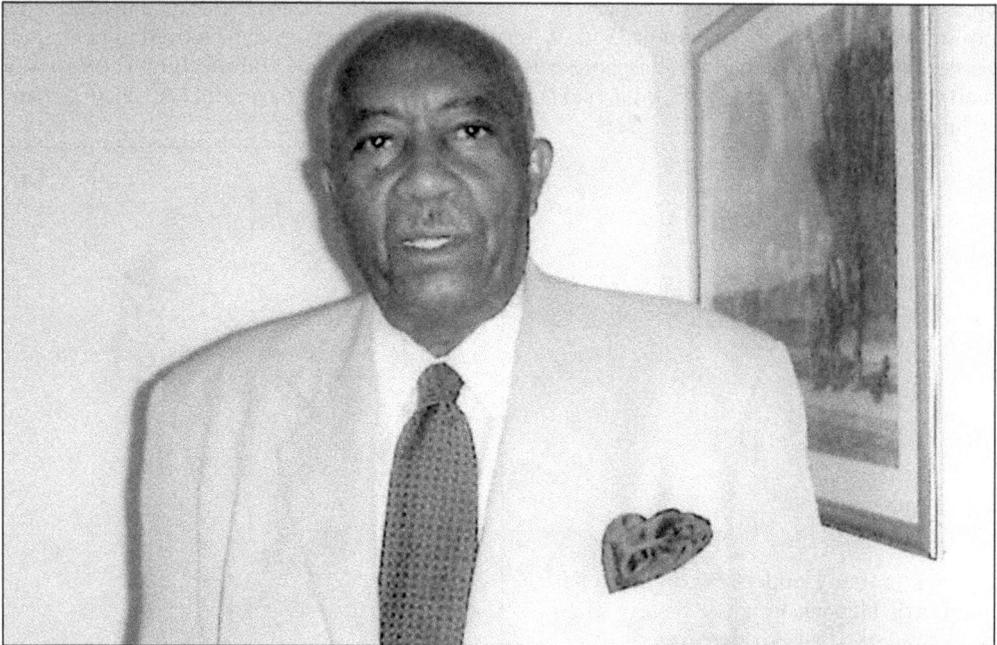

After graduating from North Carolina Agricultural and Technical State University (A&T) with a bachelor of science in biology and a minor in chemistry, Dr. Lacy Caple attended Meharry Medical College in Nashville, Tennessee. In 1951, he became the first African American dentist to practice in the city of Lexington. It was his intention to join the faculty at Meharry, but a friend invited him to the Davidson County area, where he reluctantly agreed to stay for one year. His family has been a fixture on Smith Avenue for over 60 years. Dr. Caple was the first African American to serve as chairman of the Lexington City Board of Education. (Courtesy of Renee Caple.)

John Baxter Earl Henderson, educated in the Lexington city schools, was a 1959 graduate of Dunbar High School. He received a vocational scholarship to North Carolina College at Durham (now North Carolina Central) and would receive a master's degree in social work from Atlanta University (now Clark Atlanta). While a dedicated social worker, Baxter Earl enjoyed getting the scoop on sports, news, and community features. This reporting led him to the art of photography, one of his many passions. (Courtesy of Annette Smith.)

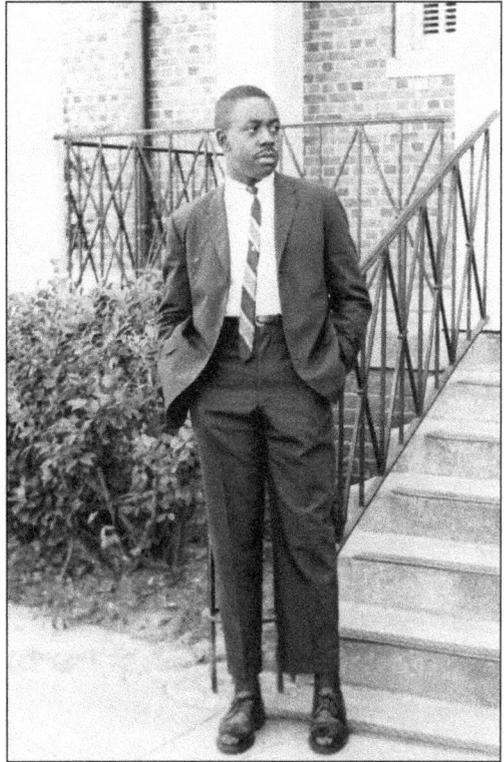

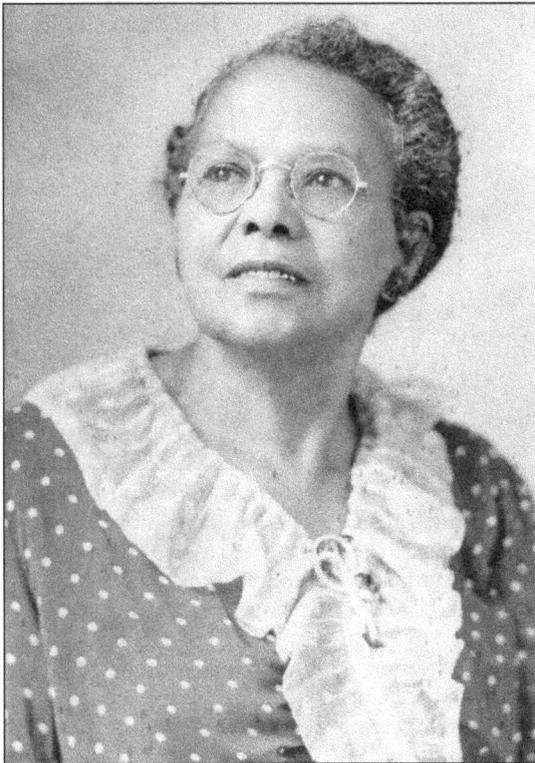

Having typhoid fever three times was not enough to dampen the life of Annie Ernestine Carter, born on May 24, 1876, in Davie County to Monroe Carter and Hettie Roberts Carter. Annie worked as a domestic and later as a nurse. She had one daughter, Gladys, and a dear sister, Myrtle Carter Austin. When she turned 100 in 1976, Annie was given a key to the city from Mayor Arnold Tesh. (Courtesy of Carolice Graham.)

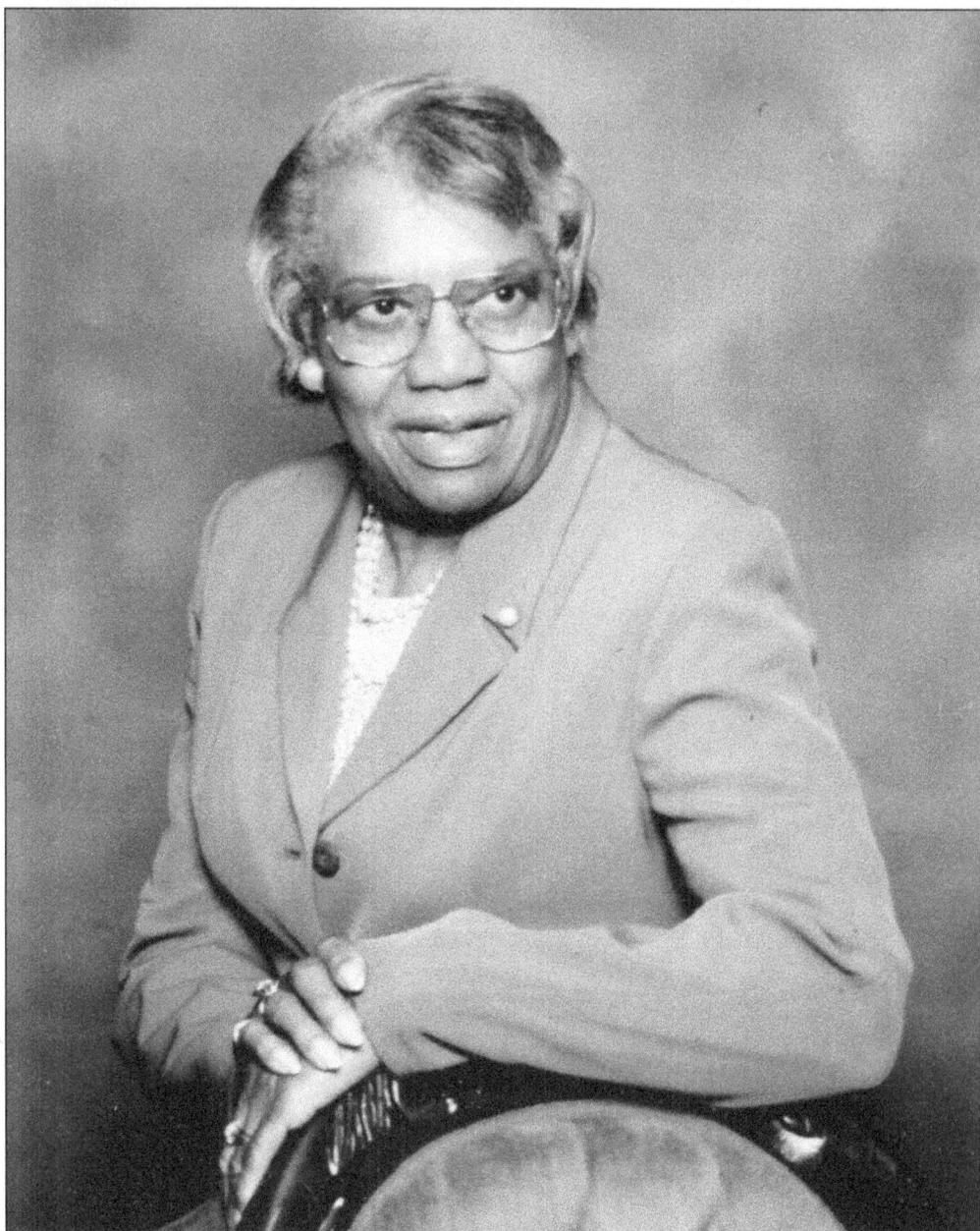

The accolades and commendations that follow Etta Michael White are numerous. She graduated from Dunbar High School and then attended Winston-Salem Teachers College (now Winston-Salem State). To help with educational expenses, Etta enrolled and graduated from Yarboro School of Cosmetology. She would relocate to New York and graduate from Monroe School of Business with exceptional marks. Upon retirement from the U.S. government, Etta was awarded the Albert Gallatin Award, the highest award presented to a civilian employee. In addition, Etta has received countless recognitions for volunteering in Davidson County; serving St. Stephen United Methodist Church; honoring Dunbar High School; and celebrating her family, the Michael, Lopp, and Brummell clans. In her spare time, she enjoys tending her flowers and traveling; crossing the London Bridge left a lasting impression. (Courtesy of Etta M. White.)

Gladys Onedia Carter was born January 10, 1910, to Annie Ernestine Carter. She received her early education in the Lexington public schools and graduated from Dunbar High. Gladys earned a nursing degree from Lincoln Memorial College in Durham. Later she attended Florida Agricultural and Mechanical in Tallahassee, where she was awarded two health degrees in lung and heart care. (Courtesy of Tonya Lanier.)

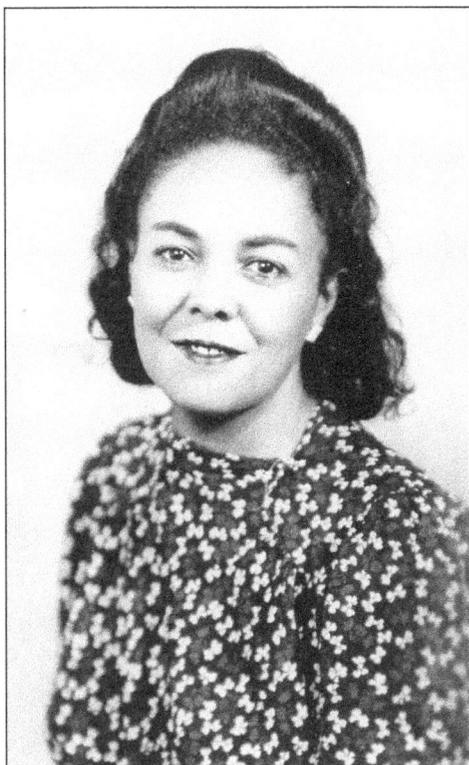

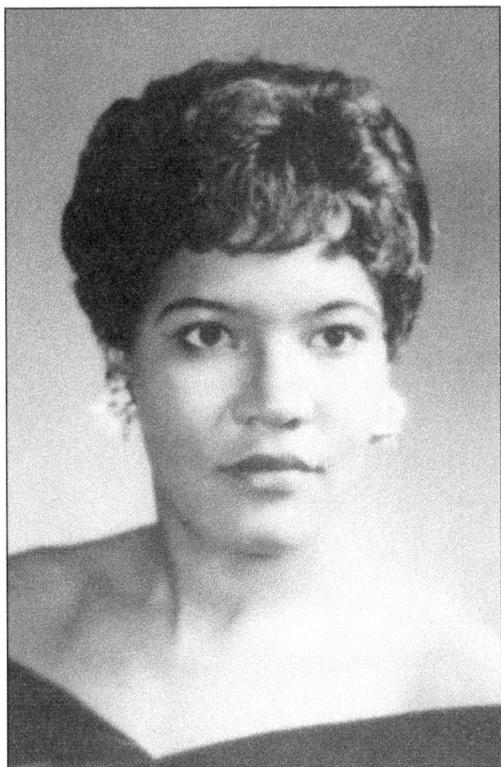

Arthur and Lucille Bingham welcomed their daughter Arletta on November 20, 1939. She received an doctorate from Howard University School of Medicine after attending Dunbar High School and Fisk University. Although she worked in pediatrics at Freedman's Hospital in Washington, D.C., she would later join the staff at the Veterans Medical Center in Salisbury as the director of anesthesia services. (Courtesy of Charles Owens.)

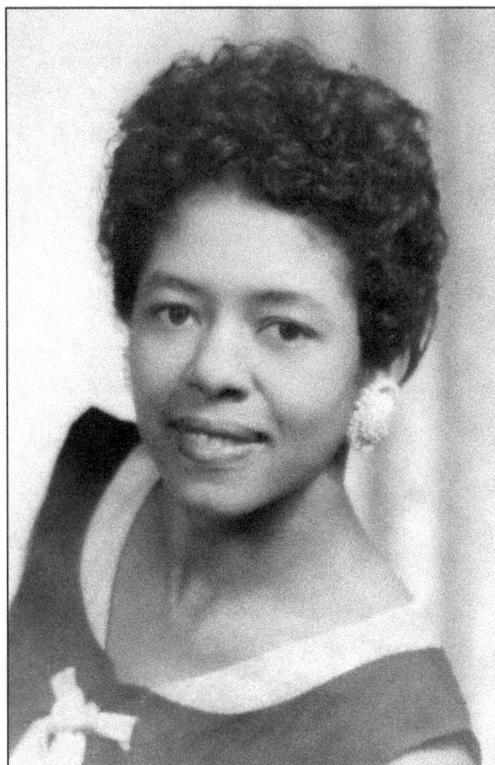

Julia Chisolm England had a stellar career as an elementary educator. Before moving to Lexington, Julia taught at Billingsville Elementary School in Charlotte. She touched many lives at South Lexington, Grimes, Pickett, and Dunbar. She married Charles "Coach" England and is a faithful member of Shadyside Presbyterian Church. (Courtesy of Julia England.)

Harvey Henderson was a stalwart force in civil rights movement. He served as a shouting voice for persons unable or unwilling to fight the desegregation battle. With his guidance, the bus line, bowling alley, restaurants, and theater were integrated in the city of Lexington. In the summer of 1963, Harvey, along with nine others, jumped into the all-white city pool, creating a huge media splash. (Courtesy of Faye Henderson.)

Ethel Bell Davis Parks was raised in South Carolina. She came to Davidson County in search of a better job. From her marriage to Pierce Parks, three children were born—Tim, Gerald, and Norma. Ethel worked for Davidson County Health Department for 25 years as a community health assistant. It was her job to go into homes to work with patients. She is a faithful member of Files Chapel Baptist Church. (Courtesy of Ethel Parks.)

Thurler Gaither was a common sight around town, riding his horse and pulling his plow. He was a handyman who was ready to help. On holidays and at special events, he would hook a wagon to his horse and carry eager children for rides. (Courtesy of Alberta Carter.)

Being an accomplished and aspiring musician, Gregory Staplefoot performed at a variety of community and church functions. He moved to New York to further his dream and taught in the New York City school system. Greg performed at the Apollo Theater and acted in the play *God's Creation*. He was a blessing to his parents, Clara and R. J. Staplefoot. (Courtesy of Tonya Lanier.)

Born on August 10, 1906, Ida Clara Bell Craven Lee, affectionately called "Clara Bell," loved her family and her church. She enjoyed being a member of Fourth Street Senior Citizens, Southside Senior Citizens, and the Hairston Clan. (Courtesy of Rev. Arnetta Beverly.)

When the Long family moved to Lexington in 1931, Richard Ottis came along. He attended barber school and joined his stepfather in the First Avenue barbershop. In 1946, Richard decided to open Long Music Company. With this endeavor, he rented jukeboxes, pool tables, and pinball machines. He also sold records in a store on Dixie Street. He and his wife, Thelma, had one daughter, Sarah. (Courtesy of Sarah Long Harris.)

After graduating from Kate Bitting Reynolds School of Nursing in 1955, Katy Hoover Evans, R.N., secured a position at Duke Medical Center. Working as a nurse during the height of racial segregation forced her into experiences and dilemmas that she honors today. Her book *Duke, Before and After Integration* delivers a candid look at the hospital industry. (Courtesy of Katy Hoover Evans.)

John Cobb was born on April 8, 1809, in Abbeville, South Carolina. He worked for Burlington Industries and, for many years, maintained the lawns of several downtown businesses. Cobb was an active member of St. Stephen United Methodist Church, served as president of the City/County Church Club, and enjoyed his Southside Senior Citizens. He and his wife, Emma, had a daughter, Bernice, and a son, James. (Courtesy of St. Stephen UMC.)

For most of his adult life, Squire Hairston was involved in one project after another to help people in Davidson County. Whether at the National Association for the Advancement of Colored People (NAACP), the Petersville community, Buncombe Baptist Church, or his Hairston clan, Squire was a voice with a cause. While employed at Davidson County Community College, Squire decided to get his high school diploma shortly after he turned 70. (Courtesy of Robert Hairston.)

# Two

# WITH ALL
# DELIBERATE SPEED

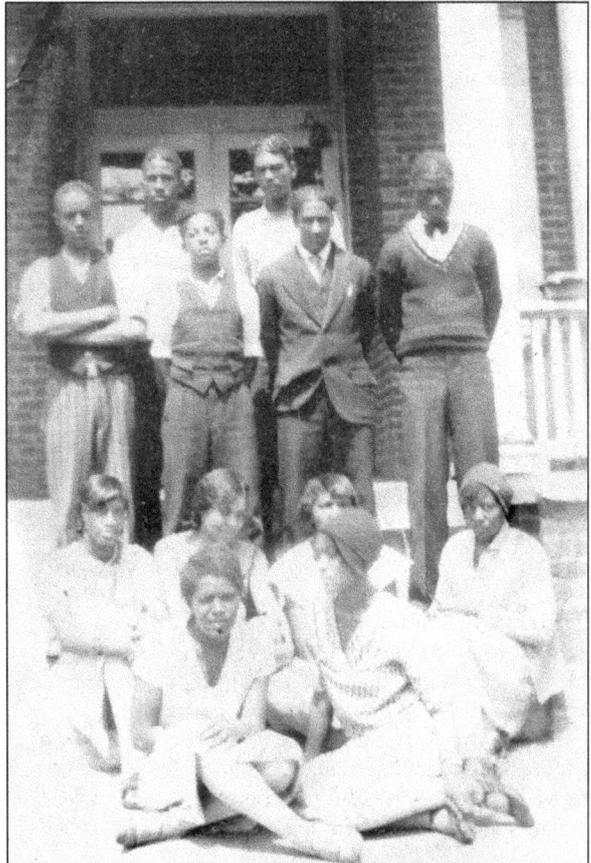

Initially called the Lexington Colored School, the facility was located on Cecil Field before being moved to Fourth Street. The first principal, Rev. W. G. Anderson, taught classes, coached sports, and served as pastor of Shadyside Presbyterian. During the 1927 school year, the seniors voted unanimously to change the name to Dunbar, honoring the great poet Paul Lawrence Dunbar. Pictured here is the 1931 class. Classmates include George Welborn, E. Owens, Harvey Hargrave, Sullivan Wellborne, Lawrence Murray, Monell Wooten, Earline Adderton, Gladys Carter, Addie Harris, ? Henderson Charity Craven, and Mable Harris. (Courtesy of Tonya Lanier.)

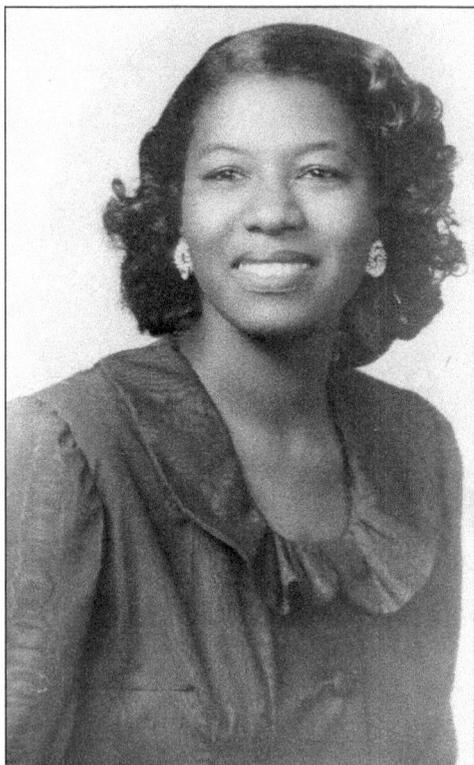

Gertrude Reid set out to improve the community in which she lived. After teaching in New York, Gertrude returned to Lexington, where she immersed herself in volunteering at the Lexington city schools and in various civic and social organizations. Gertrude was active in her church, Shadyside Presbyterian. (Courtesy of Julia England.)

Theodore Holmes Jr. was born on May 1, 1937, to Theodore and Marie Holmes. He was a 1954 graduate of Dunbar High School and a 1958 graduate of Livingstone College. After serving a few years in the Mooresville school system, Theodore moved to Davidson County, where he began a legacy at Central Davidson High. (Courtesy of H. Lee Waters Collection.)

In 1930, the entire
student body of
Dunbar High School
stands proudly with
principal Benjamin
A. Bianchi (second
from left, third row)
and teacher Rose Ellis
(second from right,
third row). Many
of these students
had moved from oil
lamps and potbellied
stoves in a one-room
schoolhouse to a
brick structure with
upscale amenities.
(Courtesy of H. Lee
Waters Collection.)

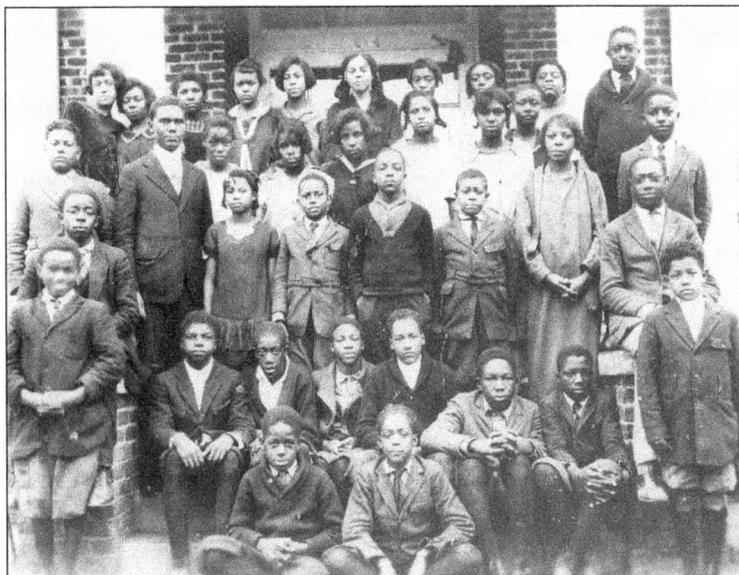

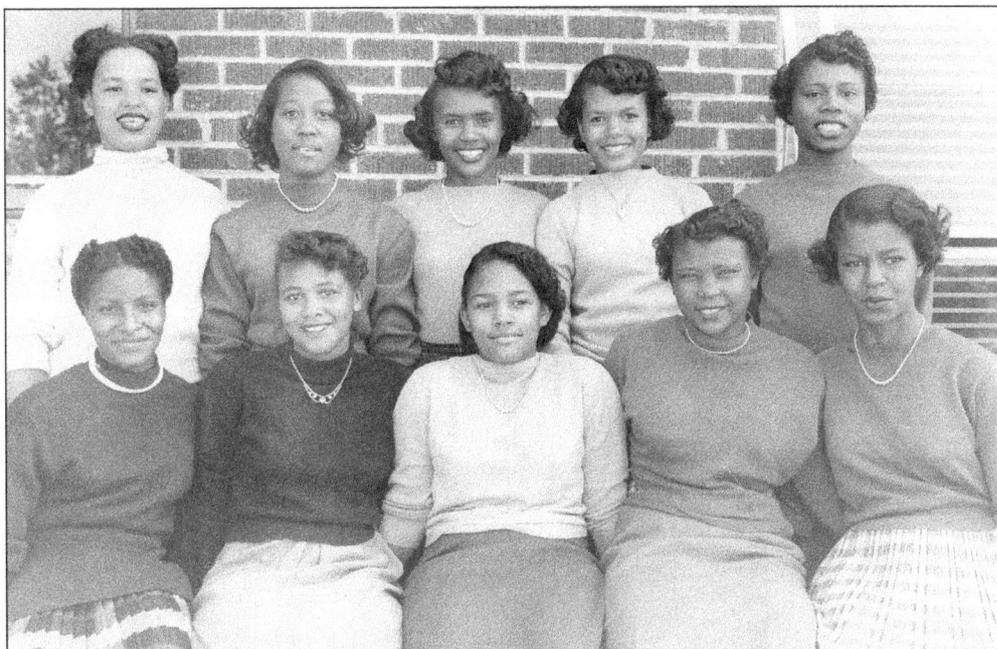

The Ebonites sponsored a sub-debutante contest in 1953. Contestants are, from left to right, (first row) Martha Crump, Elizabeth Pearson, Thelma Michael, Pearl Pickett, and Maxine Owens; (second row) Gail Holmes, Betty McGuire, Fannie Davis, Earl Lyons, and Zula Freeman. Not shown are Lena Perkins and Rose Marie Shoaf. Proceeds from the contest were used to fund a scholarship. Thelma Michael was crowned Miss Sub-Deb at a formal ball. (Courtesy of H. Lee Waters Collection.)

Lillie Mae White Evans was born in Kinston, North Carolina. After graduating from Winston-Salem Teachers College, she earned a master's degree from Columbia University in New York. On December 1, 1928, she married Rev. Ananias T. Evans. Whether she was teaching students, serving as a preacher's wife, aiding a community cause, or caring to the needs of family or friends, Lillie was dedicated and determined. (Courtesy of H. Lee Waters Collection.)

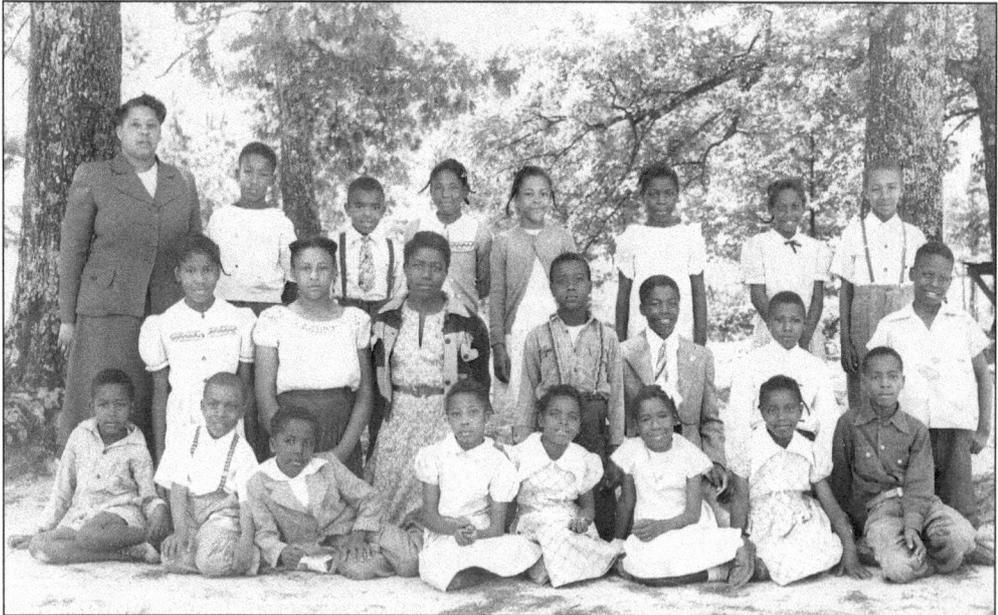

The students at Union Chapel School stand for a class photograph with teacher Mamye Sullivan Singleton. The school was an unpainted one-room building. Students used outside toilets across the street that belonged to Union Chapel Church. They had to bring their own lunch. After they completed the seventh grade, they could transfer to Dunbar High School in Lexington. The Union Chapel School closed in 1957. (Courtesy of H. Lee Waters Collection.)

The list of firsts for Rev. Dr. Arnetta Beverly is quite extensive: first African American elected to the Lexington City Council; first African American clergywoman delegate to the 2000 general conference; first African American woman district superintendent; and more. Rev. Beverly has been a licensed funeral director and embalmer and a member of the New York City Police Department and Davidson County Sheriff's Department. After taking care of the needs of her St. Matthews United Methodist Church family, she enjoys NASCAR racing, football, and reading. (Courtesy of Rev. Arnetta Beverly.)

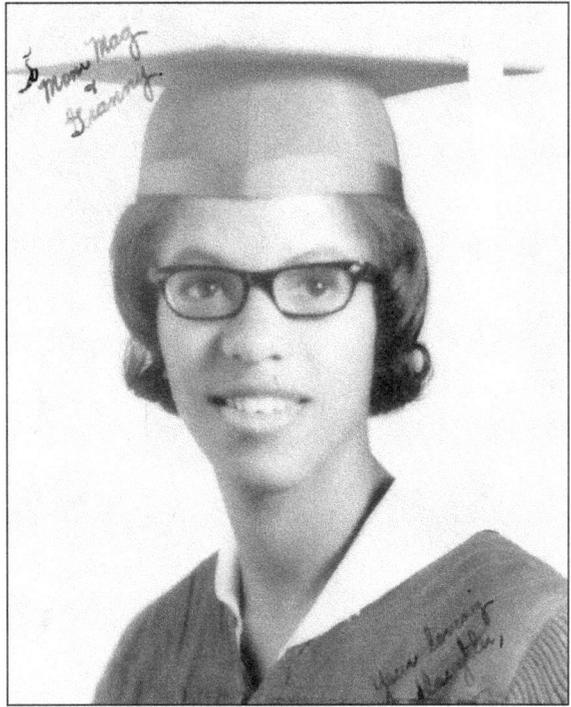

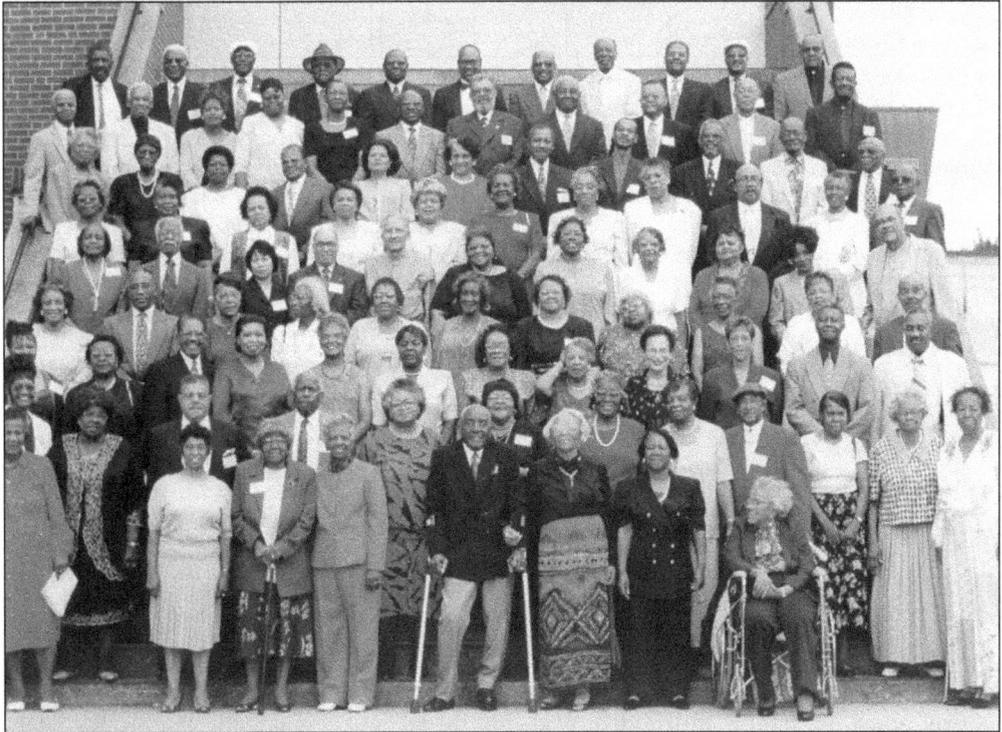

A Dunbar High School reunion is always an exciting time in Davidson County. People travel from all around to take part in a weekend full of activities. This photograph includes graduates from 1928 through 1967. (Courtesy of Alberta Carter.)

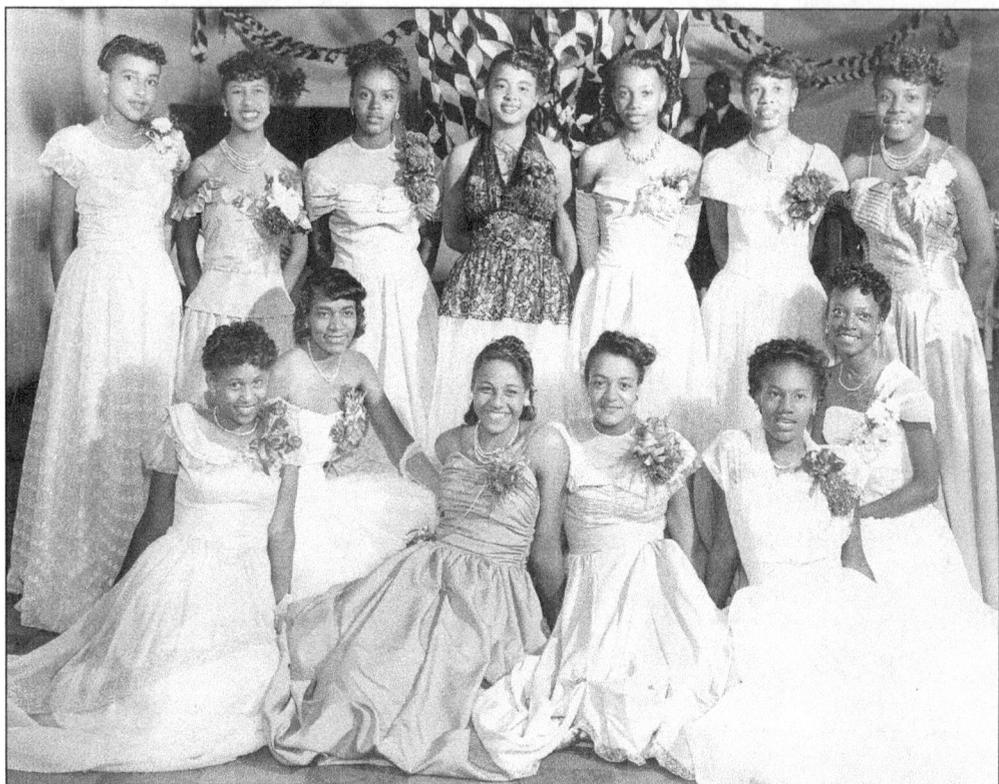

The business department at Dunbar High School sponsored the Skull and Bone Club. Girls who wished to become typists were selected from grades 9 through 12. One of the main activities of the year was to present a Mardi Gras. Club members in 1950 are, from left to right, (first row) Pauline Gooden Hargrave, advisor Helen Roberts Long, Margaret Hairston Weeks, Frances Jones Mack, Alberta Barker, and Bettie Ann Brummell; (second row) Henrietta Peoples, Vera Cureton, Emma Lee Jones, Edwina Lanier Saunders, Gwen Thompson Pearson, Louise Gordon Miller, and Alberta Brown. (Courtesy of H. Lee Waters Collection.)

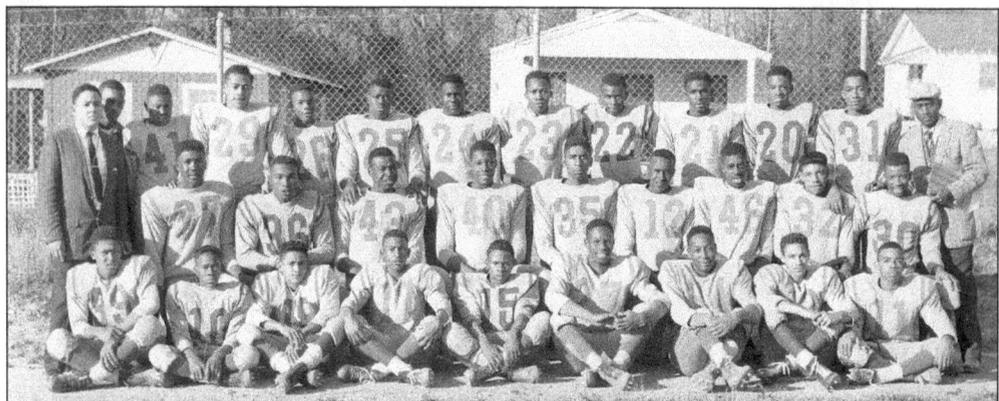

Coach William "Sugarlump" Bryant joined Dunbar High School in 1955 as athletic director and football coach. With great athletes like Wade Matthews, James Long, John Watson, Roy Holt, Mitchell McGuire, Melvin Webb, Tommy Hairston, Elmore Lyons, and John Lanier, the team was destined for a championship season. In 1957, Dunbar would win the 2A Western title in a memorable game against Morganton. (Courtesy of H. Lee Waters Collection.)

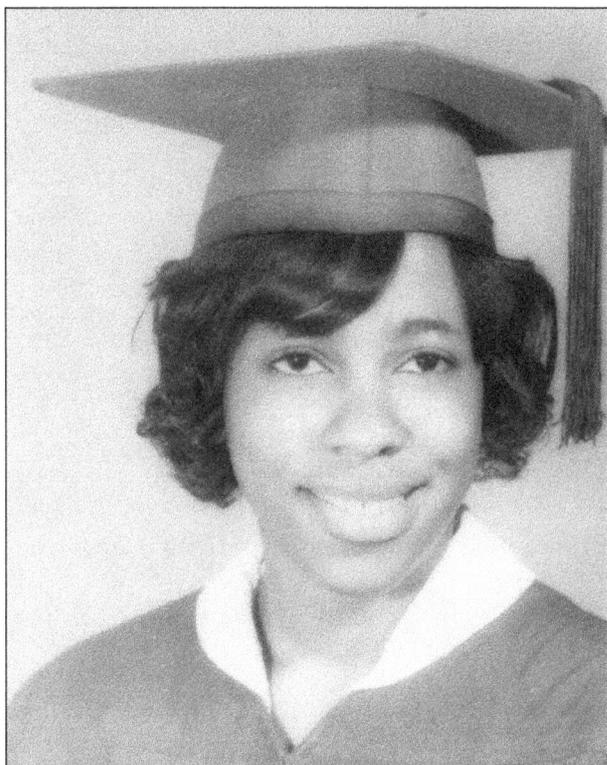

Alberta Elizabeth Wilson, nicknamed "Peanut," held the distinction of being the smallest baby ever delivered at the Lexington Memorial Hospital to survive, with the record weight of two pounds four ounces. Dr. James Redwine delivered the baby, at eight months, on March 18, 1947, to Mary and Albert Wilson. Her first day attending New Jersey School was so noteworthy that Peanut was featured in the July 28, 1953, issue of the *Dispatch*. (Courtesy of Alberta Wilson Walker.)

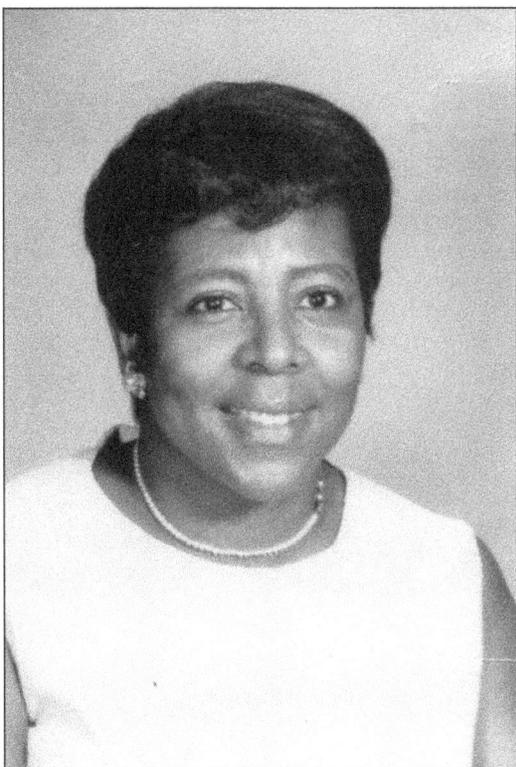

Margaret Marilyn Holmes taught at Dunbar High School from 1951 to 1968 before moving to Lexington Senior High, where she would teach until 1982. As a caring and dedicated educator, she touched the lives of many students. She served as church organist and choir director at St. Stephen United Methodist Church. (Courtesy of Alberta Carter.)

27

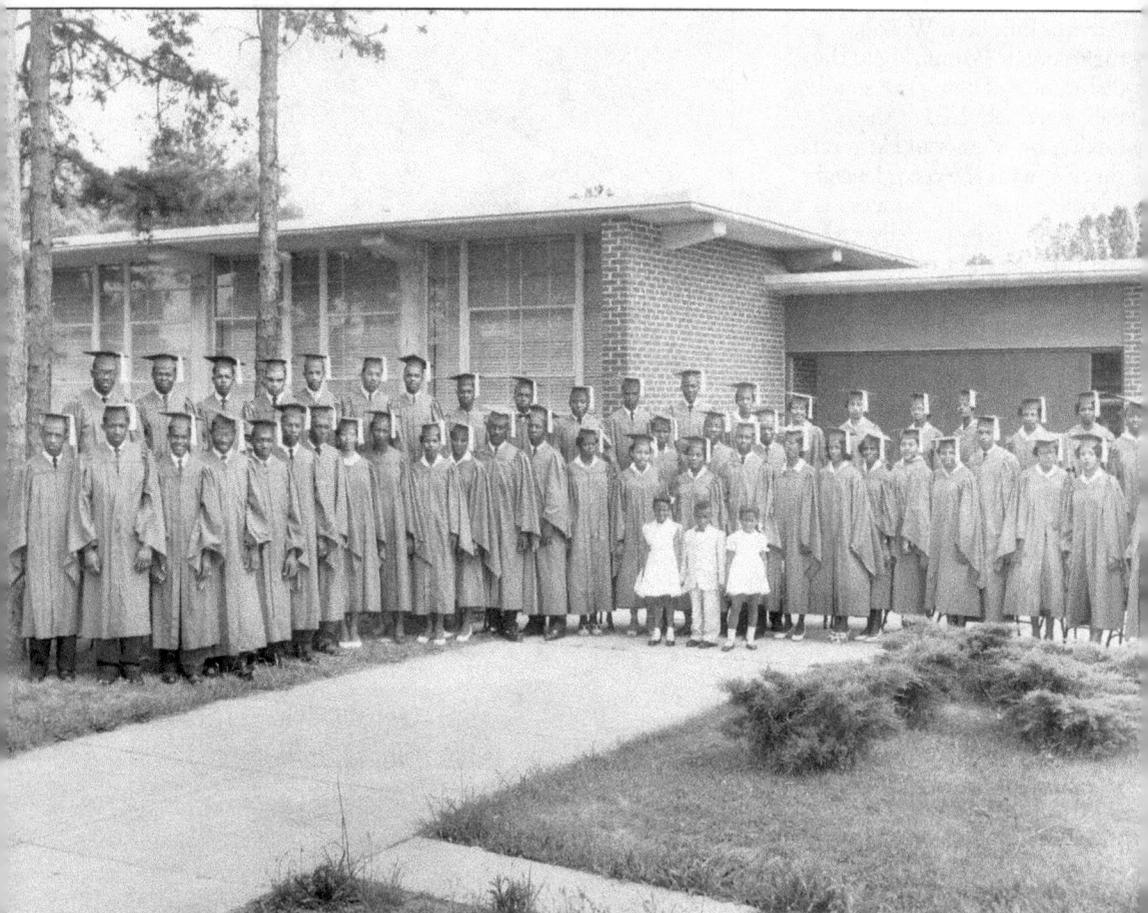

With 51 students, the 1957 graduating class from Dunbar was the largest to that date. (This record would not be broken until 1961, when the class would have 52.) The graduation exercise was held on Friday, May 31, 1957, in the school auditorium. The class motto was "To the Stars through Difficulties," class colors were mint green and white, and the class flower was a white carnation. Louise Leverette and Arletta Bingham served as co-valedictorians. Mascots shown are, from left to right, Fontaine Kirk, Dwight Terry, and Woodine Neely. Like other graduates, they vowed that even though they were going their separate ways, they would never lose their Dunbar spirit. (Courtesy of H. Lee Waters Collection.)

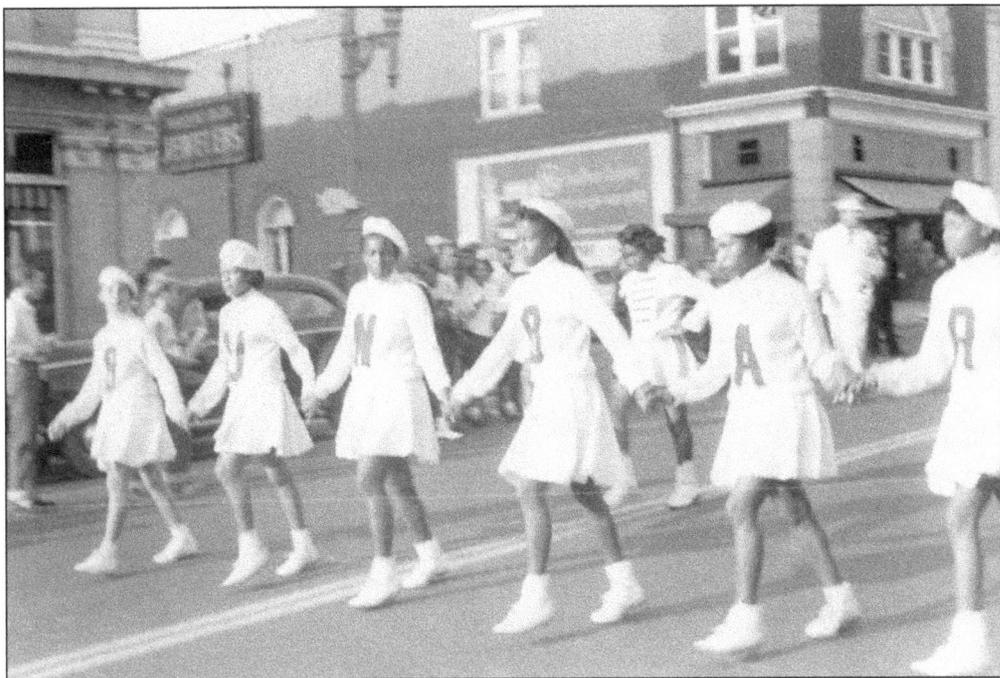

A Dunbar High School homecoming was an event that had to be experienced. Part of the weeklong festivities would be a parade. In 1951, record-breaking crowds stood along Main Street to enjoy the marching bands, queens, football team, and cars. These letter girls represent Dunbar proudly. (Courtesy of Keith Holmes.)

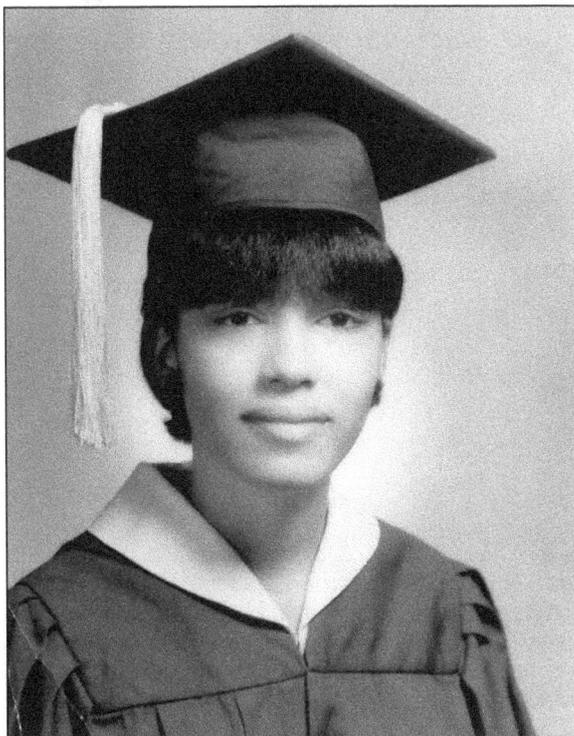

Robbie Neely Cross graduated with the Dunbar High School class of 1967. She was active in Future Homemakers of America and the yearbook staff. Robbie served as senior queen representative with Delores Blair Taylor. (Courtesy of Robbie Neely.)

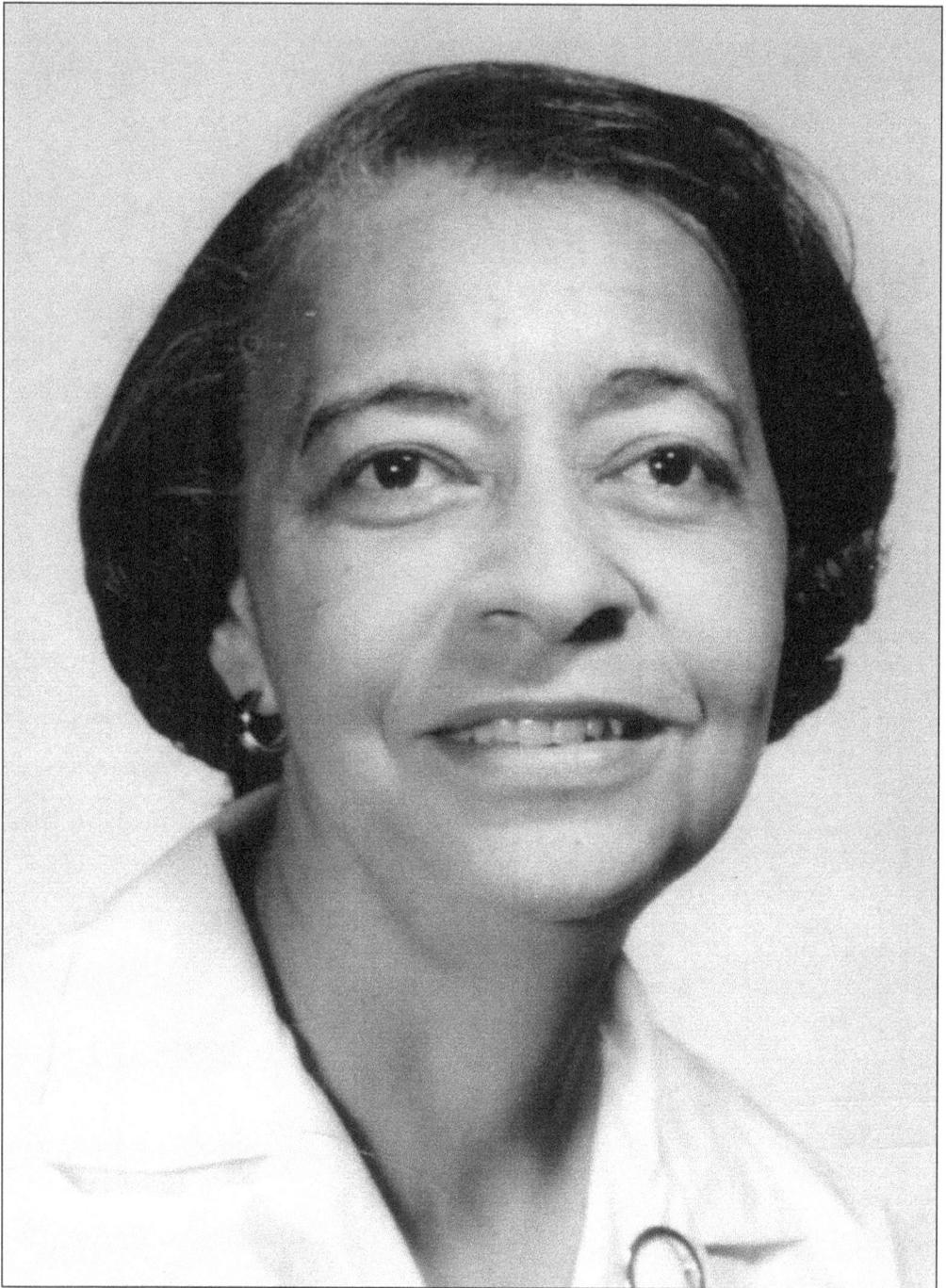

Ida Annetta Mabry was the daughter of William and Alice Mabry and was born on January 7, 1910. After graduating from Dunbar High School, Ida attended Fayetteville State Normal College (now Fayetteville State) and Winston-Salem Teachers College (now Winston-Salem State University) before receiving a master's degree from Columbia University in New York. She loved teaching and touching the lives of students. She was a faithful member of Shadyside Presbyterian Church. (Courtesy of Ella Mae Moore.)

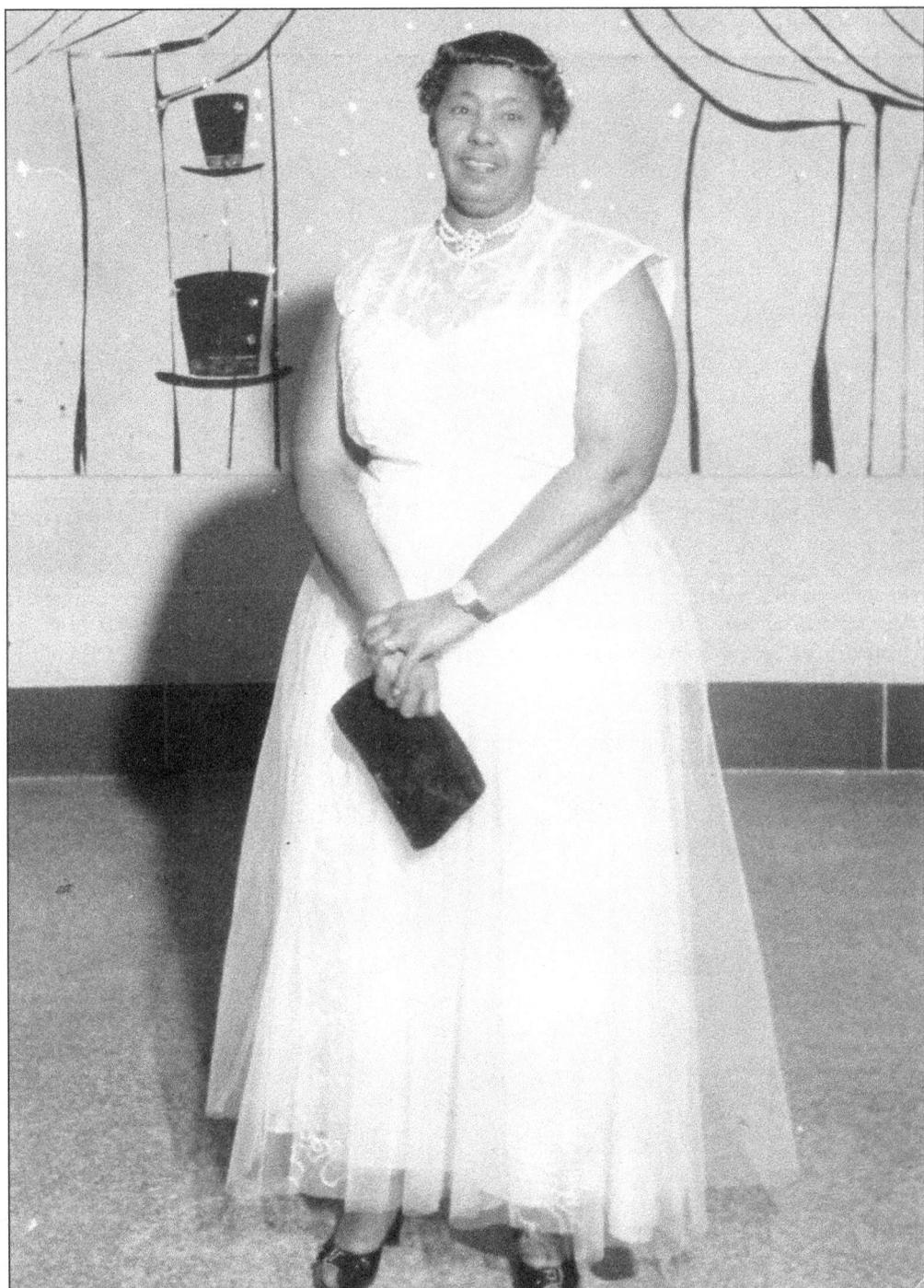

Mamye Sullivan Singleton, the daughter of Joseph and Emma Sullivan, attended Dunbar High School and Mary Potter School in Oxford, North Carolina. In her 42 years as an educator, she provided sound foundations for many. Among her accomplishments was organizing Girl Scouts for African American girls in the Lexington area. She was the devoted wife of George Singleton, and they had one daughter, Esther. (Courtesy of Annette Evans Marshall.)

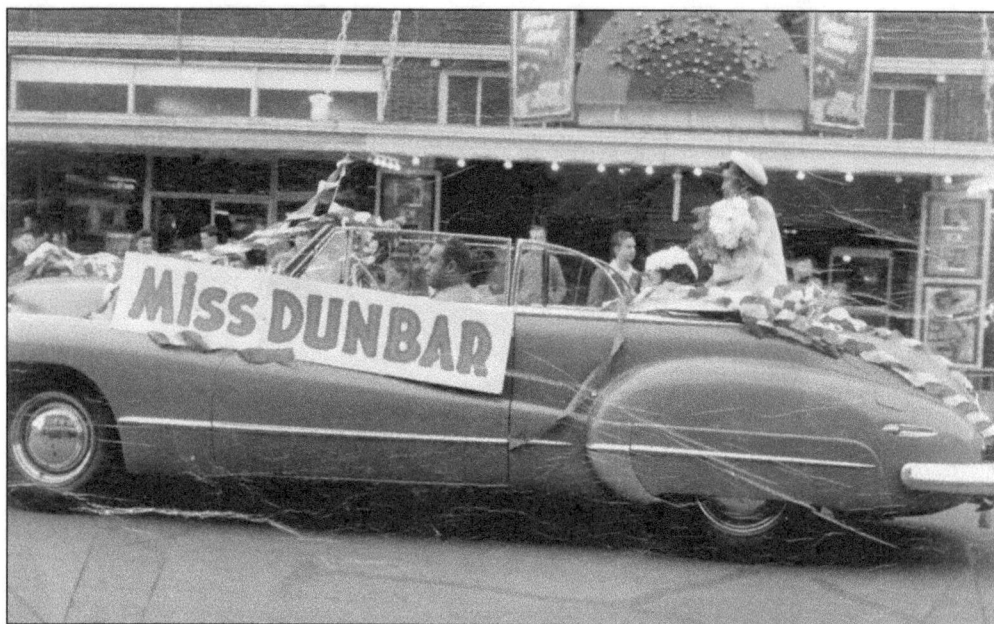

Miss Dunbar 1950 was eighth-grader Shirley Lopp. As part of her duties, she rode in the Dunbar homecoming parade. A Mr. Reid was her driver. They pause briefly in front of the Granada Theatre on Main Street in Lexington. (Courtesy of Shirley Lopp.)

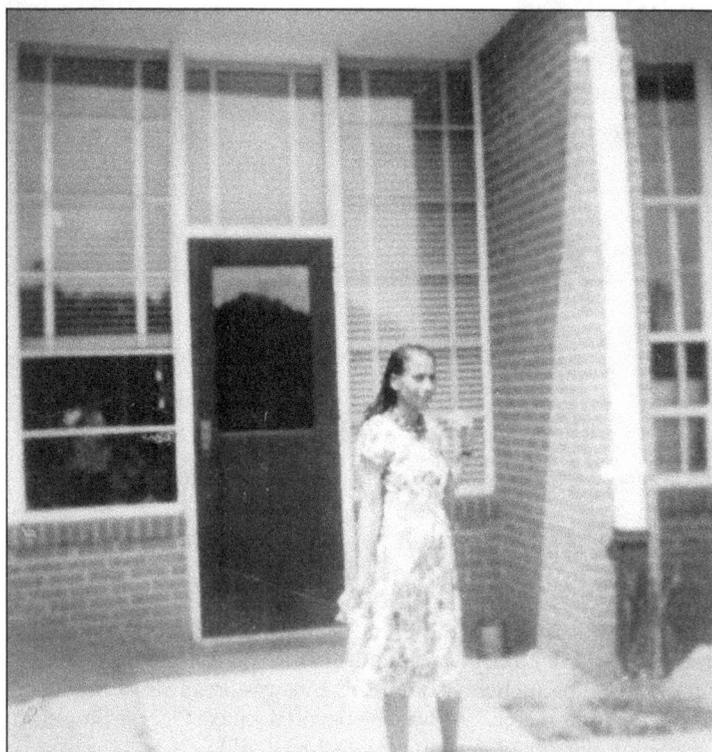

Jessie Miller stands outside her South Lexington Elementary school classroom. When she moved to Holt Elementary School, she became a media specialist. Her library was a source of information for students. Having these eager young people serve as media center helpers was an instant hit. The library proved a great place to be. (Courtesy of Carolice Graham.)

In 1967, as president of the South Lexington student body, Don Griffin accepted the keys to a brand new school. His leadership ability continued through his Dunbar High School years. It is no surprise that Don has a career in television, where he has held the positions of general assignment reporter, consumer reporter, and weekend anchor. In Charlotte, he can be seen on WSOC-TV Action 9 News. (Courtesy of Don Griffin.)

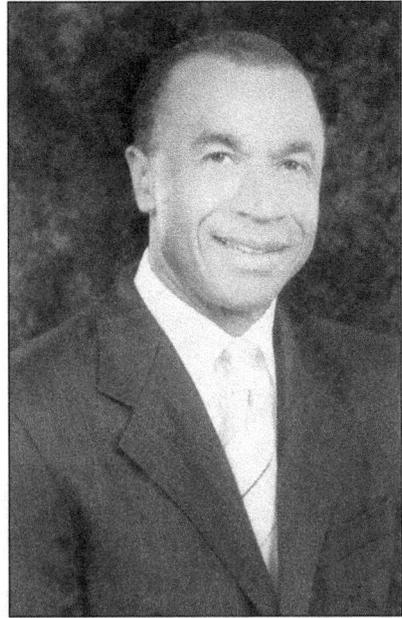

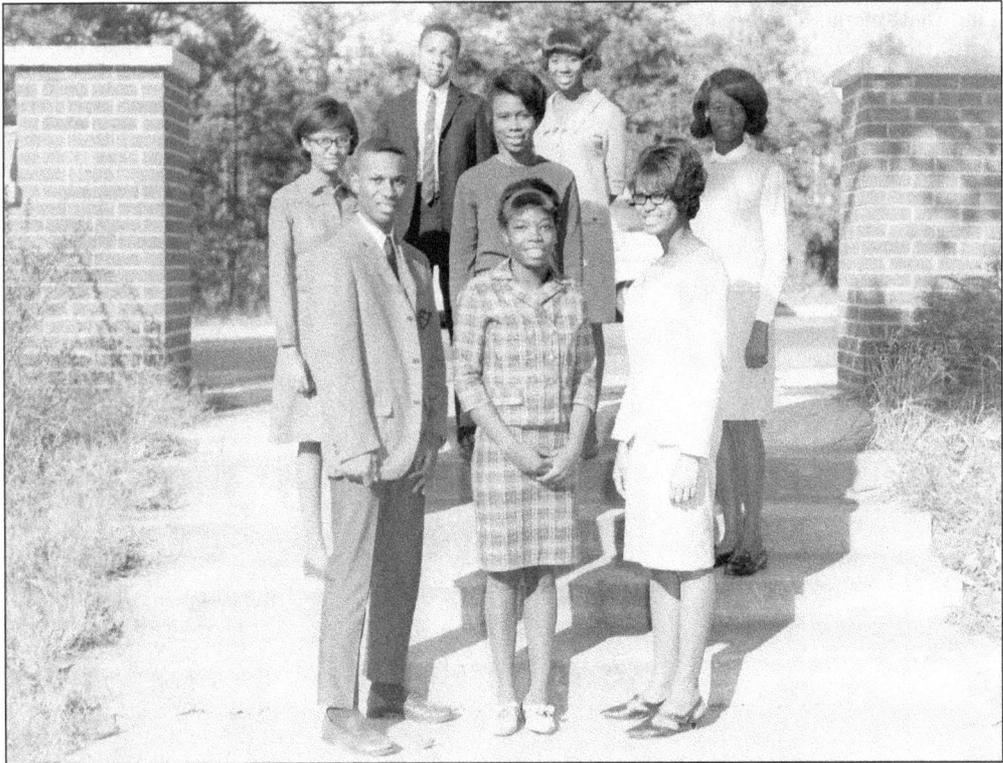

Developing good leaders and good character was a fundamental practice of the Dunbar administration. This began with a good student body. A few class officers gather on the lawn of the Smith Avenue School. They are, from left to right, (first row) Cecil Dalton, Patricia Knotts, and Vickie Jones; (second row) Carolyn Petty, Mary Clark, and Evelyn Hargrave; (third row) Charles Griffin and Geraldine Hoover. (Courtesy of Robbie Cross.)

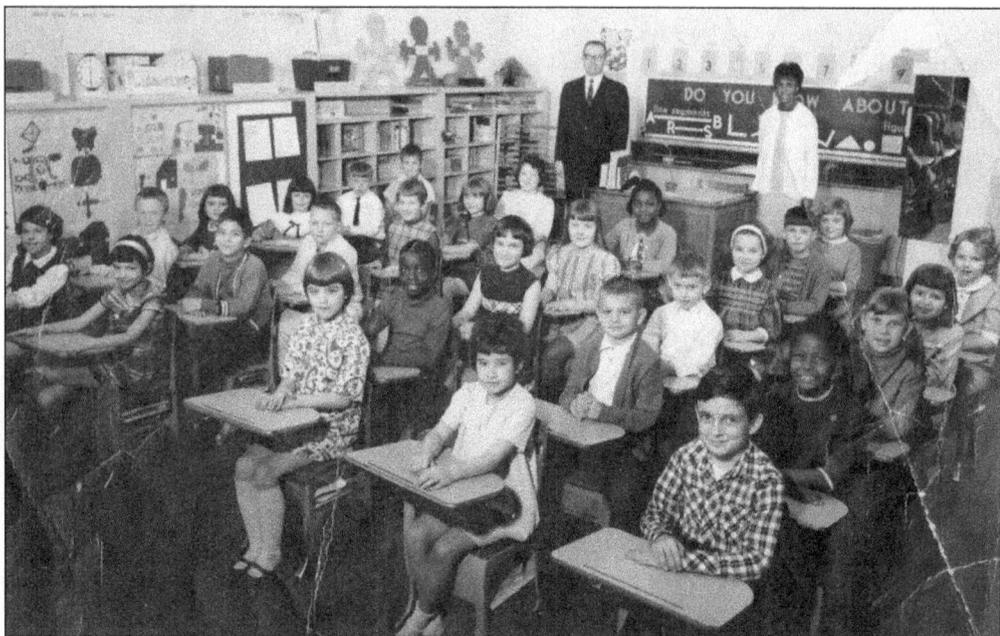

This Southmont second-grade class appears eager to learn. African American students Dorothy Cotton, Henrietta Pickett, and Greg Sullivan were happy to have Helen Murray as their teacher. She would stretch the minds of many students. (Courtesy of Clayton Lanier.)

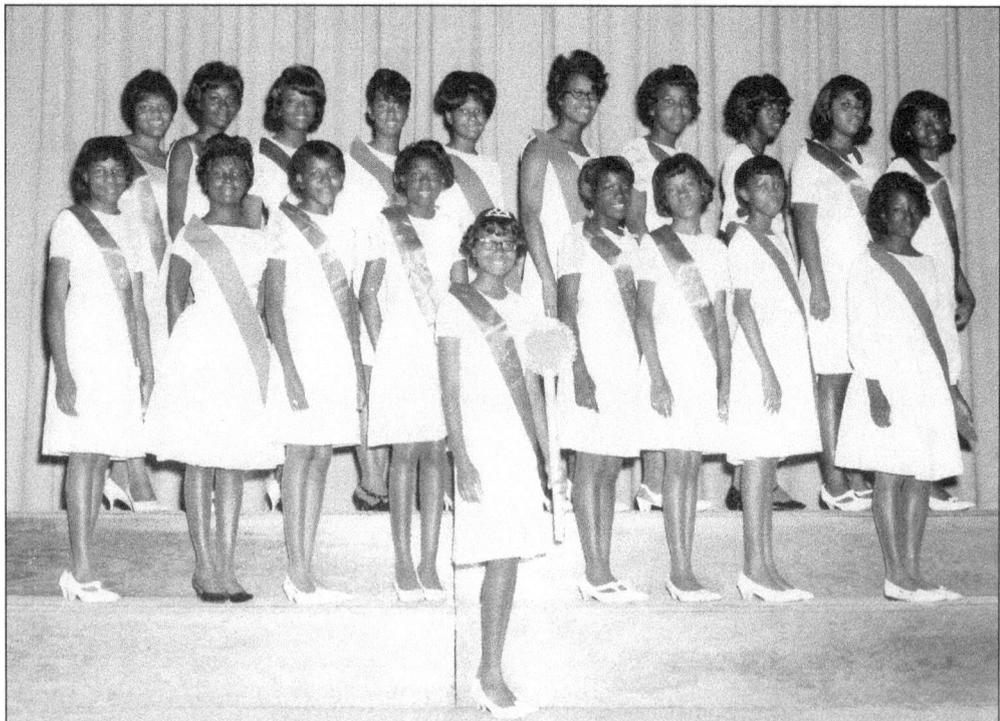

With books came beauty, and lovely young ladies were plentiful at Dunbar. It was an honor to participate in the many pageants sponsored by the community and the school. Carol Long is crowned Miss Sweetheart 1966. (Courtesy of Robbie Cross.)

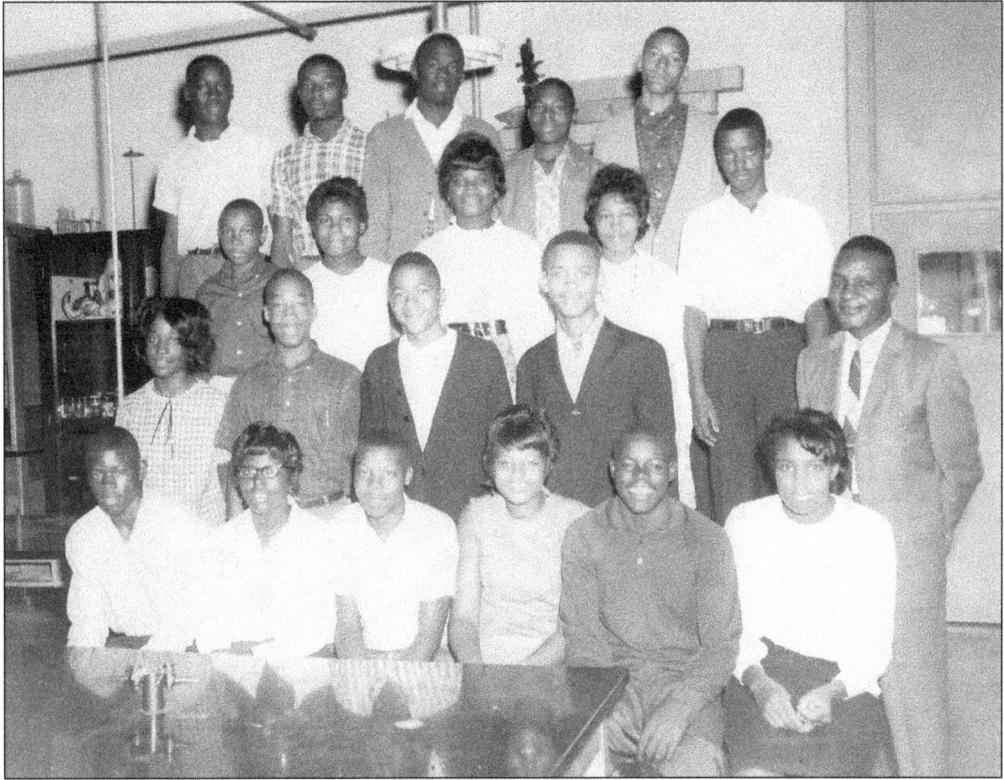

Dr. David Moose and his ninth-grade science class take a break from their Bunsen burners, test tubes, and flasks to pose for a photograph. Like other teachers at Dunbar, Dr. Moose had high expectations of his students. (Courtesy of Robbie Cross.)

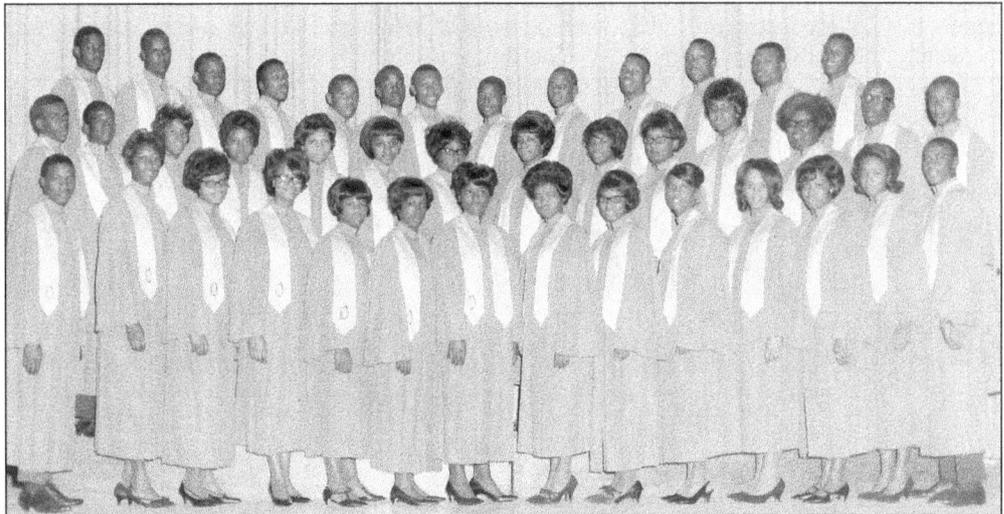

Jerry Mayfield, director of the Dunbar Glee Club, had an ear for music. In addition to teaching a variety of songs, Mayfield emphasized good posture and proper breathing. She would quickly persuade non-singing students to select another extracurricular activity. Glee Club officers were Lewis Hargrave, president; Judy Henderson, vice president; and Sarah Hargrave, secretary. (Courtesy of Robbie Cross.)

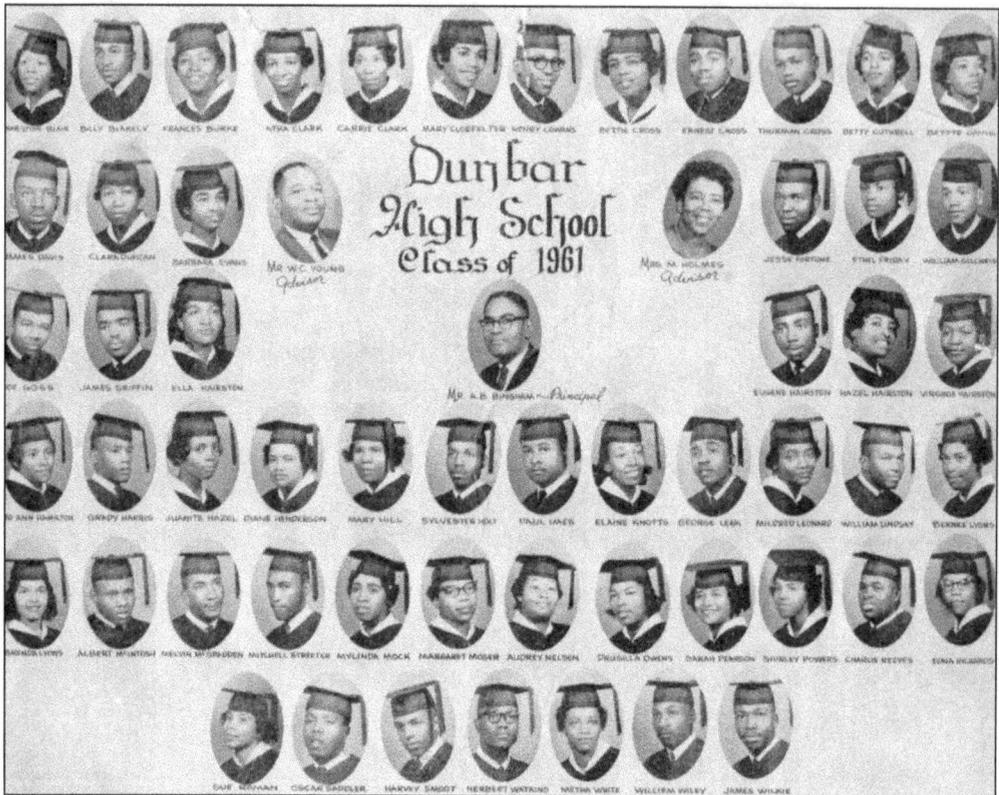

The class of 1961 earned the distinction of being the largest class ever to graduate from Dunbar High School with 52 students. Herbert Watkins was valedictorian, and Elaine Knotts was salutatorian. Elaine later nurtured and refined the minds of students as a tenacious teacher and community college instructor. While working for IBM, Herbert would be described as being one of the most powerful men in Charlotte. (Courtesy of Robbie Cross.)

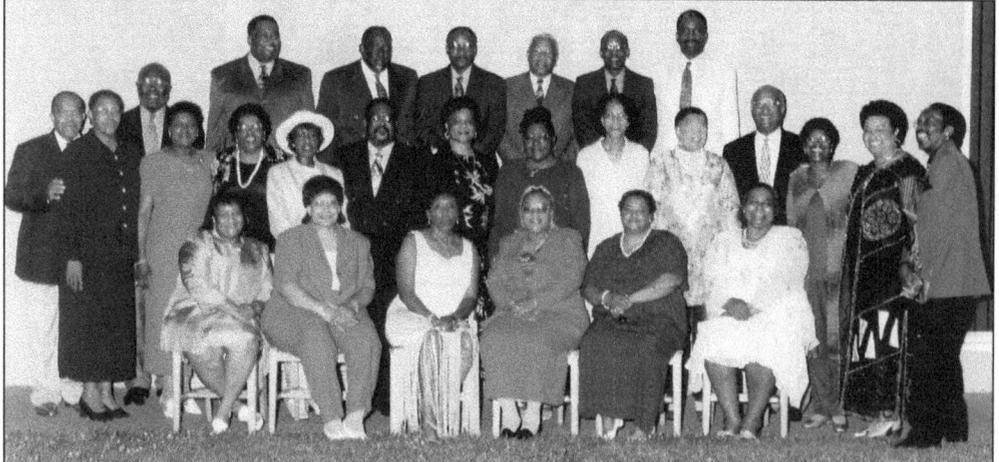

The 1961 Dunbar High graduates pose 41 years later, in 2002. Staying together has been a priority. The group hosts mini-gatherings, social events, and fund-raisers throughout the year. They also sponsor trips and cruises. This class is extremely proud of its togetherness. (Courtesy of Pauline Norman.)

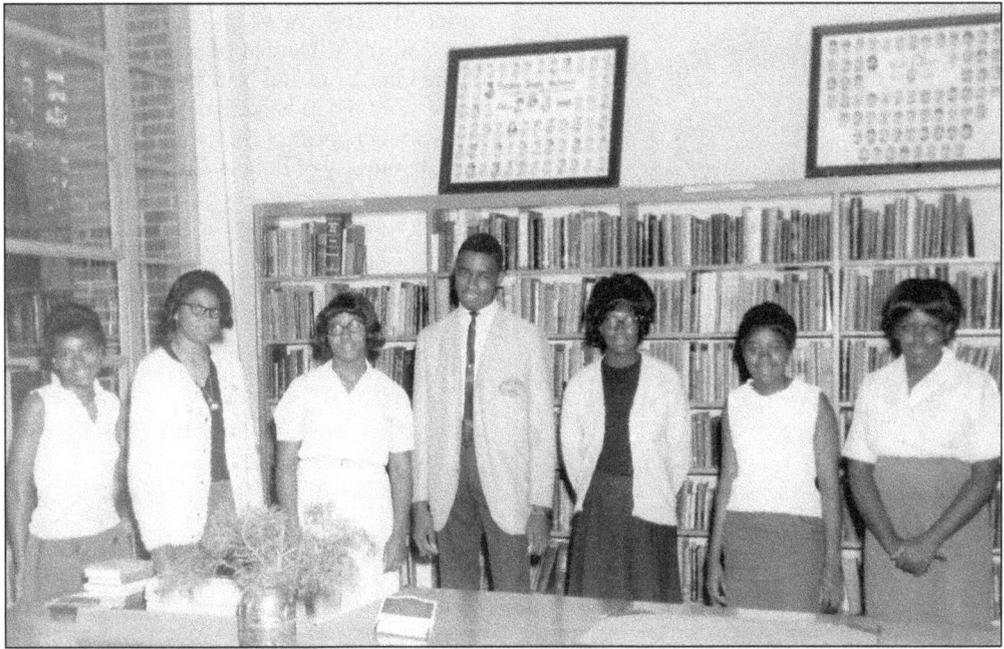

The Dunbar Library Club consisted of eighth graders used as helpers in the library. Duties included shelving books, assisting smaller children, sending overdue slips, and helping at the circulation desk. The club's motto was "When we are collecting books, we are collecting happiness." In 1967, officers were Dwight Roberts, Mary Pearson, and Dela Smith. (Courtesy of Robbie Cross.)

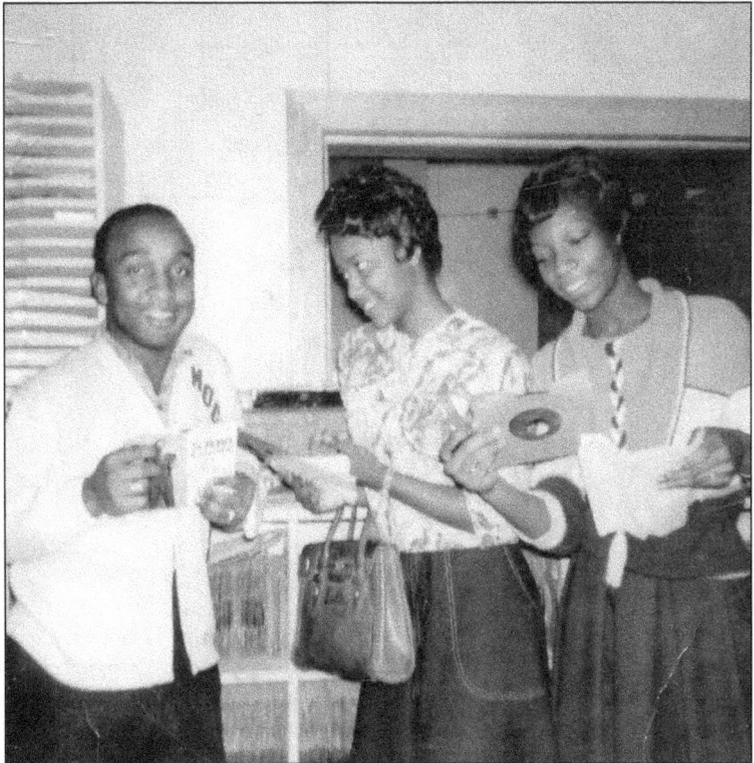

Thomas "Moose" Johnson seems more captivated by the camera than the 45s that Libby Matthews (center) and Peggy Davis are trying to show him. In high school, there was plenty of time to make friends and have fun. (Courtesy of Rev. Arnetta Beverly.)

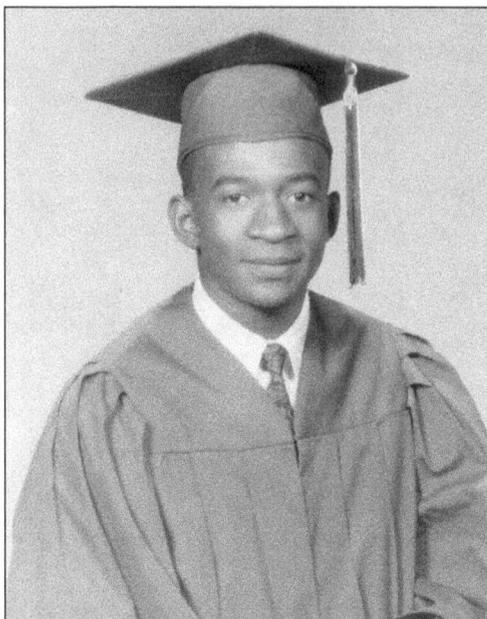

Bruce M. Cross enjoyed his high school years. While at Dunbar he was part of the Glee Club and National Honor Society, served as basketball statistician, and was a member of the yearbook staff. (Courtesy of Robbie Cross.)

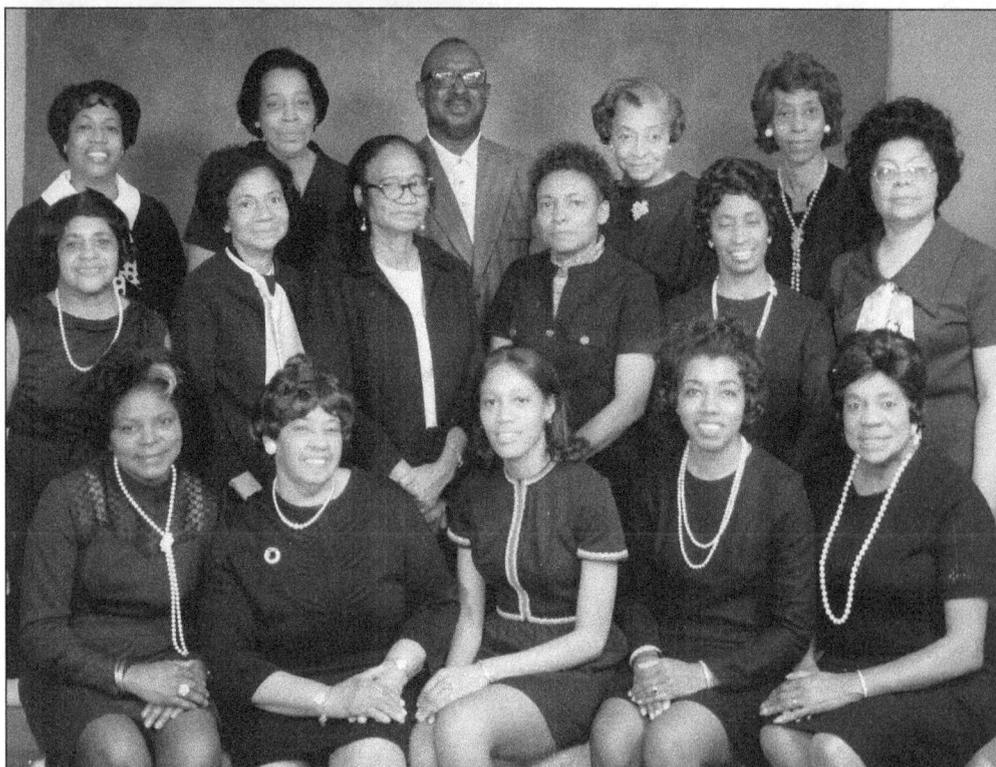

Alumni of Teachers College, later Winston-Salem State University, gather for another reunion. They are, from left to right, (first row) Jettie Moore, Mamye Singleton, Lillian Morgan, Savannah Adderton, and Frances Hargrave; (second row) Frances Hairston, Jessie Miller, Lillie Mae Evans, Marcellett Barrett, Eunice Sellers, and Naomi Morrison; (third row) Doretha Michael, Beatrice Reid, Joe Yarbrough, Ida Mabry, and Althea Hartman. (Courtesy of Annette Evans Marshall.)

Mary Meachum Talbert began her career as a secretary for A. B. Bingham at Dunbar School. Realizing that she could make a greater impact in the classroom, she became a teacher. After teaching a few years at Dunbar, she transferred to Central Davidson High School. (Courtesy of Mary Talbert.)

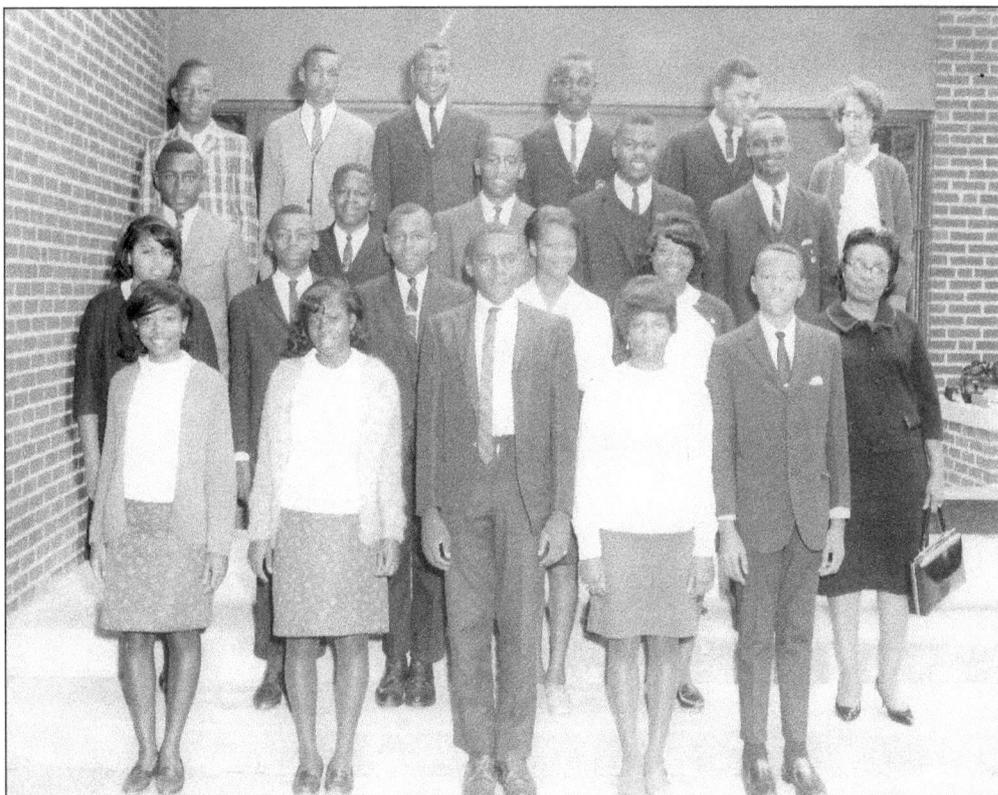

Marian Ferrell Young and her ninth-grade home economics class share a group photograph. Young graduated from Winston-Salem Teacher's College and received her master's degree from Penn State University. Her husband was Wilson C. Young. She expected great things from her students. (Courtesy of Robbie Cross.)

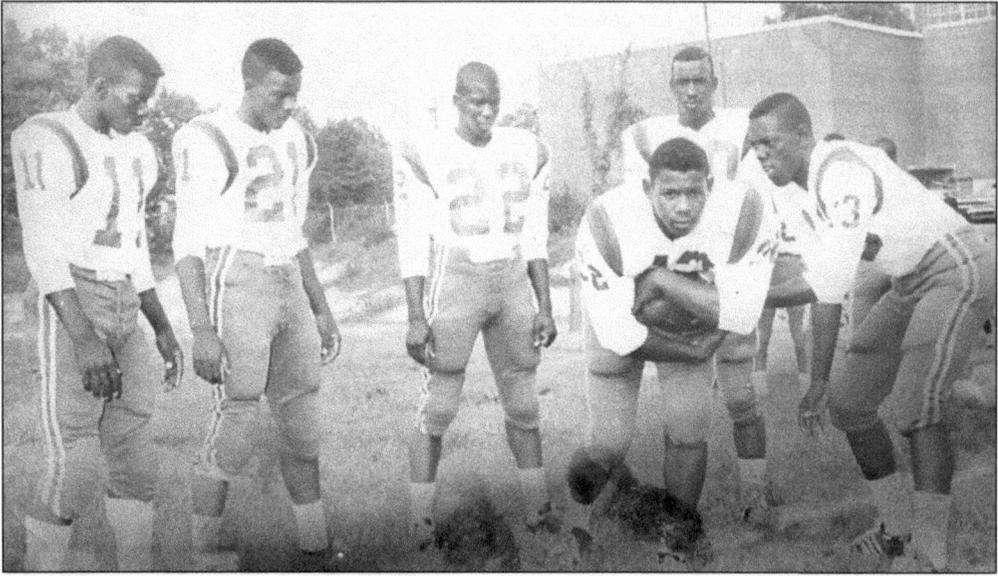

As with education, people were passionate about the sports at Dunbar High School. With great coaching from C. A. McCullough, William "Sugarlump" Bryant, Charles England, and Elmore Lyons, athletes reached new heights. Offensive players in 1967 were, from left to right, Hollis Clodfelter, Lewis Hargrave, Bobby Fortune, Herbert Dula, Robert Craven, and William Walser (in front with the ball). (Courtesy of Robbie Cross.)

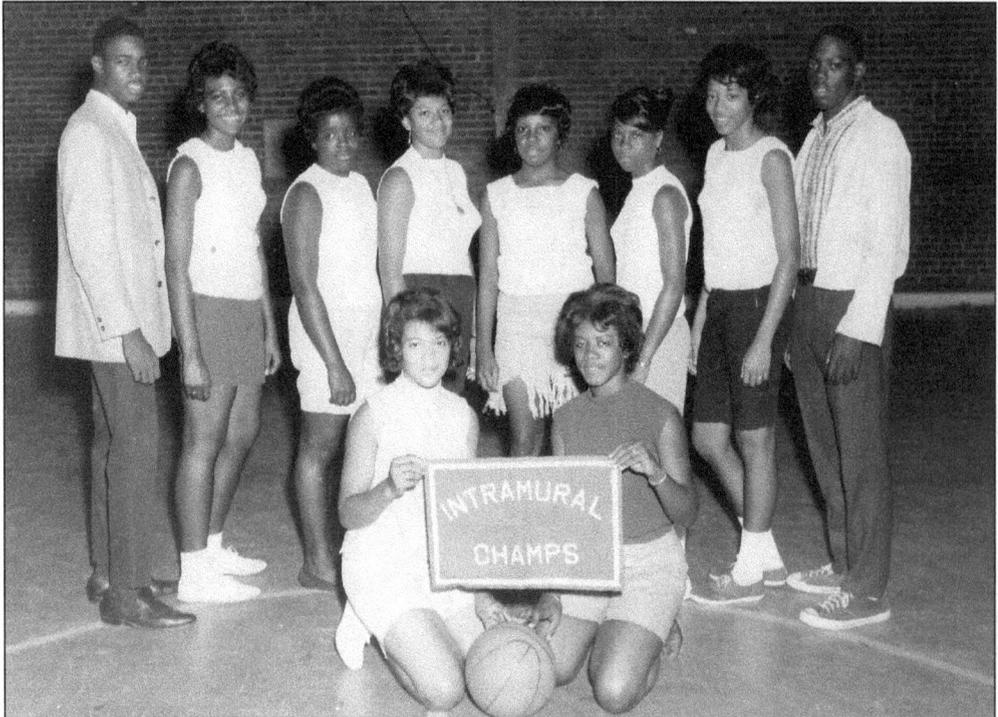

Having well-rounded students was essential to the education system at Dunbar. In addition to studying hard, students were expected to play hard. These intramural champions are proud of their recent honor. (Courtesy of Robbie Cross.)

## *Three*

# HONOR, COURAGE, COMMITMENT

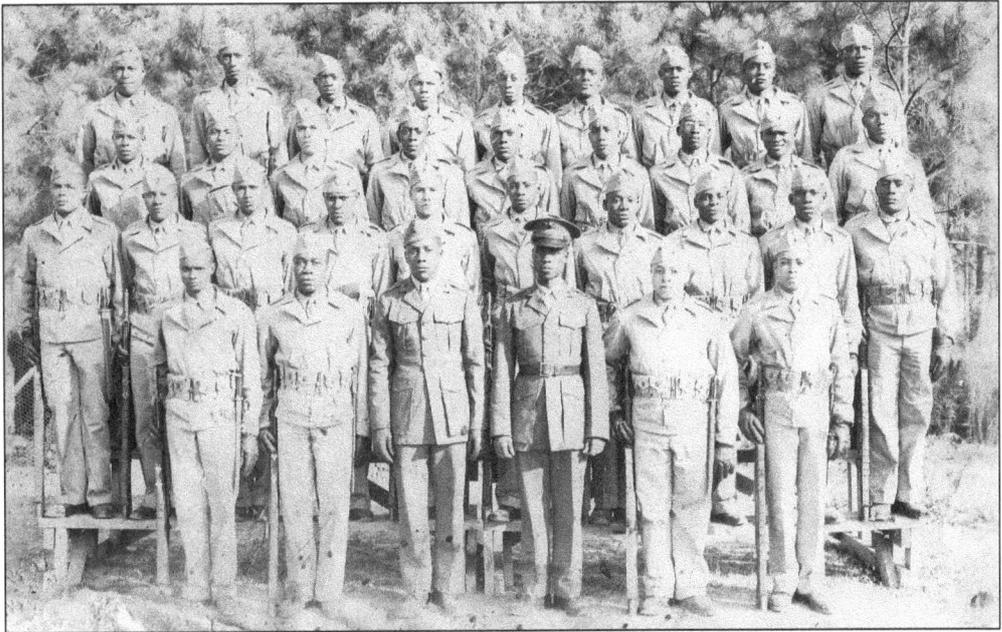

Until 1942, the U.S. Marine Corps refused to recruit minorities. Creation of the Fair Employment Practices Commission in 1941 changed this practice. The marines' first black recruits received basic training at a segregated base close to Camp Lejeune. L. M. Lockhart (fourth row, second from left) stands proudly with his 1943 marine battalion. These men were among the first black marines at Montford Point in Jacksonville, North Carolina, thereby earning the name "Montford Point Marines." With a pioneering spirit, the recruits faced hostility and distrust on and off the base. In 1948, Pres. Harry Truman signed an executive order requiring the military to desegregate. Montford Point was deactivated shortly thereafter. (Courtesy of Rona Lockhart.)

George Singleton was part of the 93rd Infantry Division, an all-black unit in the U.S. Army. While stationed at Emirau Island in the Pacific, he signaled a message that saved the lives of two white men who had been involved in a plane crash. Because of this, Singleton was awarded the Bronze Star on September 23, 1943. He was proficient in Morse code, semaphore code, sign language, and high-speed radio operating. (Courtesy of Esther Powell.)

Lee Madison was born in 1926. After being drafted into the army and serving in World War II, Lee attended and graduated from Modern Barber College on September 18, 1946. He and Marshall Bell operated a successful barbershop on Fourth Street. (Courtesy of Alberta Carter.)

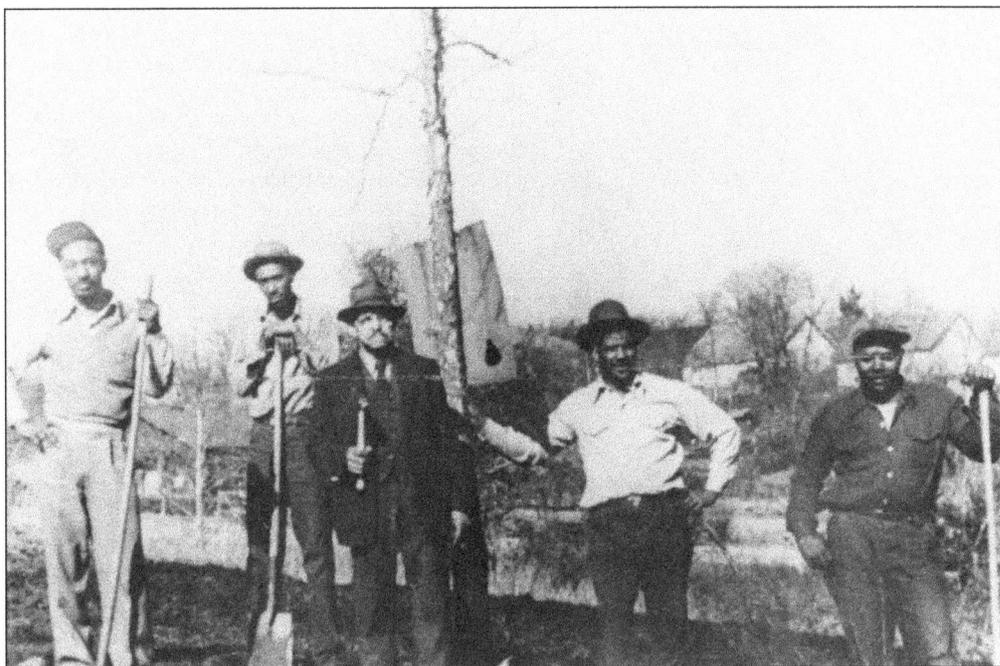

James Smith, L. M. Lockhart, John Bradshaw, Sam Hargrave, and Woody Neely assist in the ground-breaking and weed-burning gathering for American Legion Banks-Miller Post 255 on Arthur Drive. The post was built in the early 1950s. A fire would force remodeling of the original structure in 1971. More commonly called The Hut, this facility became a cornerstone in the community. Originally called the Dorie Miller American Legion Post, the name was changed to Banks and Miller in honor of Richard R. Banks, a highly decorated soldier killed on June 30, 1966. George Singleton served as its first commander. (Courtesy of Banks Miller Post 255.)

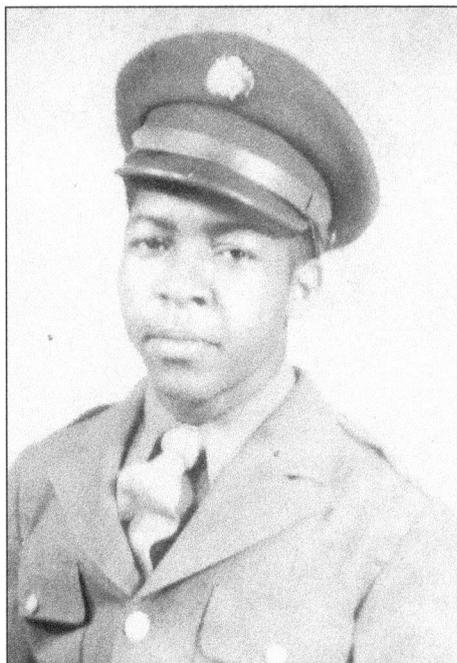

Luther Tate, like his friends, was drafted into the army in the Second World War. When his military service ended, he returned to Lexington in 1948 and graduated from high school with his brother James. Luther worked briefly as a truck driver for the furniture industry. For many years, he worked at The Homestead, a resort in Hot Springs, Virginia. He married the love of his life, Annie Sue, and they had six children—Janice, Edith, Maurice, Andrea, Cheryl, and David. (Courtesy of Edith Tate.)

World War II veteran Jay Partee often recalls his time stationed in Marseilles, France. As part of the 878th Quartermasters Gas Supply Company, he and his unit supplied food, ammunition, and fuel to Gen. George Patton's Third Army. When Jay returned to Lexington in 1946, he resumed his job as a janitor and greenskeeper at the Lexington Golf Club. (Courtesy of Nora Partee.)

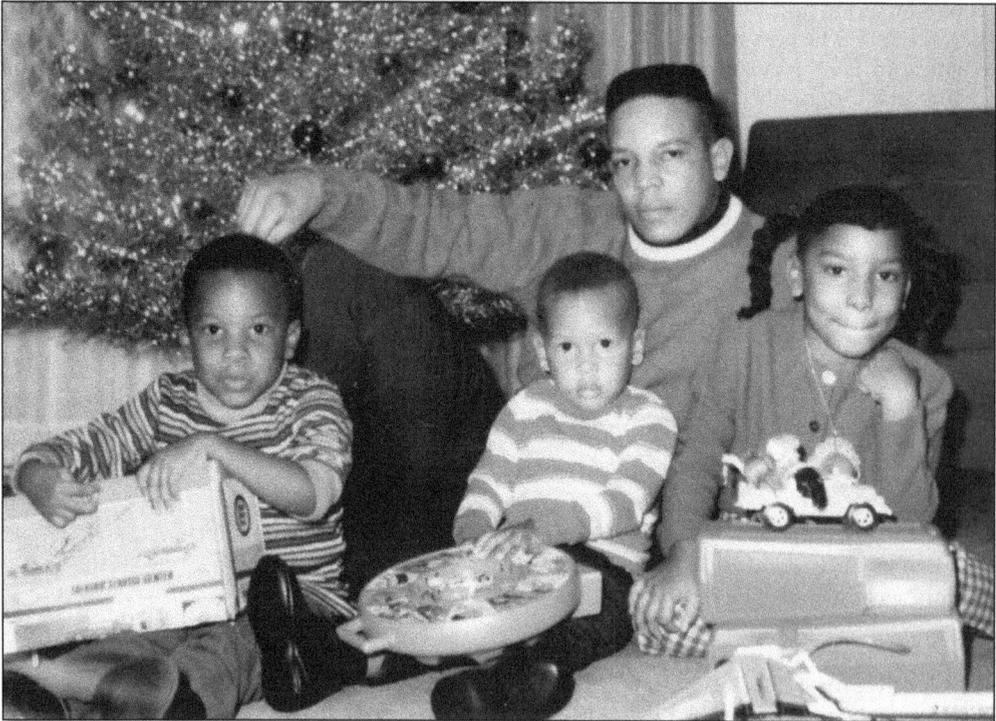

Sgt. David Walden was eager to serve his country. With permission from his mother, Catherine, he enlisted in 1948 at the age of 16. On his third tour to Vietnam, Sergeant Walden was killed when a booby trap exploded. In this special 1965 Christmas photograph, he poses with his children—from left to right, Kenneth, Dave, and Vida. (Courtesy of Betty Jean Jones.)

Joseph Lee Holmes was drafted into the army in 1941. Serving in the war afforded him the opportunity to see the world after being stationed in Germany. He and wife Melvena are the proud parents of four children—Melaine, Bryce, Jo-Ann, and Anthony—and have 13 grandchildren and five great-grandchildren. (Courtesy of Melvena Holmes.)

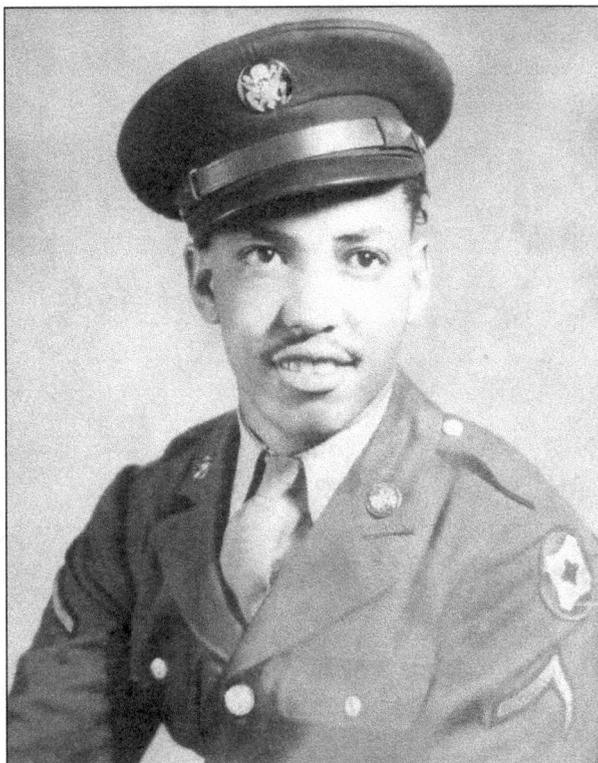

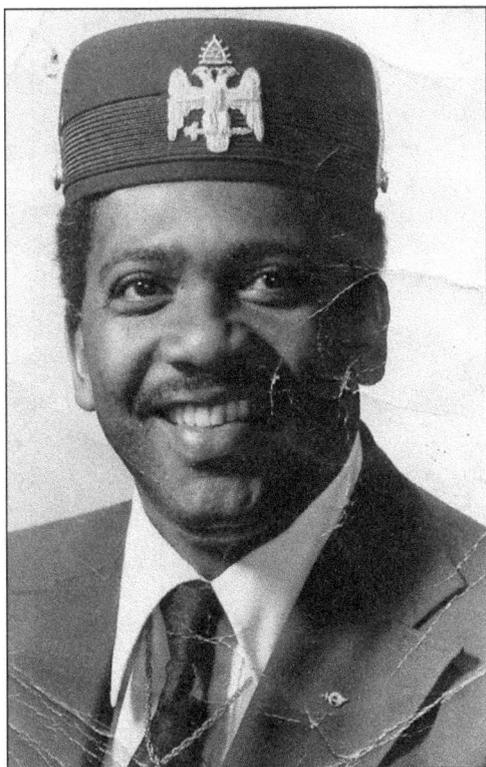

General Wayne Talbert came to Lexington at the tender age of two months with his parents Alberta and General Talbert. He always worked: gathering coal and kindling, delivering groceries in a wheelbarrow to Century Oaks Boarding house, carrying the *Dispatch*, washing dishes at Dixie Lunch, or cooking at various establishments in the community. Prior to marrying Mary Meachem in 1955, Wayne enlisted in the U.S. Army 508th Regimental Combat Team. His name caused him confusion while in the military. Once a limousine arrived thinking they were picking up a general. He also received a general's pay for months, and had to explain over and over that his first name was General. Extensively involved in Masonic organizations, Wayne became, in 1978, the first man in Lexington to receive his 33rd degree. (Courtesy of Wayne Talbert.)

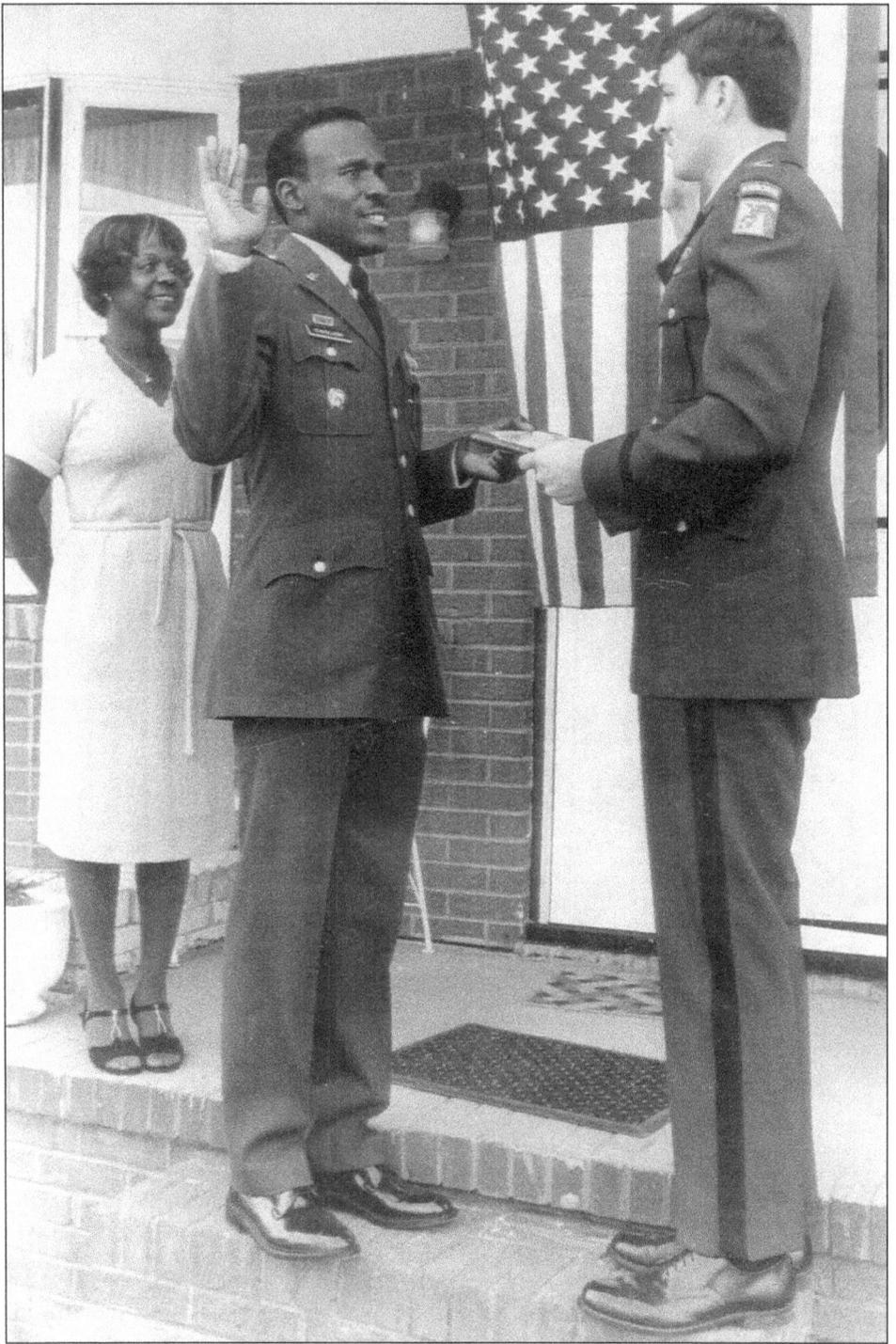

Ella Mae Moore is all smiles as she watches her son, Vernon English, reenlist in the U.S. Army. Vernon was an administrative supervisor in the 16th Military Police Group Personal Administration Center. Later Vernon would walk 20 miles to raise funds for the Sickle Cell Anemia Foundation. (Courtesy of Ella Mae Moore.)

*Four*

# PEW PARTNERS

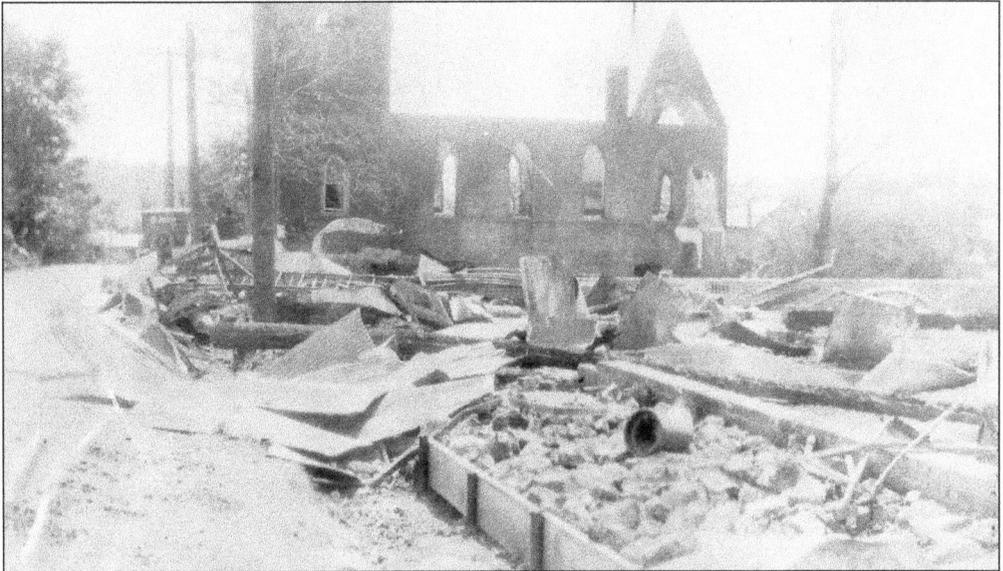

This is the result of a late-night fire at United Furniture Company in 1936. Summerhill Baptist Church was destroyed. Rev. A. T. Evans, though saddened by the incident, vowed to rebuild bigger and better. Evans supervised the youth in the salvaging of material and bricks from the old church to be used as the foundation for the new. Summerhill was reconstructed as First Baptist, and the community, city, and county were never the same. (Courtesy of Annette Evans Marshall.)

Rev. A. T. Evans was a major leader in the African American community. As a young preacher, he came to Davidson County after graduating from Livingstone College of Theology in 1929. He pastored First Baptist Church from 1928 to 1969 and New Smith Grove Baptist from 1931 to 1969. From 1929 to 1930, he was principal of New London Elementary School, then he transferred to Southmont Elementary School, where he served from 1930 to 1939. Evans formed the East Lexington Buying Club, built the first black swimming pool, was vice president of the Interracial Ministerial Association, and president of the Davidson County branch of the NAACP, and received his Masonic 33rd degree. He and his wife, Lillie Mae, were pillars in the civic and religious life of Davidson County. (Courtesy of H. Lee Waters Collection.)

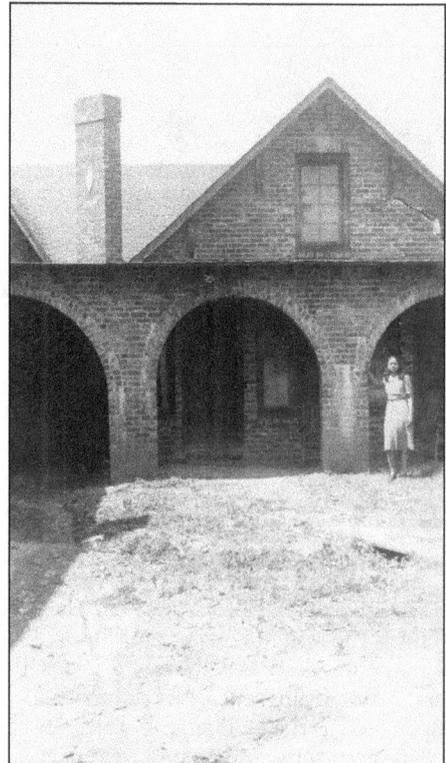

Lillie Mae Evans stands in front of the parsonage of Summerhill (now First Baptist) Church on Church Street. This site was secured in 1869 and named Summerhill because of the elevation and the surrounding landscape. (Courtesy of Annette Evans Marshall.)

Shadyside Presbyterian's sanctuary on East Center Street was constructed in the 1940s. The original building's stuccoed corner bell tower was reused in the new sanctuary, which has double-hung, round-arched windows and a gabled portico. The adjacent brick parsonage replaced a frame dwelling at the same location in 1950. Rev. Calvin Crump currently serves as pastor. (Courtesy of H. Lee Waters Collection.)

Rev. F. D. Betts prepares to preach in this late-1950s photograph. The Files Chapel Senior Choir waits to provide the music. Among the choir members are Connie Jackson, Annie Lanier, Ethel Parks, Betty Marshall, Charlie Bangor, Bernice Nance, Etta Crump, Lula Bell, Jitterbug Davis, Sephrum Simmons, Christine Frazier, Erma Ellis, and Viola Hargrave. (Courtesy of H. Lee Waters Collection.)

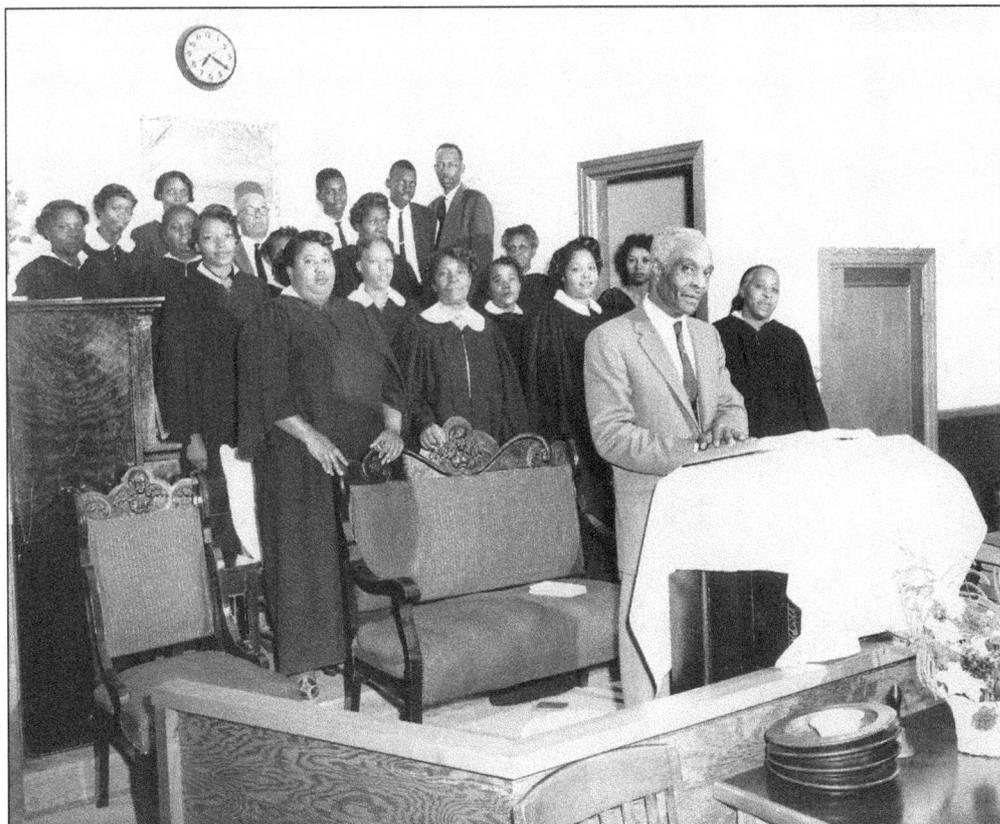

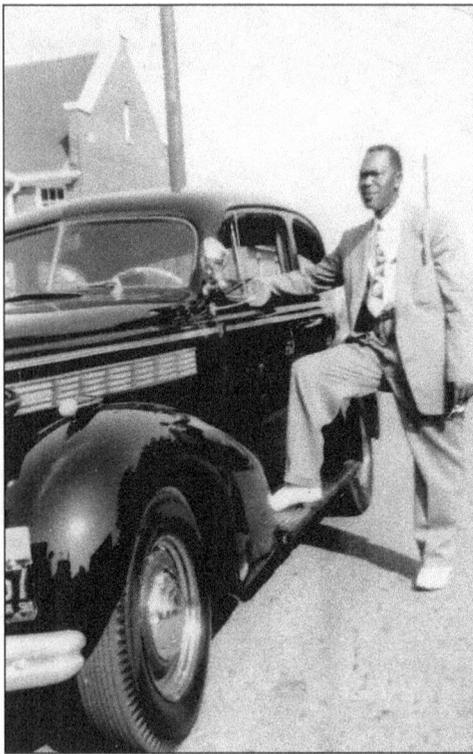

After a Sunday service at St. Stephen United Methodist Church, Rev. Calvin L. Gidney poses beside Lewis Michael's 1938 Buick. To supplement his income, Reverend Gidney also worked at Carolina Panel Company. He and his wife, Gertrude Parks Gidney, had four children—Miriam, Gwendolyn, Calvin, and Charles. (Courtesy of Lewis Michael.)

Originally associated with First Baptist Church, Union Baptist organized in 1884. Henry M. and Laura Hargrave donated property on East Third Avenue to serve as the Union Baptist sanctuary site in 1905. The congregation moved to its current location at 110 Lincoln Avenue in 1954 under the leadership of Rev. S. D. McIver. Rev. Darryl Thomas is the current pastor. (Courtesy of H. Lee Waters Collection.)

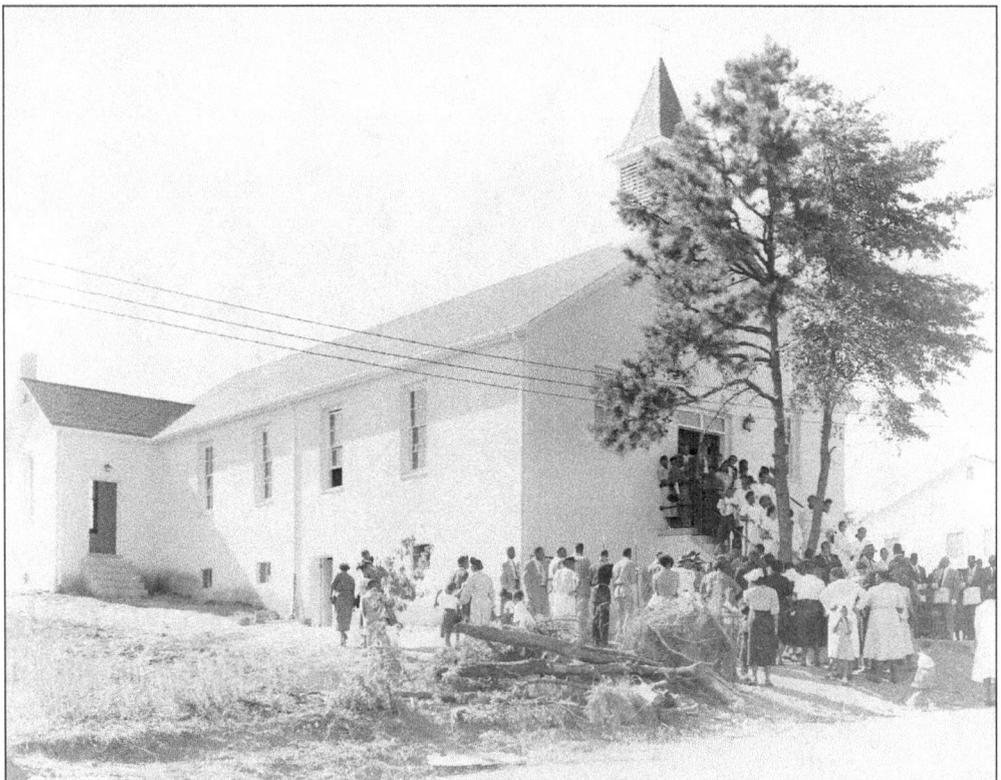

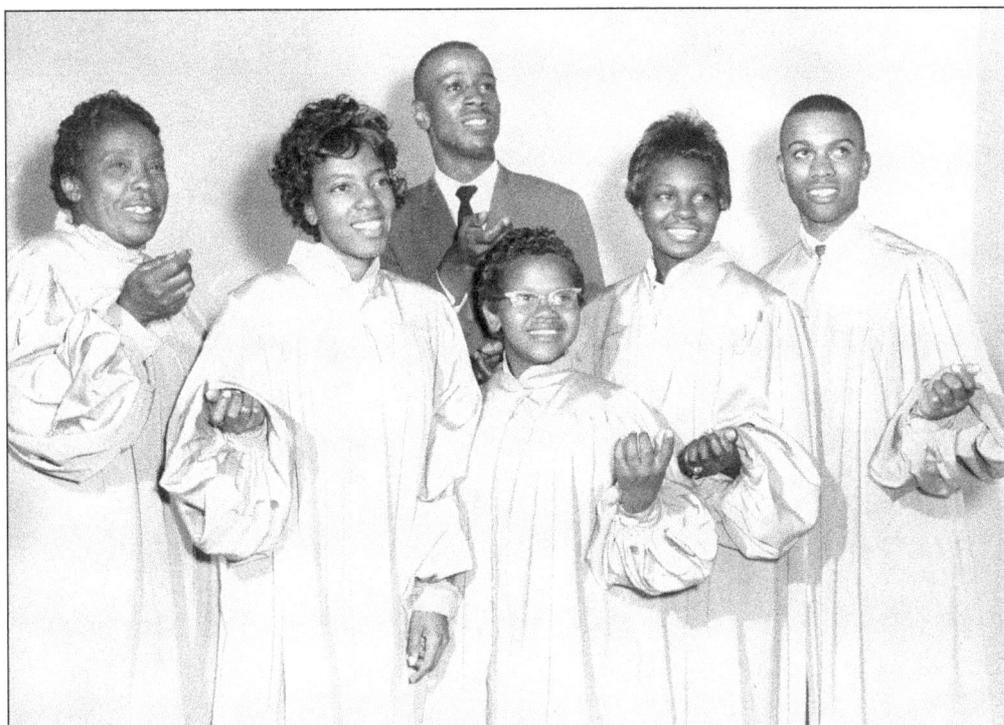

Over the years, Billy Paul and the Angelic Nightingales shared traditional gospel favorites. The real heart of their music ministry was sharing the good news of Jesus Christ in song. The group was composed of lead singer and director Billy Paul Melker (center) and backup singers, from left to right, Hattie Thomas, Christine Melton, Shirley Ann Thomas, Emma Brown Thomas, and Johnny Leak. (Courtesy of H. Lee Waters Collection.)

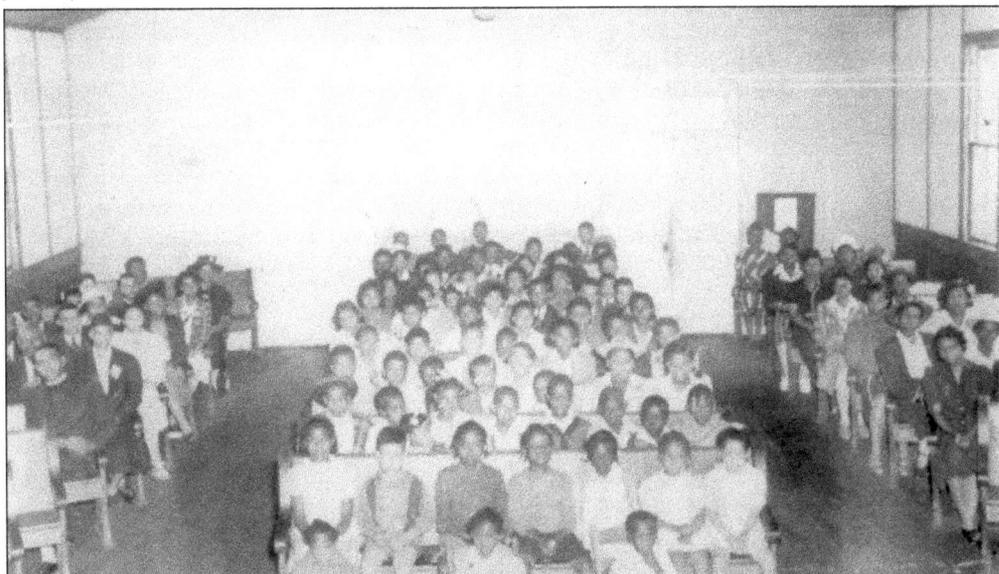

This early 1940s photograph of New Jersey AME Zion church shows the entire congregation. New Jersey is the oldest AME church in Davidson County. Rev. Allen Stimpson pastors the congregation at this time. (Courtesy of Robbie Cross.)

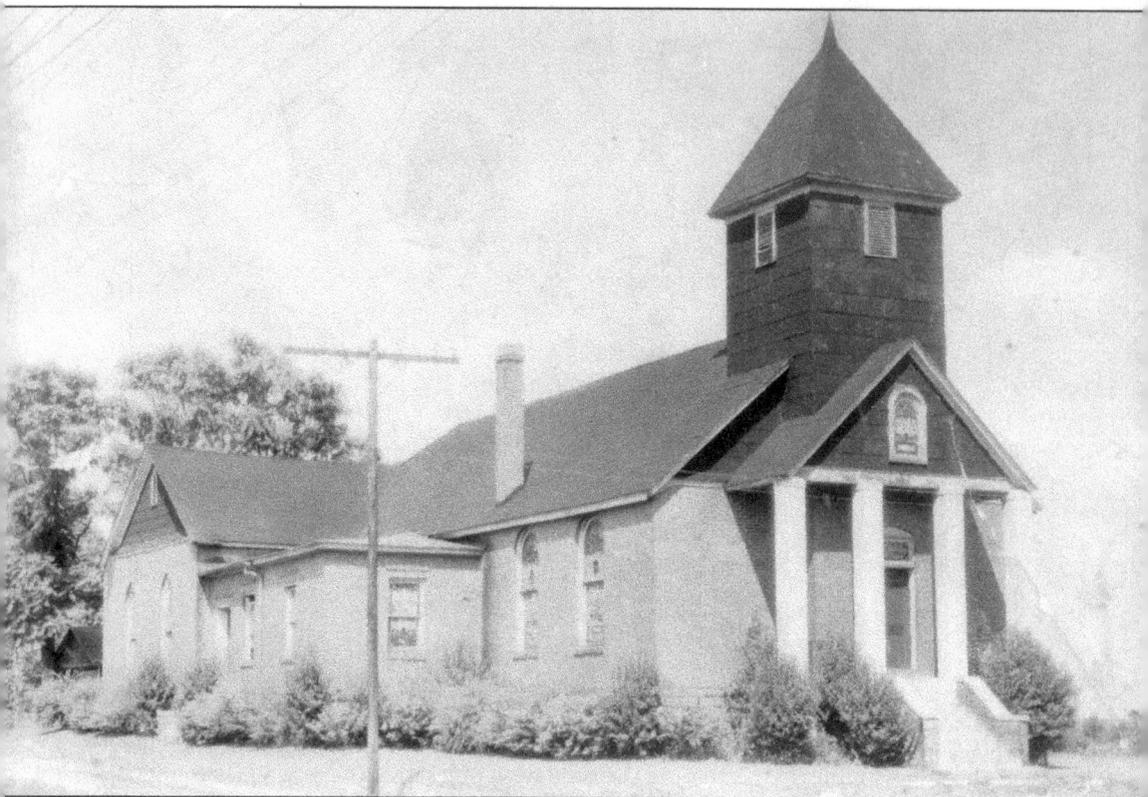

From its formation in 1868 until the present, St. Stephen United Methodist Church has played an important role in the religious, political, and social lives of Lexington's African American community. During the 1960s, the church served not only as a place of worship but also as a spot for civil rights movement meetings and planning sessions. Local tradition has it that a small group of former slaves organized King Methodist Church in 1868. The congregation did not have a permanent place of worship until 1874, when members purchased the former First Methodist Episcopal Church on Salisbury Street for $400. After church member and community leader R. Baxter McRary successfully petitioned for a name change, King Methodist became St. Stephen Methodist Episcopal. A fire destroyed the church in 1886, but the congregation would rebuild in 1892. St. Stephen is further distinguished as Lexington's oldest African American congregation. This church is currently pastored by Rev. Donnell FitzJefferies. (Courtesy of St. Stephen UMC.)

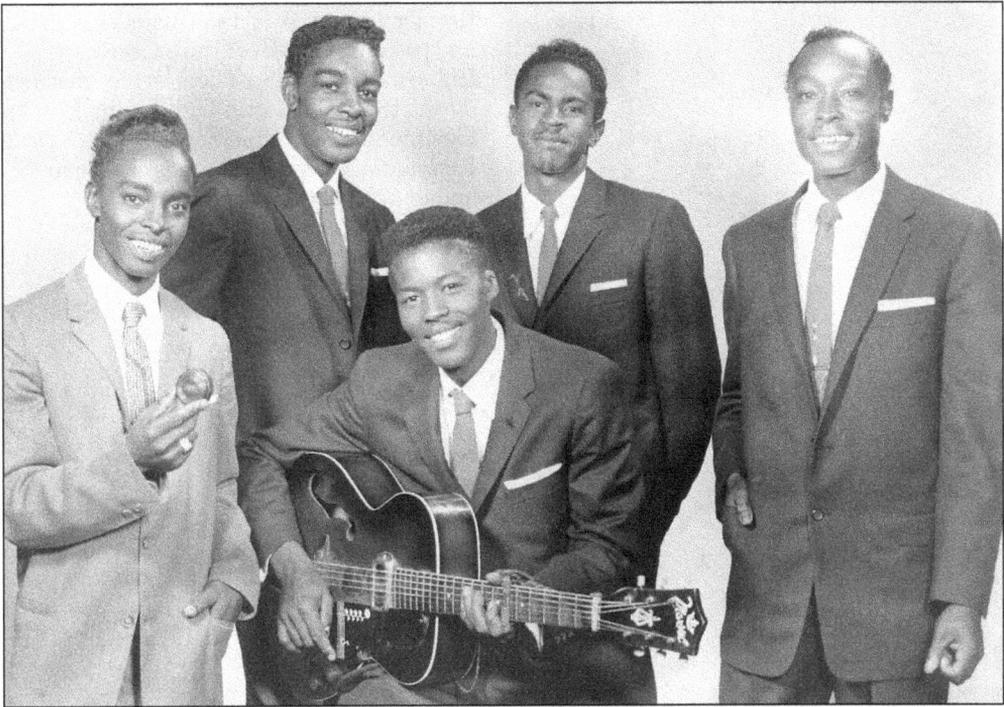

Through the ministry of music, the Silver Stars were dedicated to connecting people to God's message through song. The group's gospel ministry was shared in churches and community events large and small. Members in the 1950s included, from left to right, Leroy Smith, William Smith, Curtis Griffin, Joe Smith, and George Smith, seated with the guitar. (Courtesy of H. Lee Waters Collection.)

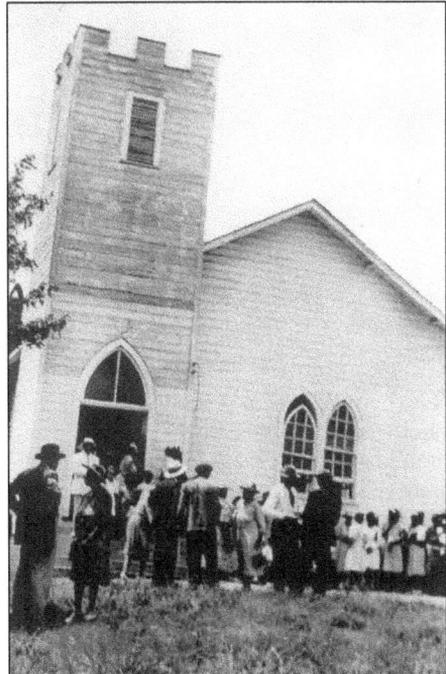

New Smith Grove was organized in 1872 in Linwood, North Carolina, with Rev. Z. Horton as its first pastor. In 1931, under the leadership of Rev. A. T. Evans, the church moved to Belltown. This relocation caused the congregation to split into Smith Grove View and New Smith Grove. A portion of the old church was used in the construction of the new facility. Rev. Ronald Shoaf is the current pastor. (Courtesy of Louise Godfrey.)

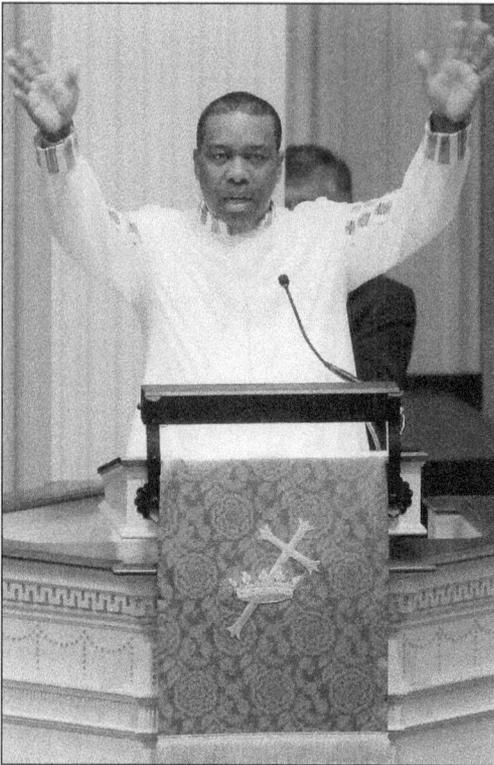

Rev. Dr. George B. Jackson, founder and pastor of Citadel of Faith Christian Fellowship Church in Thomasville, preaches during the 2008 Martin Luther King Jr. Community Fellowship Service. As a community activist, Jackson is chairman and founder of the Martin Luther King Jr. Social Action Committee. (Courtesy of Donnie Roberts/the *Dispatch*.)

Rev. John B. Mason poses in this photograph with one of his precious granddaughters. He and his wife, Edna, were the proud parents of 14 children. His pastoring career included Bethlehem Baptist, High Point; Smith Grove Baptist, Linwood; Yadkin Grove Baptist, East Spencer; and the family's home church, Cedar Grove Baptist in Advance. (Courtesy of H. Lee Waters Collection.)

54

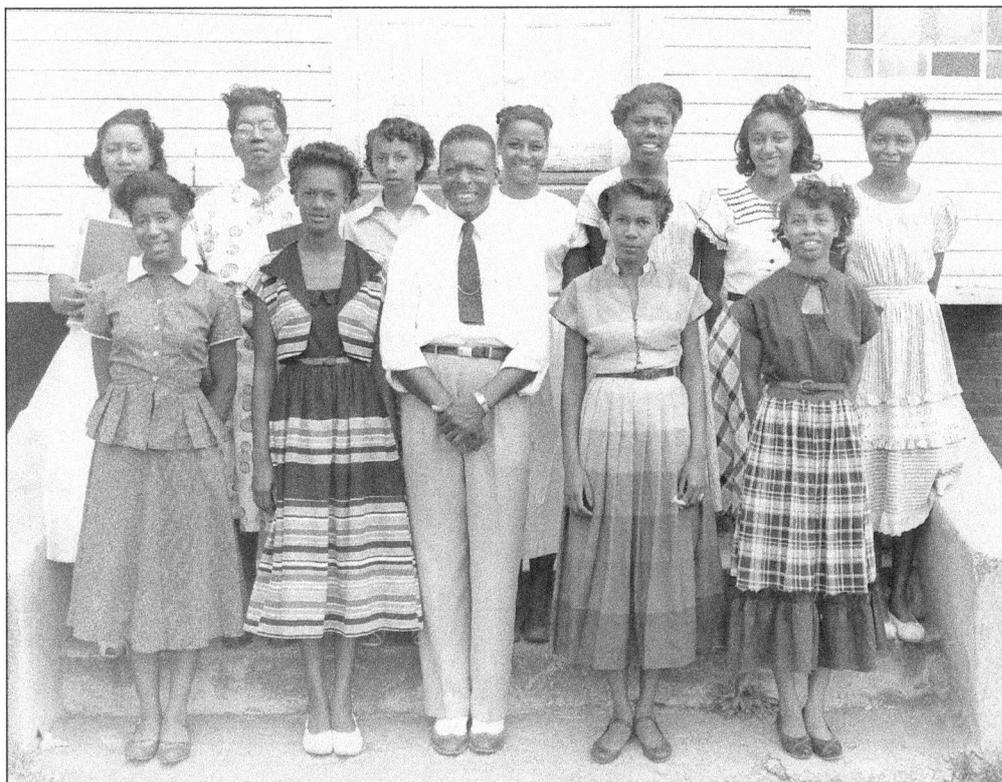

Rev. James Leon Pridgen found time to gather the vacation Bible school teachers and leaders of Union Baptist Church. Workers include, from left to right, (first row) Kaye Williams, Alberta Barker, Rev. J. L. Pridgeon, Luvenia Daye, and Louise Gordon Miller; (second row) Elizabeth Pridgen, Zala Crump, Gwen Thompson Pearson, Margaret Hairston, Corina Reid, Katy Holmes, and Mozella Davis. (Courtesy of H. Lee Waters Collection.)

Rev. Lois Hargrave Gooden graduated from Deliverance Bible Institute in Newark, New Jersey. In 1971, she held her first crusade in Lexington, and in 1972, she founded Lexington Deliverance Tabernacle. She served on several community boards and received numerous awards. (Courtesy of Barbara Walser.)

First Baptist Church has a rich history in Lexington. From its humble beginnings in 1867 to recent changes in 2010, First Baptist has always been on the cutting edge. For many years, it reached the community through its religion, recreational, and cultural programs. Rev. Herbert Miller II is the pastor and teacher who leads this church today. (Courtesy of Bruce Cross.)

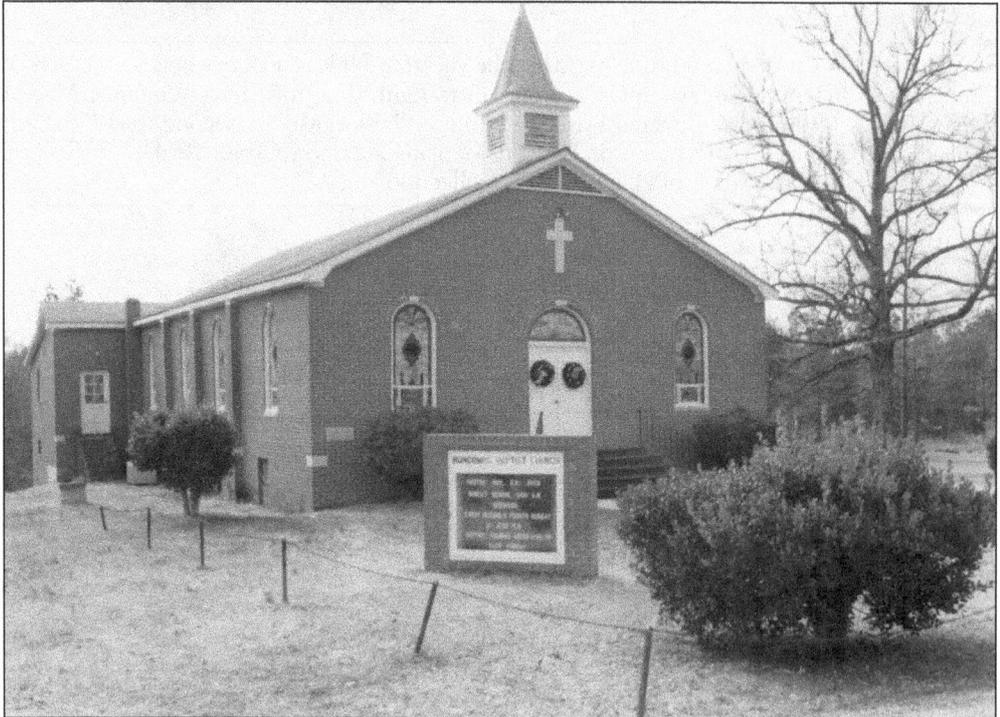

Buncombe Baptist Church serves Petersville and surrounding communities. The history of this fine church reaches back many, many years. Rev. Claude Forehand is the pastor. (Courtesy of Robert Hairston.)

Mary Inez Walker Sampson Pruitt, on her way to church while in her 40s, stops briefly outside her Moore Drive home. In her 105 years, Pruitt held many positions—nanny, foster parent, domestic worker, midwife, and a cook at Holt School. She often shared with friends that she had tried to live a life that would make God proud. She passed away on May 2, 2009. (Courtesy of Barbara Walser.)

On April 8, 1955, Elder C. J. Owens (far right) and his congregation gather in front their new church, Owens Temple Church of God and Christ, in the Washington Park area. Grand opening services were held. Representatives of the North Carolina District of the Church of God were invited. Elder Owens was the son of Annie Albright. (Courtesy of H. Lee Waters Collection.)

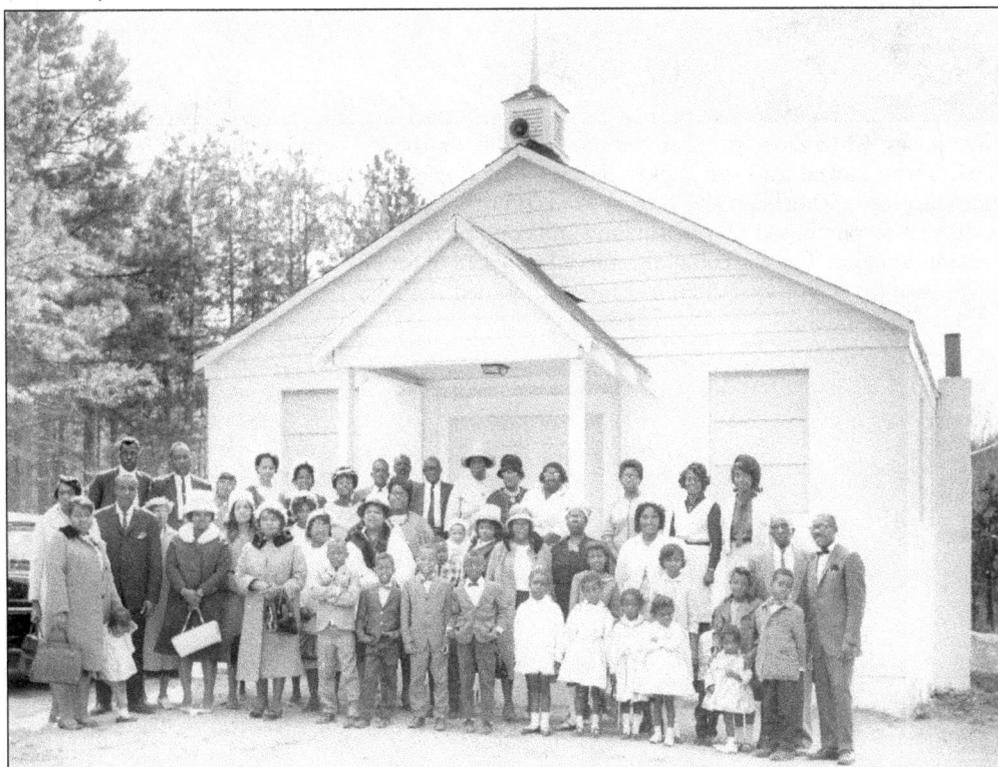

New Jersey AME Zion was founded around 1881 or 1882. The name Jersey originated from settlers who moved into the Yadkin River Valley Region from the Jersey settlement. The first meeting place was held on the current PPG Industries site. On March 23, 1886, the 50-member congregation purchased 1.5 acres of land and constructed a log cabin on the northern end of the present property. The log cabin also served as a school for blacks during the late 19th century. The present pastor, Rev. Allen W. Stimpson, joined the New Jersey family in 2000. (Courtesy of Drusilla Stephen.)

# Five

# In Good Company

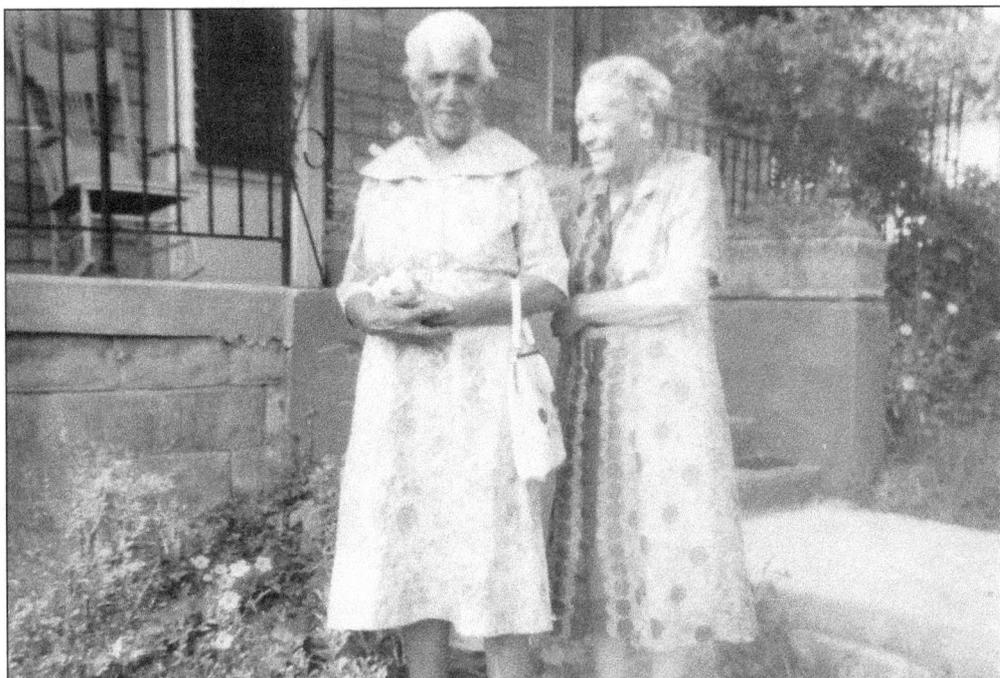

Mary Springs (left) and Annie Carter share a laugh outside of Mary's East Second Street home. Mary was born to George and Evan Perryman on March 14, 1887. Annie, born on May 24, 1876, was the daughter of Monroe and Hettie Carter. The ladies were good friends and dedicated members of St. Stephen United Methodist Church. (Courtesy of Tonya Lanier.)

Rachel Hargrave Koontz (left) and Caroline "Demp" Carson are picture perfect as they pose outside Dunbar High School. These ladies were always decked out in the latest fashions and hairstyles. (Courtesy of Alberta Carter.)

Teresa (right) appears quite happy sharing the sofa and this photo opportunity with her sister Regina. Always close, they would eventually welcome Pam and Kim into their sisterhood. They are the daughters of Pauline Ausborne Norman and Kenny Norman. (Courtesy of Regina Hilton.)

Good friends Ophelia Knotts (left) and Lib Brown share an afternoon. Both ladies were active in their churches and enjoyed taking care of their families. (Courtesy of Lewis Michael.)

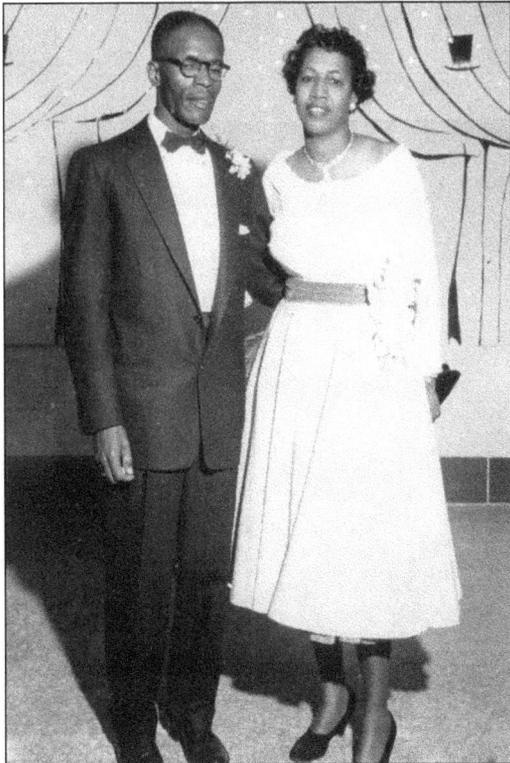

Dorthea Dusenberry Michael and Wesley Michael share this special moment at one of many formal functions. Dorthea was a dynamic educator, while Wes made a decent living in manufacturing. The couple had one son, Johnny. (Courtesy of Annette Evans Marshall.)

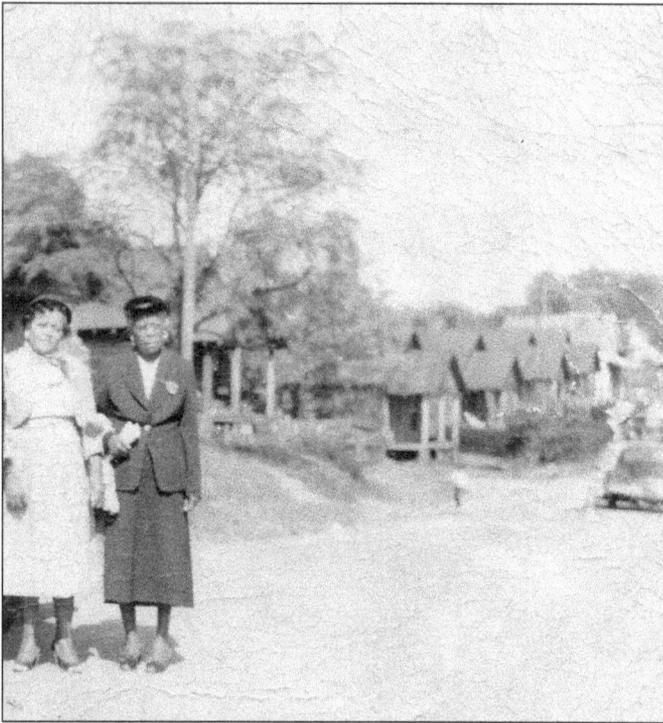

Clara Bell Lee and her mother, Maggie Craven, stop briefly on Railroad Street. Railroad Street was a very popular side of town; the families in this area were close-knit and willing to help each other. (Courtesy of Rev. Arnetta Beverly.)

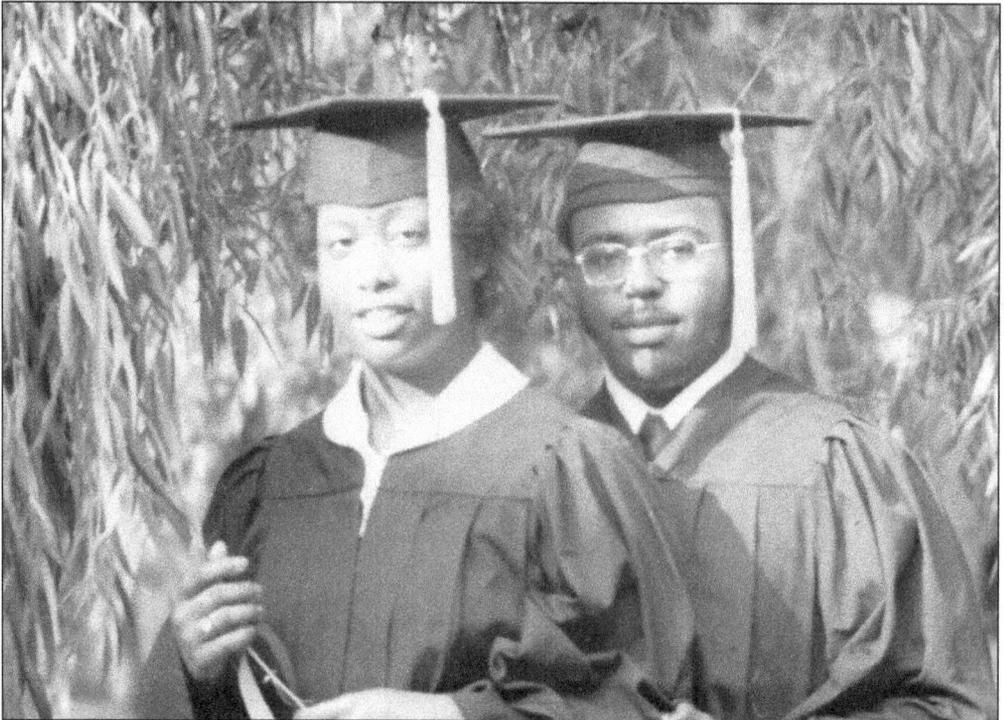

Keith and Yvette Holmes were born on August 19, 1957, to Wilbur and Margaret Holmes. They graduated from Lexington Senior High in 1975. Keith is a home health care provider, and Yvette works for Fairfax County, Virginia, government. (Courtesy of Keith Holmes.)

At the Davidson County Agricultural Fair in 1966, Bonnie Moore-McCrae and her mother, Ella Mae, pose for this memorable photograph. Always dressed in the latest fashions, mother and daughter are best friends. (Courtesy of Ella Mae Moore.)

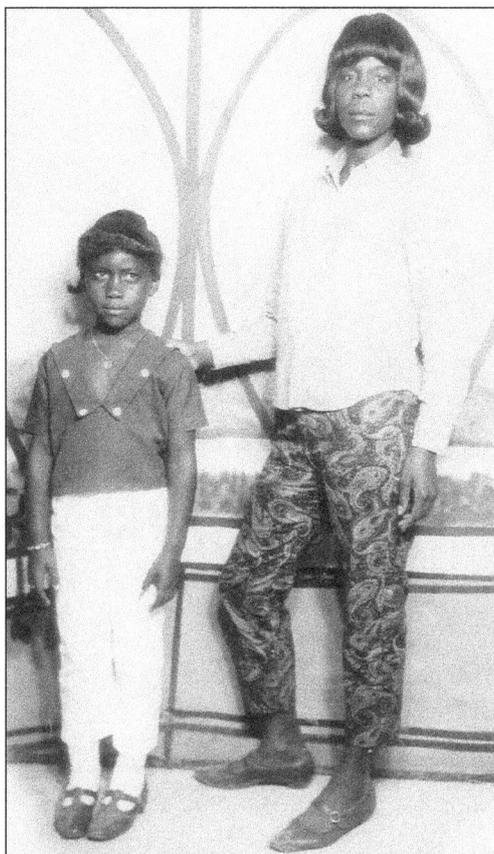

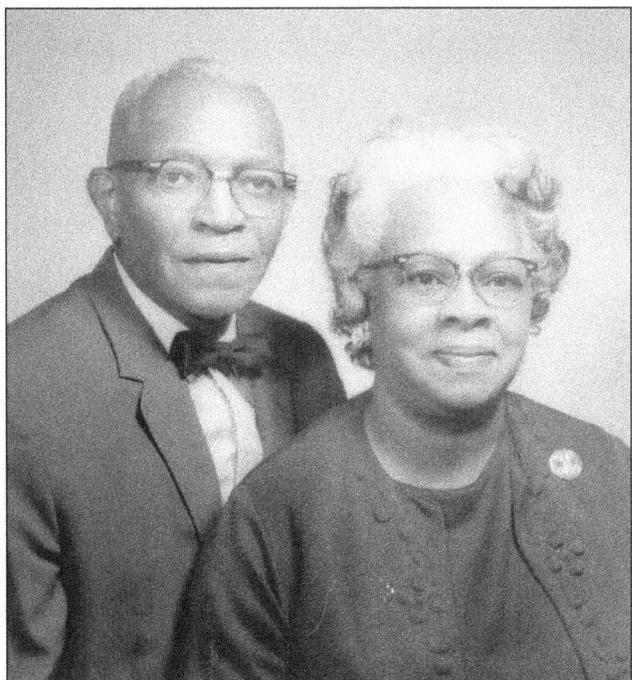

Walter "Walt" Hargrave and Lorine Harris Hargrave made a great life out of little pieces. Although Walter quit school in the fifth grade, he was smart and could fix anything. He became a licensed barber and a clock and watch repairman. In his basement, he had a barbershop, community store, and place to repair jewelry. Lorine enjoyed being a homemaker. To help out at times, she would work as a domestic for the Johnson family. They had two daughters, Rachel and Mary Lou. (Courtesy of Tammy Craven.)

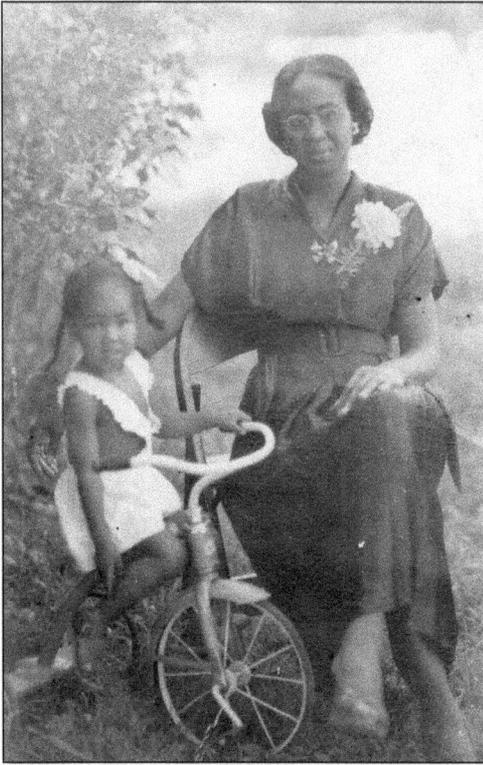

In this 1950s photograph, Barbara Walser enjoys a special moment with her grandmother, Inez. Even with a hectic schedule, "Mother Pruitt," as she was affectionately called, always found time to spend with family. (Courtesy of Barbara Walser.)

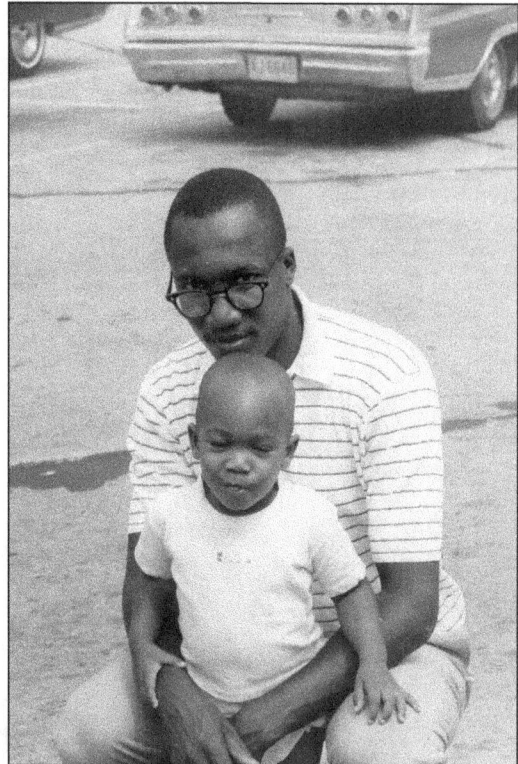

Rudolph Wilson and his son Gerard share a special moment. Rudy's parents were Henry and Jennie Wilson. Gerard's parents are Rudy and Tina. He would become big brother to Tobin and Marcus. (Courtesy of Henry Wilson.)

In this early-1950s photograph, Herbert Dula Sr. and big sister Arnetta pose lovingly for the photographer. They are the children of Elizabeth and Henry Paul Dula. Siblings Clarence and Uleetha would join them later. Herbert obtained a bachelor of science degree in marketing from Winston-Salem State University. He joined the navy and rounded out his career as an IT architect with IBM. He is the proud father of two sons, Herbert Jr. and Bradford. Arnetta serves as a United Methodist minister in the Western North Carolina Conference. She loves spending time with her family, especially her two sons, Casey and Ronnie. (Courtesy of H. Lee Waters Collection.)

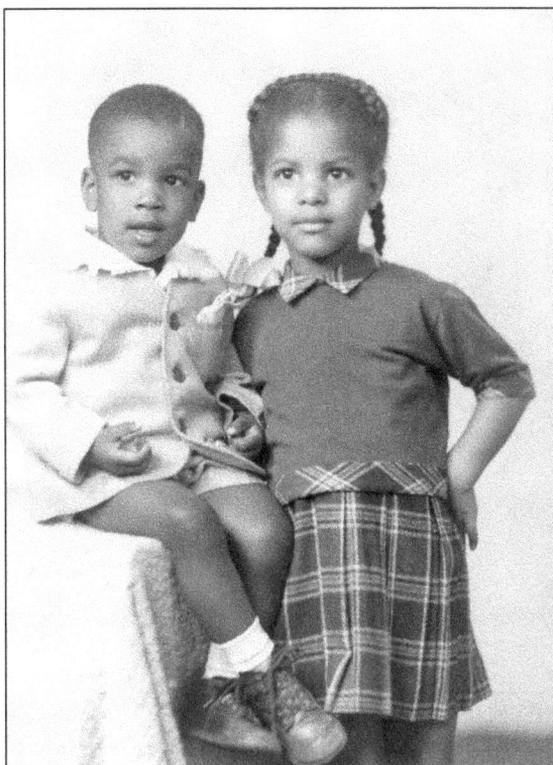

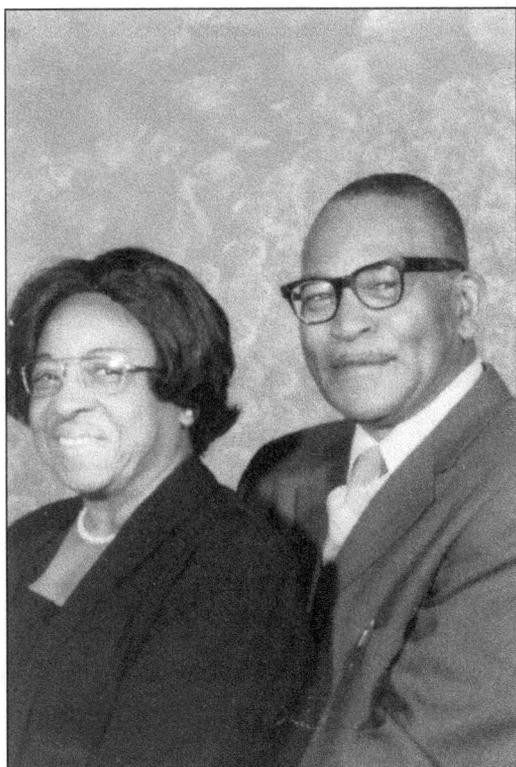

Alfonso and Clora Smitherman shared 54 years of marriage. Al was a chief cook at the New Hotel and later received tasty reviews at Claude's Restaurant. He went to Duke University for a short while to study dietetics. One of Clora's lifelong dreams was to earn a high school degree. She accomplished this goal by enrolling Davidson County Community College at the age of 78. (Courtesy of Alberta Carter.)

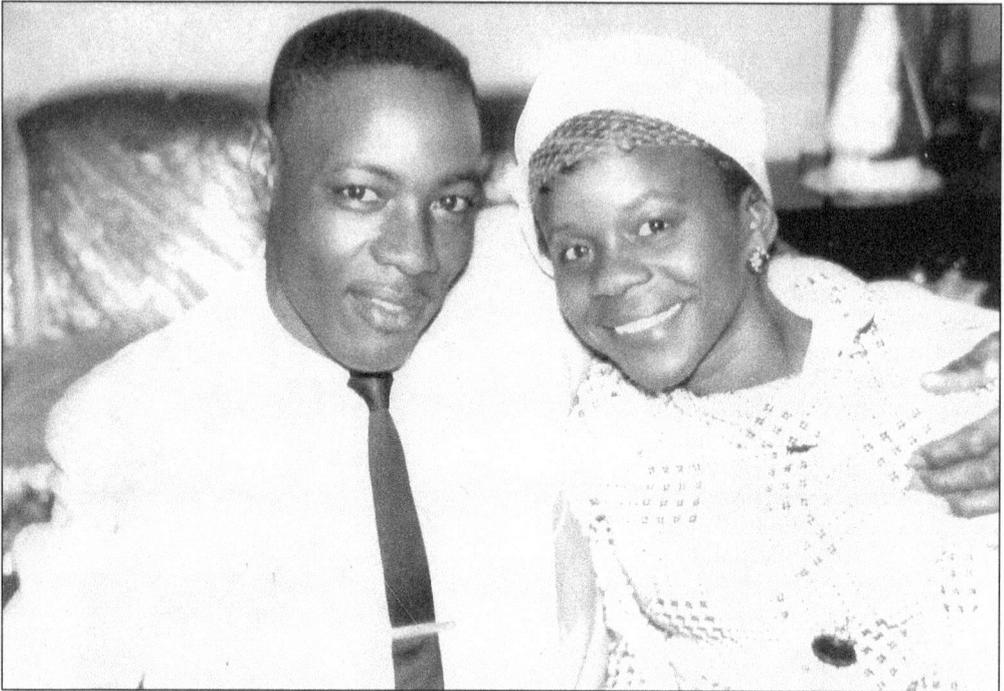

Ella Mae English and Eddie Moore are all smiles in 1961. Ella Mae majored in early childhood development. She worked as a day care operator prior to joining the Davidson County Sheriff's Department. Her community involvement includes Davidson County Democratic Party, NAACP, Lexington City Ward 1 precinct chair, and Union Baptist Church in addition to other boards and commissions. (Courtesy of Ella Mae Moore.)

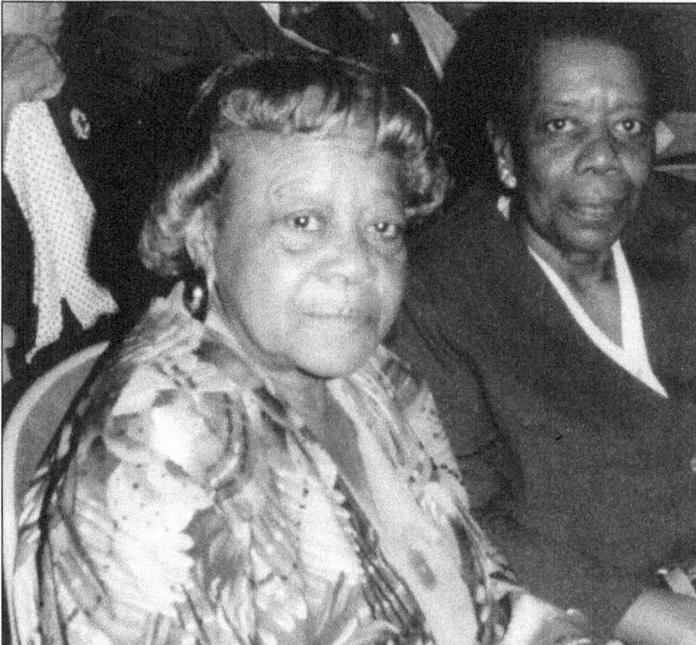

Christine Norman, more warmly known as "Ma 'Tine," and Katherine Lowe are all smiles at a civic center event. Ma 'Tine enjoyed her homemaker role and loved to assist people in the community. Katherine was a registered nurse at Coney Island Hospital. She served in the U.S. Army as a second lieutenant from 1945 to 1946. (Courtesy of Pauline Norman.)

Loyal Lady Ruler Mary Talbert congratulates new inductee Naomi Morrison to the Abdallah Temple No. 189 of the Jno G. Lewis Consistory No. 326. (Courtesy of Mary Talbert.)

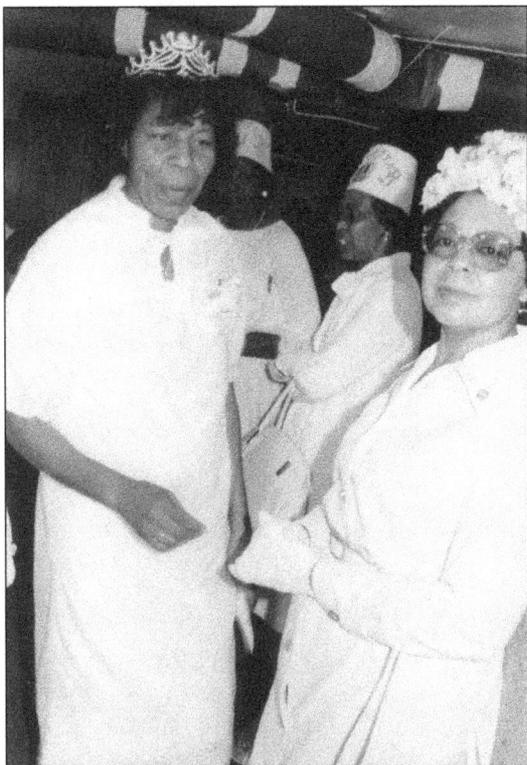

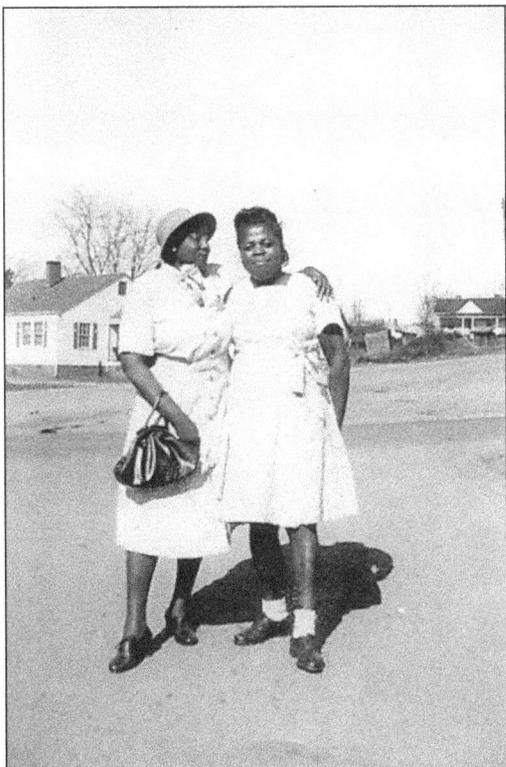

Clattie Sowers and Vera Small love this sunny Sunday afternoon. These ladies were good friends and both worked as domestics. When not tending to the needs of their families, they could always be counted on to help a neighbor out. (Courtesy of Ruth Small.)

Elizabeth McCall and Cardell Walker were married on July 22, 1938. They had two sons, Melvin and Joseph. In addition to working for the Lexington City school system, Elizabeth was employed at Siceloff's Manufacturing Company, First Baptist Church School Daycare, and Carolina Theatre. Because of her sweet spirit, the community looked for her greetings at Walmart where she finished her career. (Courtesy of Alberta Walker.)

Clayton Lanier and Eulah Lanier Petty pose as loving siblings. The Lanier children had the best of both worlds—grandparents that lived in the country and grandparents that lived in the city. The brother-sister duo began their education at Southmont Elementary, but a family move caused transfers to Lexington city schools. (Courtesy of Clayton Lanier.)

*Six*

# HISTORY MAKERS

Jennie Wilson looks through a family album in her mother's Belltown home. Jennie was a dedicated member of New Smith Grove Baptist Church. She and husband Henry were blessed with four children—Ferdinand, Richard, Rudolph, and Judy. (Courtesy of Henry Wilson.)

Tiny Tot Day Care flourished under the leadership of Audrey Nelson. She served 11 years as a teacher and 21 as director. Her commitment to education and the well-being of children was evident through her unselfish dedication. Although she had no children, she was mothering too many. (Courtesy of Keith Holmes.)

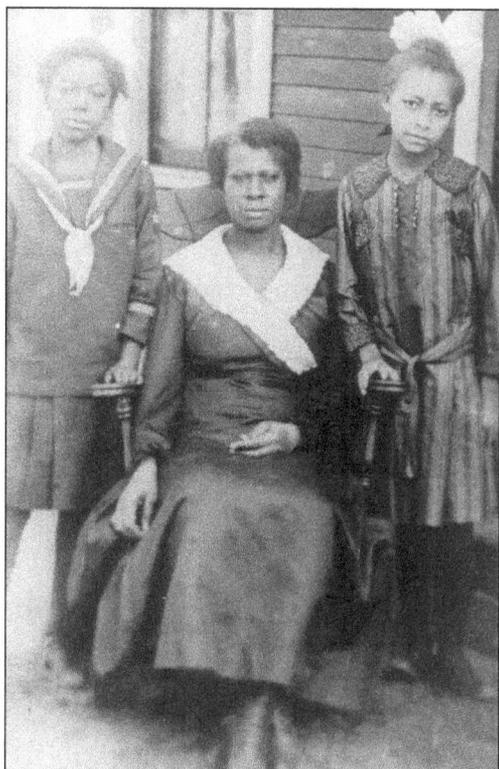

Bertha Powell (seated) shares this photograph with her granddaughter Gertrude Mabry (left) and niece Ida Mabry. The ladies were preparing to go to church at Shadyside Presbyterian. Bertha worked as a cook at the March Hotel. Gertrude and Ida would attend Federal University and become schoolteachers. (Courtesy of Barbara Brooks.)

Irvin Luther stops during an October 1967 move. He was a Dunbar High School graduate who loved to write poetry. (Courtesy of Patsy Bush.)

Cora, the youngest daughter of James and Ida Lanier, poses on the campus of North Carolina College (now North Carolina Central University) in 1957. Her father's new Pontiac Super Chief hauled the new college student to Durham. (Courtesy of Tonya Lanier.)

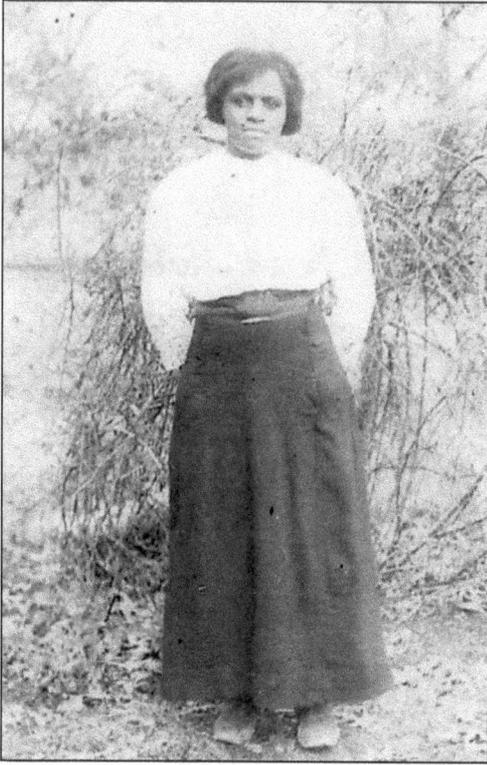

Beaulah Lindsay Hargrave poses for this photograph in 1936. She and her husband, Early, did not have any children. Beaulah would travel into town from Linwood to play nursemaid to sister Laura, who had 10 children. (Courtesy of Ruth Holt Small.)

Annie Sue Tate had an angelic voice. She loved to sing, and the community was delighted to listen. An active member of St. Stephen Church, Annie Sue was a dedicated member of the senior choir. She and her husband, Luther, had six children—Janice, Edith, Maurice, Andria, Cheryl, and David. (Courtesy of Edith Tate.)

Dr. Rev. W. E. Banks knew that true change required deep commitment and an open heart. An avid supporter of the civil rights movement, Dr. Banks made great strides. He fought to end discriminatory hiring practices and assisted in the organizing of Davidson County Community Action, Inc., Thomasville Church Homes, and Shaw University High Point Center for Alternative Programs in Education. During his 32-year tenure at First Baptist Church in Thomasville, the congregation grew tremendously. (Courtesy of Rev. George Jackson.)

A friendly face that can be spotted in many churches, rest homes, and hospitals is that of James Elmo "Pop" Hogan. Pop feels it is his mission to visit and share a kind word. He claims he is doing the Lord's work. Pop is a faithful member of New Zion Baptist Church in Linwood. (Courtesy of Katherine Lambert.)

Mattie Davis Drakeford was born on July 27, 1913. She graduated from Dunbar High School in 1933. Mattie married O. B. Drakeford on June 19, 1933. She was a faithful member of Union Baptist Church and had a flair for fashion. (Courtesy of Tonya Lanier.)

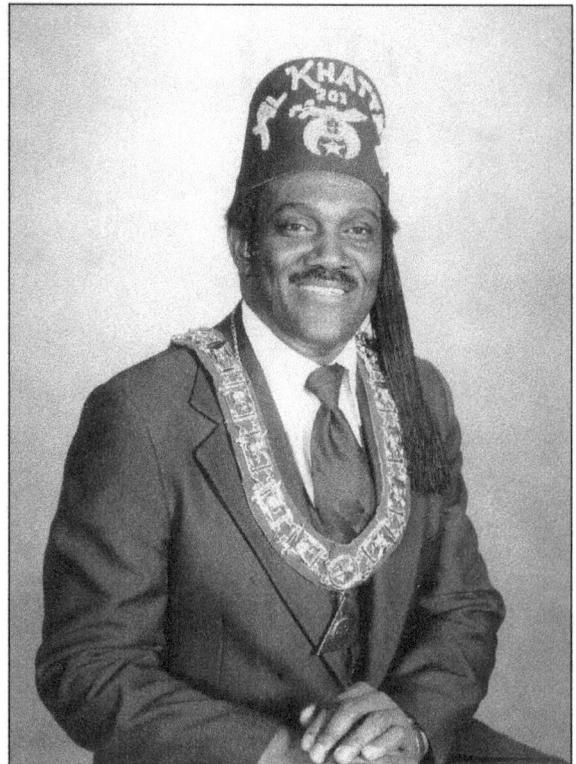

A tireless advocate for social justice and civil rights, Alonzo Wesley Gill was active in many organizations, most notably the Davidson County branch of the NAACP. From 1960 to 1963, he co-owned Dee and Gill's Service Station and was part owner of Associated Furniture, Inc., in Thomasville. His civic involvement included Banks and Miller Post No. 255, Acacia Lodge No. 66, and Potentate of Al Khattab Temple No. 201, just to name a few. (Courtesy of Robbie Cross.)

Patsy Koontz Bush retired from the City of Lexington Customer Service Department after 24 years. She is a faithful member of Friendship Baptist Church, where she serves as financial secretary, sings in the senior choir, and regularly attends Wednesday night Bible study. (Courtesy of Patsy Bush.)

At a Dunbar High School reunion, 1956 classmates Charles Carson (left), Robert Arthur Bingham (center), and John Leak catch up on old times. Charles retired from a job as a marine surveyor with the federal civil service. Robert's career had been in oral surgery, and John was the former assistant police chief of Harrisburg, Pennsylvania. (Courtesy of Annette H. Smith.)

Christine "Crissie" Cross was a faithful member of First Baptist Church, where she found delight in being church mother and communion steward. She worked for the Wright family for 45-plus years. Although she was married to James, she liked spending time with her siblings—Thelma Heitman, Lucy Hayden, Madie Payne, Jessie Mason, Harvey Mason, Norris Mason, and Payton Mason. (Courtesy of Madie Payne.)

Charles Lindsay, a successful Linwood farmer, married Lear Hargrave. They had 10 children—Laura, Beulah, Jim, Caroline, Bessie, Jack, John, Verlin, May, and one child that died at birth. The family attended Old Smith Grove Baptist Church. (Courtesy of Ruth Holt Small.)

Pauline Elizabeth Ausborne stands on North Railroad Street. The daughter of Zettie and Arthur Ausborne, she attended Dunbar High School and later Brookstone Business College in Thomasville. Pauline is a lifelong caregiver and a strong supporter of her family. (Courtesy of Pauline Norman.)

Melvena Reid Holmes, a 1947 graduate of Dunbar High School, sits in front of the fireplace in the dormitory living room during her freshman year at Bennett College. Each of the girls in her group posed for a photograph here before a school dance. (Courtesy of Melvena Holmes.)

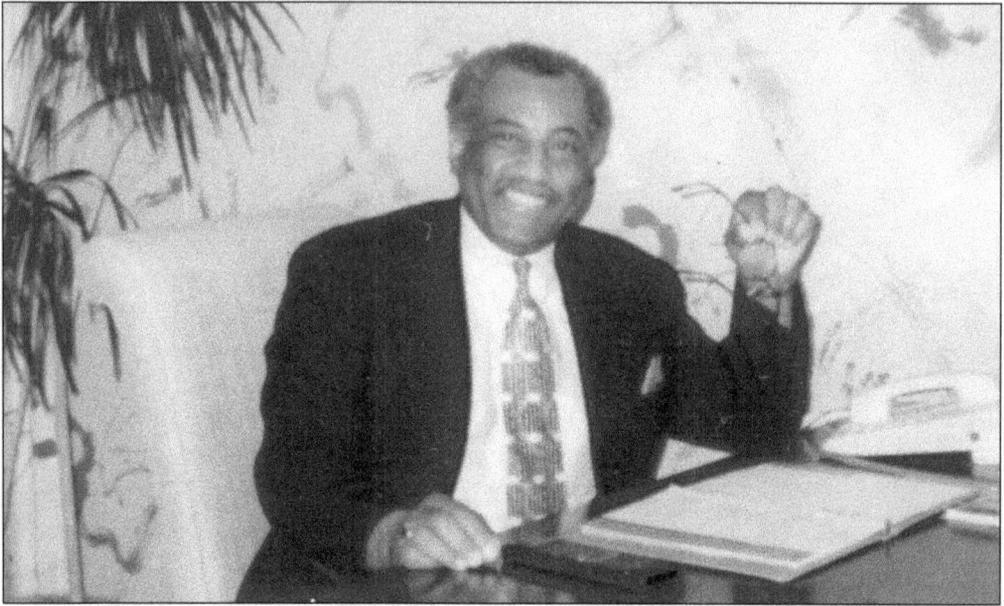

In April 1968, the City of Lexington hired its first African American fireman, Charles Powell. Charles had worked for Dakota Cotton Mills but decided to apply for the fireman position due to its challenge and growth opportunity. (Courtesy of Charles Powell.)

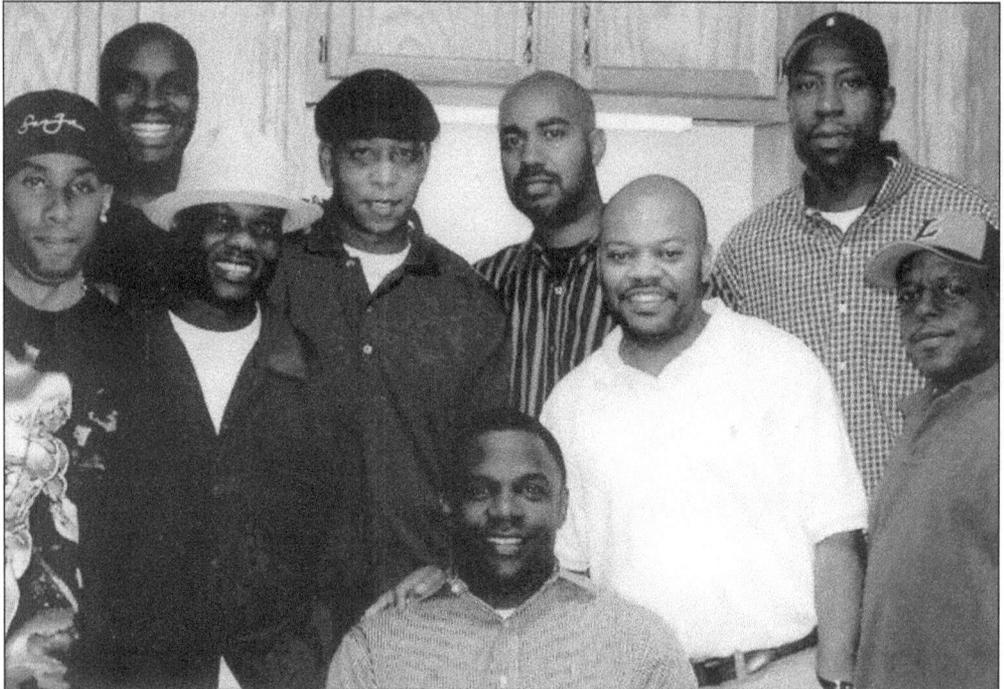

Group 89 is a band of brothers focused on helping to make positive change in the community. From left to right, members Marvis Elam, Marcus Holt, Norris Elam, Steve Owens, Corey McMillian, Marcus Dukes, Ray Henderson, Charles Woodberry, and Tyrone Steele vow to make history every day by setting a good example for the next generation. Group 89 was founded in August 2008. (Courtesy of Corey McMillian.)

*Seven*

# BY ANY MEANS NECESSARY

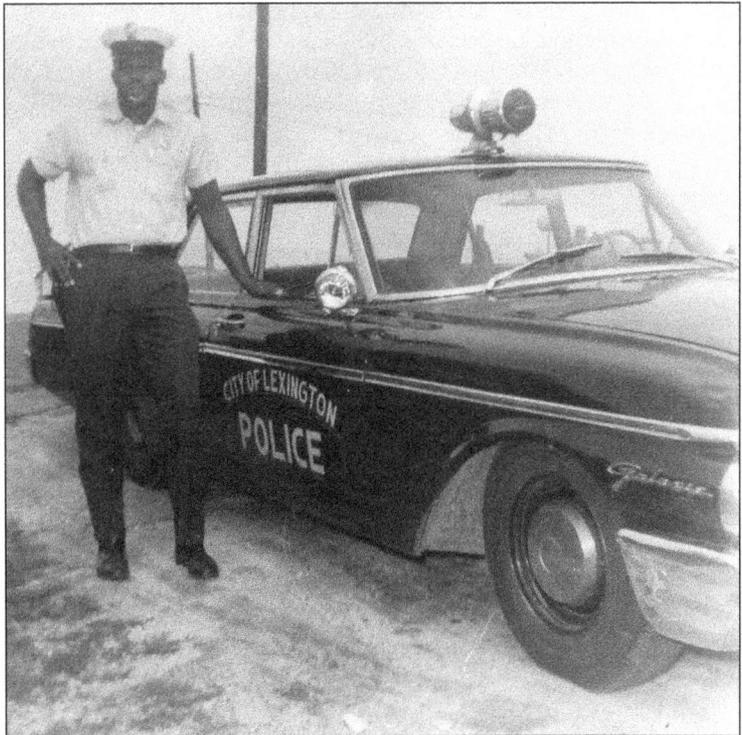

George Lattiner was the first full-time police officer for the city of Lexington. He was hired part-time in 1962, assumed full-time duties in 1965, and was made platoon sergeant in 1973. Because law enforcement officers of color have always had to do more than uphold the law, George faced many challenges. (Courtesy of Patsy Bush.)

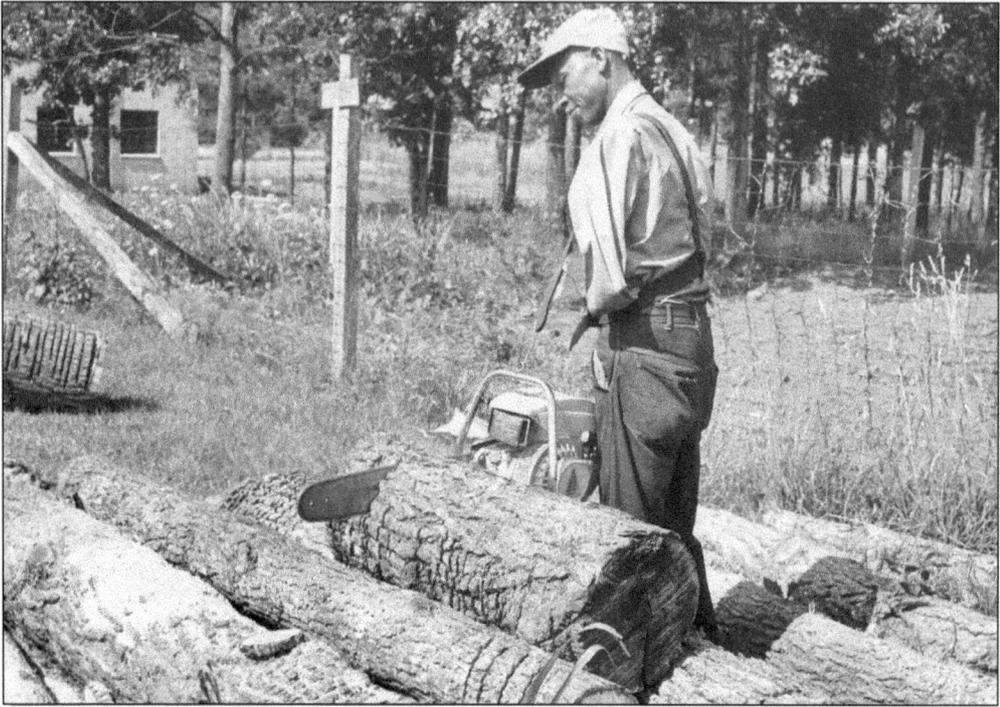

While working to build the Yadkin River dam in 1927, William "Taft" Adderton Sr. had an accident that caused his arm to be amputated. Instead of feeling sorry for himself, William decided to make the most of this disability. He went to a shoe shop and concocted a leather strap with a hook that would secure his chainsaw, and became one of the county's greatest loggers, hired by many sawmills and lumberyards. William also loved to cook, tend his garden, and spend time with wife Sara and their six children. (Courtesy of H. Lee Waters Collection.)

His interests in electronics led Wilbur "Chic" Holmes to study the subject at North Carolina A&T University. He found a profitable hobby repairing televisions, radios, and small electrical appliances for his Lexington neighbors. While working at Fiber Industries, Wilbur developed a technique that would save the company millions of dollars. Because of his industrious spirit, he was quickly promoted to first operator. He was also a World War II veteran. (Courtesy of Keith Holmes.)

Her mother being denied service at the city hospital prompted Gladys Hoover Holmes to seek a nursing career. Hoover graduated in 1948 from Kate Bitting Reynolds School of Nursing. She worked in the intensive care unit at Lexington Memorial Hospital. Gladys began a trend of caring professionals in the Hoover family. (Courtesy of Katy Hoover Evans.)

Zenner Cowans Wright (left), Mildred Gee, and Lillian King Greene (right) enjoy a wedding reception. After working at the March Hotel, Zenner found steady employment as a cook for the Gee family. Lillian's desire to make more money led her to work for the Gees during the day and Wennonah Cotton Mill in the evening. (Courtesy of Herbert Wright.)

Eddie "Snag" Moore graduated from Modern Barber College on August 31, 1966. He worked at Bradshaw Barbershop until opening Bright Spot Barbershop in 1982. (Courtesy of Lovetta Moore.)

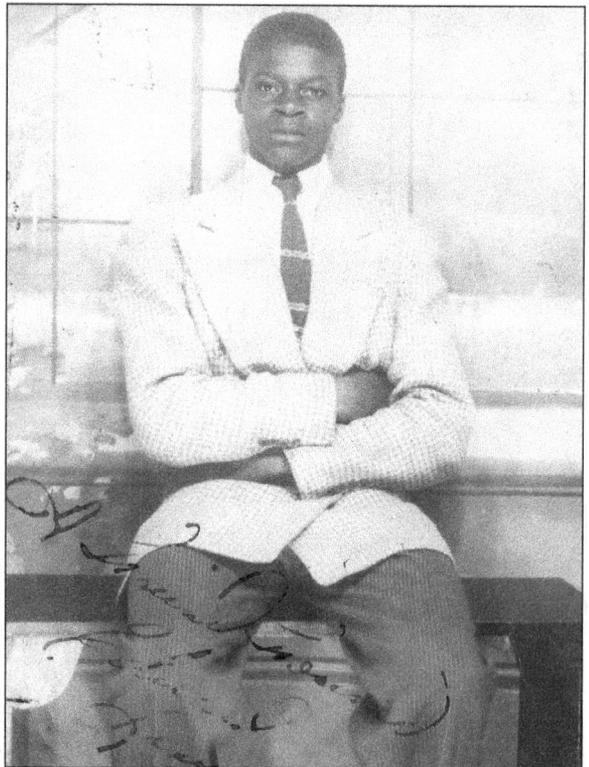

Edward Long was part of an extensive line of hard workers. His father, V. K. "Preacher" Long Sr., moved the family to Lexington in 1925. Edward did not follow in the barbershop venture; he chose the record business. The Long Music Company rented jukeboxes. Edward took great pleasure in visiting the restaurants, cafés, and clubs to service the equipment. He attended college to learn how to make repairs on small appliances like televisions and radios. (Courtesy of Alberta Carter.)

The Homestead, Virginia's premier mountain resort, is where bellhop Walter Lewis Craven eagerly served many distinguished guests. When he returned to Lexington, Walter became the first black bus driver for the City of Lexington. He worked for several furniture companies and the Lexington Housing Authority and thoroughly enjoyed his job as a skycap for Piedmont Triad Airport in Greensboro. He and his wife, Isabel Thomason, raised three children—Keith Jr., Wanda, and Katrina. (Courtesy of Wanda Craven.)

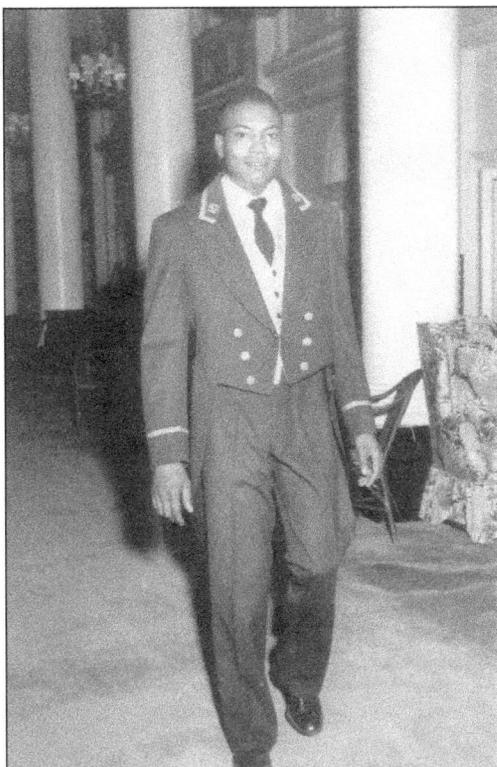

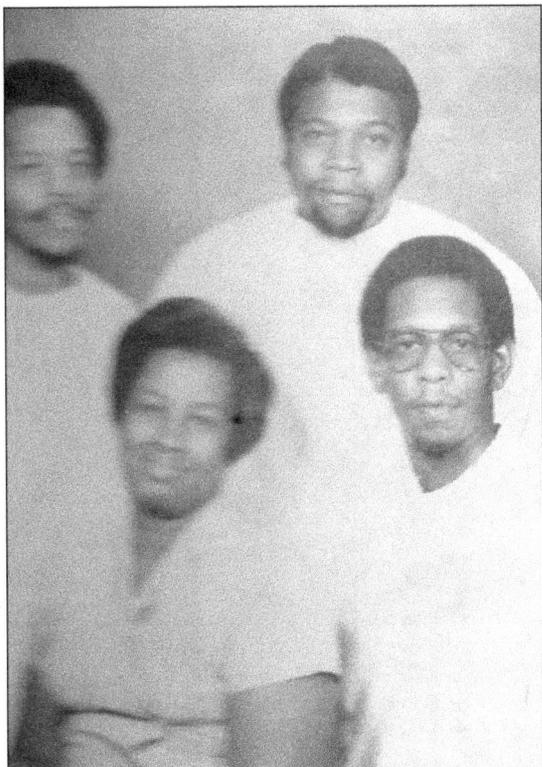

The title of first Davidson County female barber goes to Lucilla Bradshaw (front left). She was the proud owner of Bradshaw's Barber Shop on Dixie Street prior to moving to a new location on Cotton Grove Road. Lucilla recruited many great barbers, like Eddie "Snag" Moore (left), Charles Ward, and Jake Lindsay (right), all pictured here. (Courtesy of Sharon Ward.)

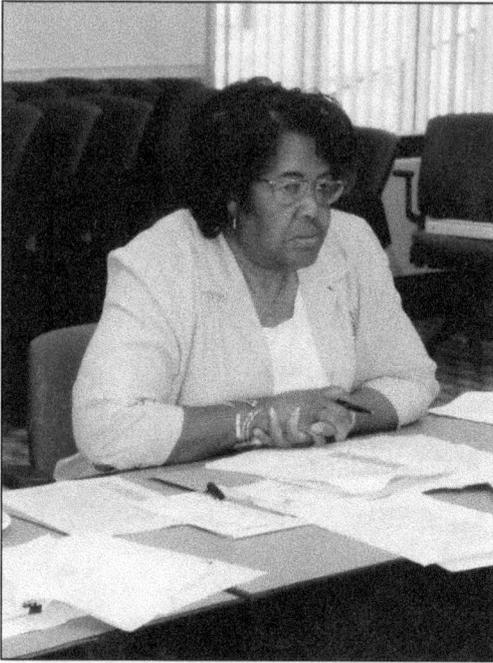

As a community service director for Davidson County Community Action, Barbara Walser listens attentively in a regional workshop. Having served 30 years with this nonprofit agency, Barbara enjoys helping clients. She also is devoted to being overseer of Lexington Deliverance Tabernacle, a church started by her mother, Lois Hargrave. (Courtesy of Barbara Walser.)

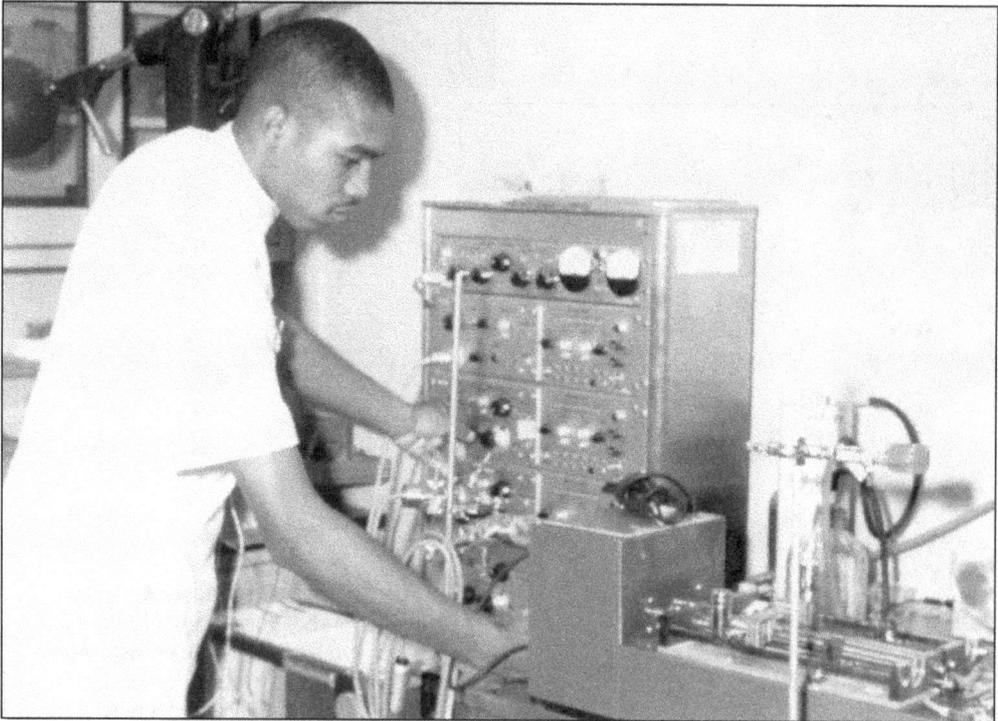

Described by his commanding officer as an "unusually capable histology technician" with the Microbiology Section of the U.S. Air Force Aerospace Medical Division, Ferdinand Franklin Wilson enjoyed his time in San Antonio, Texas, but wrote often, missing his home. He was a 1957 graduate of Dunbar High School and a 1962 graduate of North Carolina A&T. (Courtesy of Henry Wilson.)

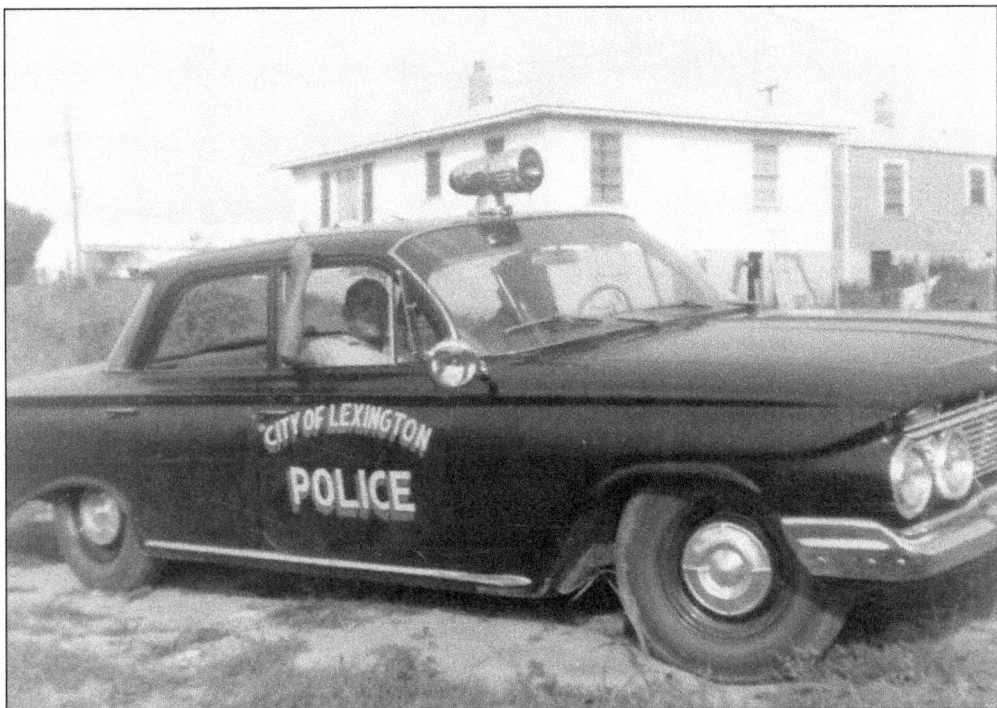

Henry Dula (passenger) and George Lattiner (driver), part-time Lexington police officers, are on cruise patrol in July 1963. Even at the height of racial tensions, they were hired to work only weekends. Lattiner would continue to work at Dixie Furniture, while Dula maintained his job at United Furniture Company. These men showed courage under fire. (Courtesy of Patsy Bush.)

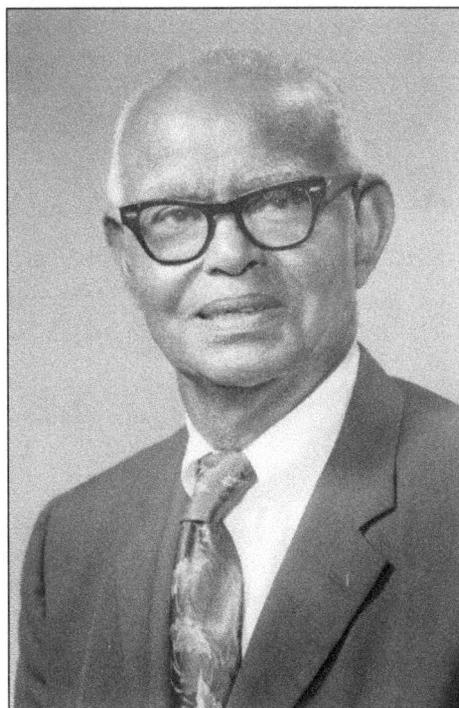

Lance Crump was the first black undertaker in the city of Lexington. He opened Ideal Funeral Home. Prior to his business, blacks were going to Timberlake for their burial arrangements. Rev. A. T. Evans, Rev. L. W. Wertz, George Owens, and Howard Robinson persuaded African Americans to contact Lance and not Timberlake during their time of bereavement. Other funeral homes in the county now include Morrison Studevent, Gilmore's, S. E. Thomas, and Robert's. (Courtesy of H. Lee Waters Collection.)

Frank Hoover Sr. worked hard as a farmer to make a decent life for his family. The farm eventually became a homestead situated in the Reeds community. Hoover married Laura Brown on December 10, 1916, and they raised 12 children. (Courtesy of Katy Hoover Evans.)

Rachel Hargrave Koontz was born in 1924. One of her proudest moments was being valedictorian of the Dunbar High School class of 1941. After graduating from Mayco Beauty College in Greensboro, she became a beautician. Shampoo and press and curls were the typical demands, although Rachel was known for her "killer" finger waves. (Courtesy of Tammy Craven.)

Charles Ward welcomed many clients with a smile. After graduating from Harris Barber College in Raleigh, he was immediately recruited by Lucilla Bradshaw. He was drafted into the army in 1967 and would serve in the Vietnam War. After being discharged, Ward returned to providing exceptional barbering services. (Courtesy of Sharon Ward.)

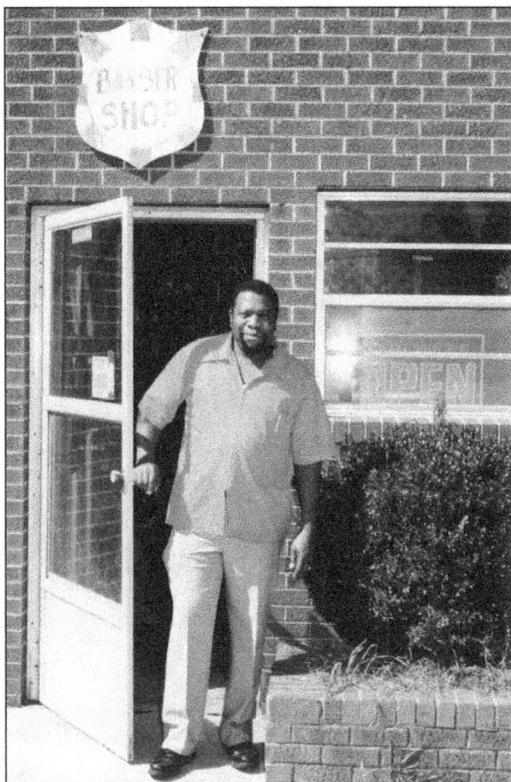

In 1982, Walter Early Thomason (right) was named U.S. Bellman of the Year. Walt worked at the March Hotel before joining The Homestead in Hot Springs, Virginia. He retired after 50 years of dedicated service. (Courtesy of Wand Craven.)

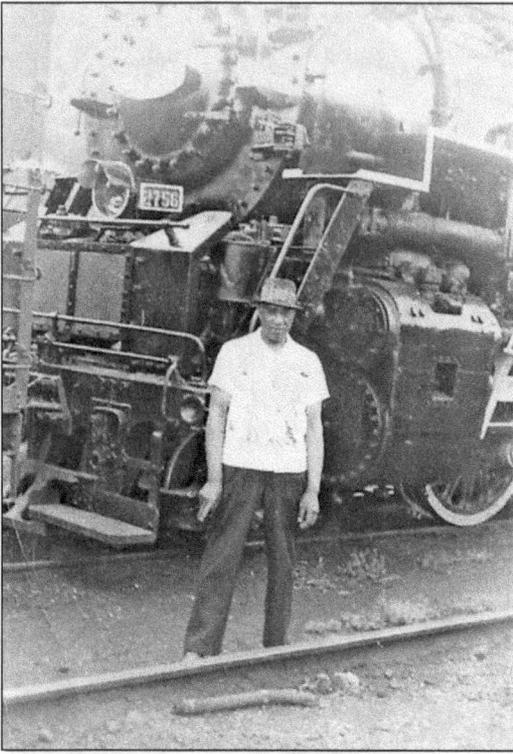

Joe McGuire stands in front of the train on which he served as a Pullman porter. Pullman porters served passengers on the train. They were expected to carry luggage, make beds, serve food and beverages, and be available to guests day or night. Joe attended Smith Grove School as a youngster. (Courtesy of Ruth Small.)

Theresa Scott enjoys one of many moments with her students. She served the Davidson County school system for 30 years: first as a teacher, later as assistant principal, and then as one of the first African American principals. She graduated from Virginia State University in Petersburg, Virginia, and Appalachian State University in Boone. (Courtesy of Theresa Scott.)

# Eight

# In the Midst of Greatness

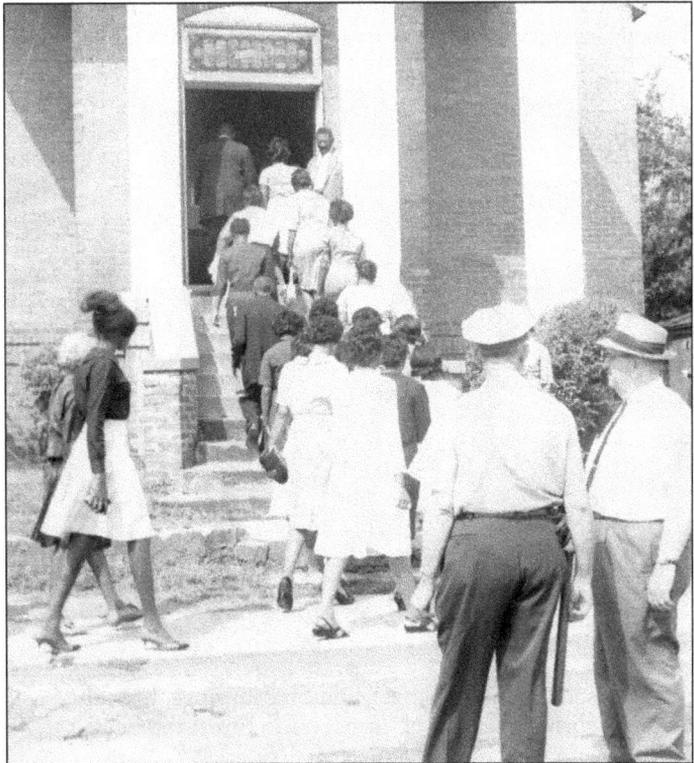

Marchers flow into St. Stephen UMC following a peaceful demonstration on Main Street in Lexington. There were many protests during the early 1960s. Blacks wanted to eat inside a restaurant instead of getting an order through a little back entrance. They felt it was only fair that they could sit inside the air-conditioned section at the movies or at the lunch counter and enjoy a soda. Groups gathered on a weekly basis to accelerate these and other changes. (Courtesy of H. Lee Waters Collection.)

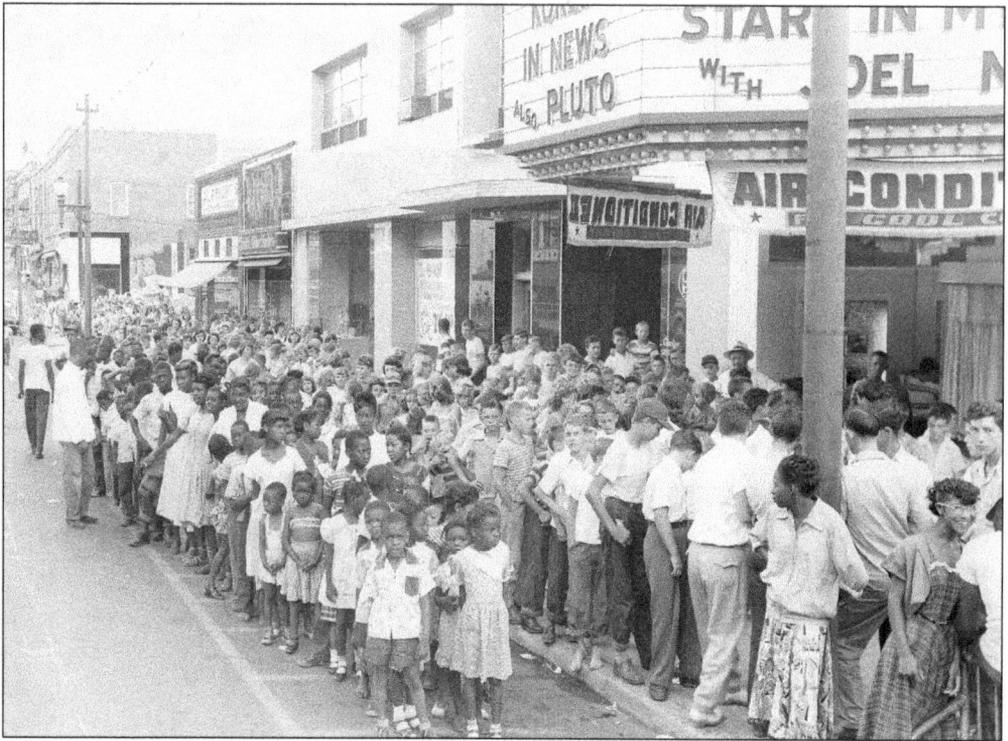

This July 22, 1950, photograph shows anxious children in segregated lines waiting to enter The Carolina Theatre. As part of the summer recreation program, a free movie was shown each Tuesday for eight weeks. (Courtesy of H. Lee Waters Collection.)

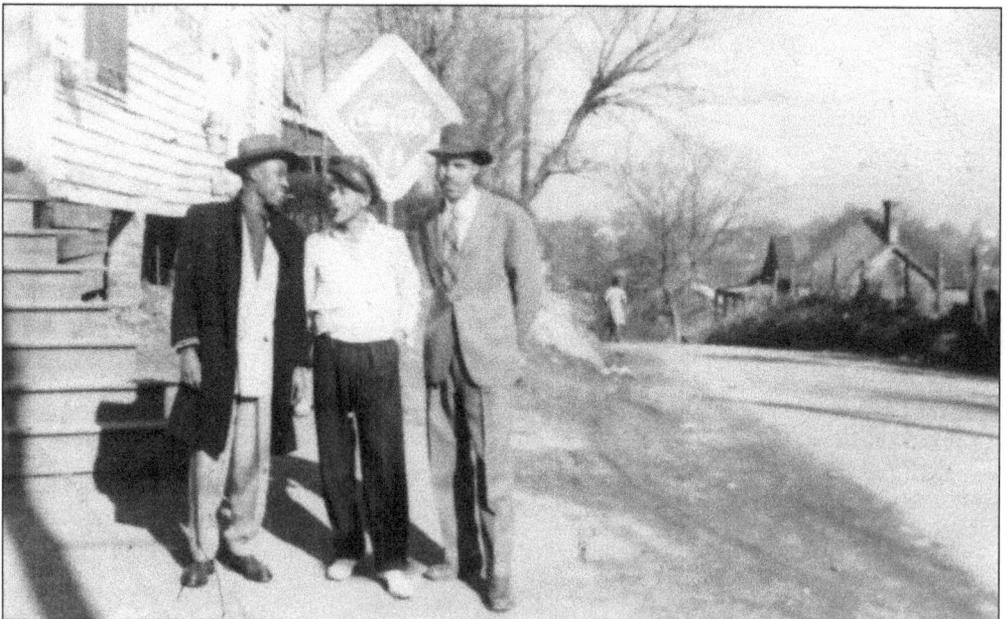

Lee Madison, Shando Michael, and Shag Springs shoot the breeze in front of a café on Fourth Street. A thriving section of town, Fourth Street was home to a boardinghouse, café, dance hall, poolroom, and, of course, Dunbar High School. (Courtesy of Alberta Carter.)

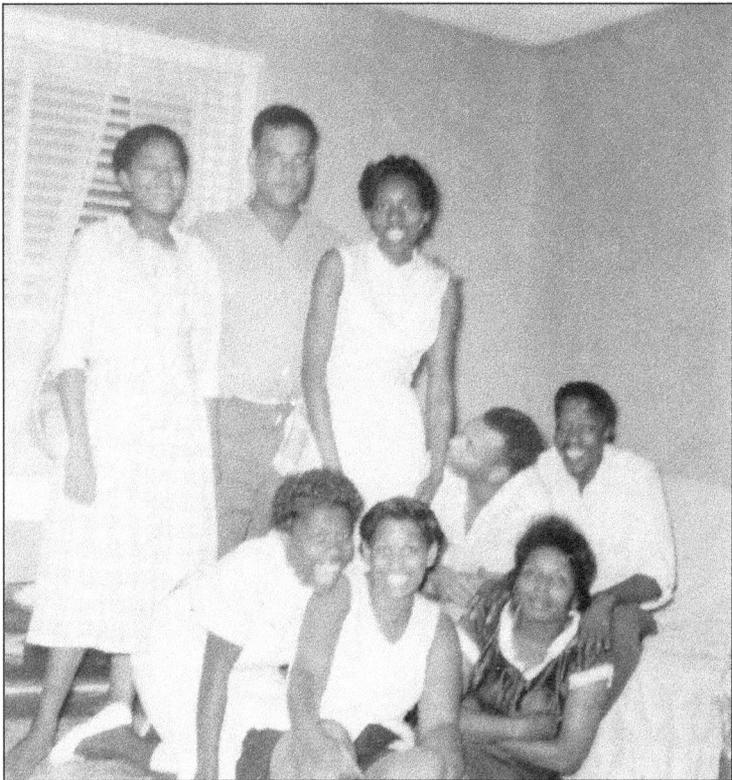

Having fun with friends and family is essential to a healthy life. Clockwise from left, Annie Sue Tate, William Hargrave, Sue Woodberry, Junior Reid, William Woodberry, Ruth Small, Pauline Hargrave, and Dollie Reid smile for the camera. (Courtesy of Edith Tate.)

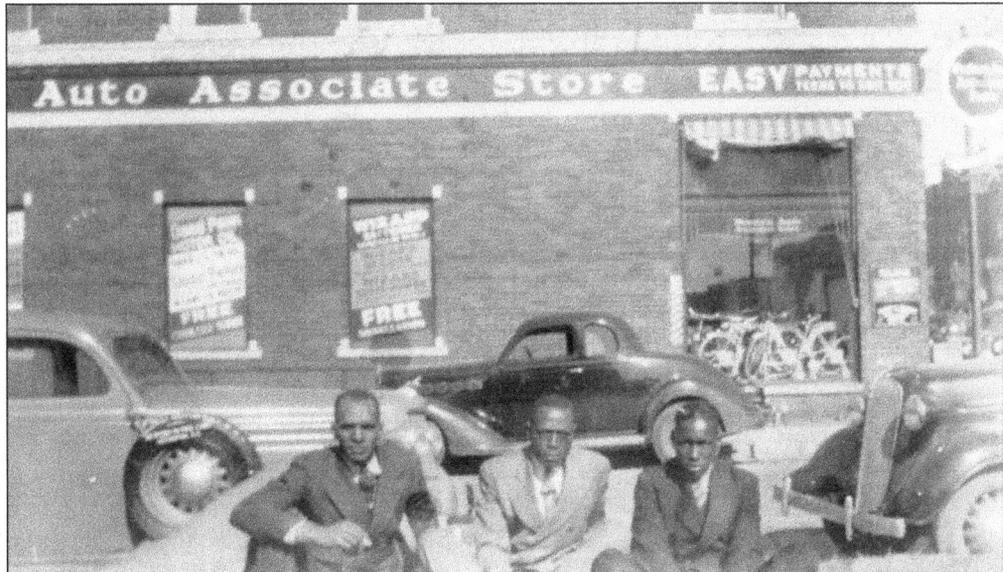

Roscoe Clemmons (center) join his friends for a trip to downtown Lexington. All dressed up, the trio decides not to waste a photo opportunity. The street is lined with 1939 Fords. (Courtesy of Alberta Carter.)

A neighborhood storytelling was not uncommon at the home of Elizabeth Dula (second from right). From left to right, James Kirk, Clarence Dula, Uleetha Dula, and Justin Kirk listen attentively to one of many history nuggets, Bible stories, life lessons, or words of encouragement. (Courtesy of Rev. Arnetta Beverly.)

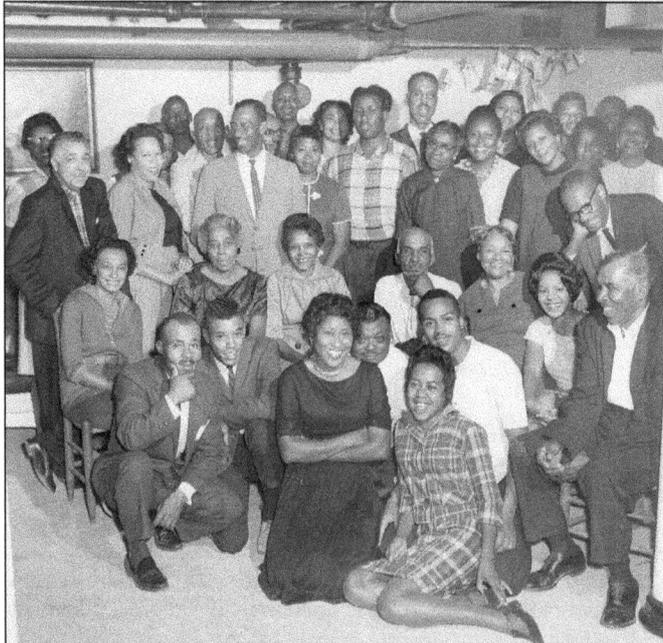

Elnora Springs (third from right, second row) was surprised at the crowd attending her birthday party in the basement of her King Street home. Friends and family always enjoyed celebrations of any kind. Pictured are Beulah Craven, Loy Hargrave, Wes Michael, Billy Marshall, Clarence Springs, Jon Walser, Bill Holt, Cliff Springs, Jan Cole, Lulu Holt, Bessie Holt, Ladarius Reid, John Roberts, Gladys McIntosh, Beatrice Reid, Drusilla Carson, Kalford Carson, Louise Springs, Sam Springs, and John McIntosh. (Courtesy of H. Lee Waters Collection.)

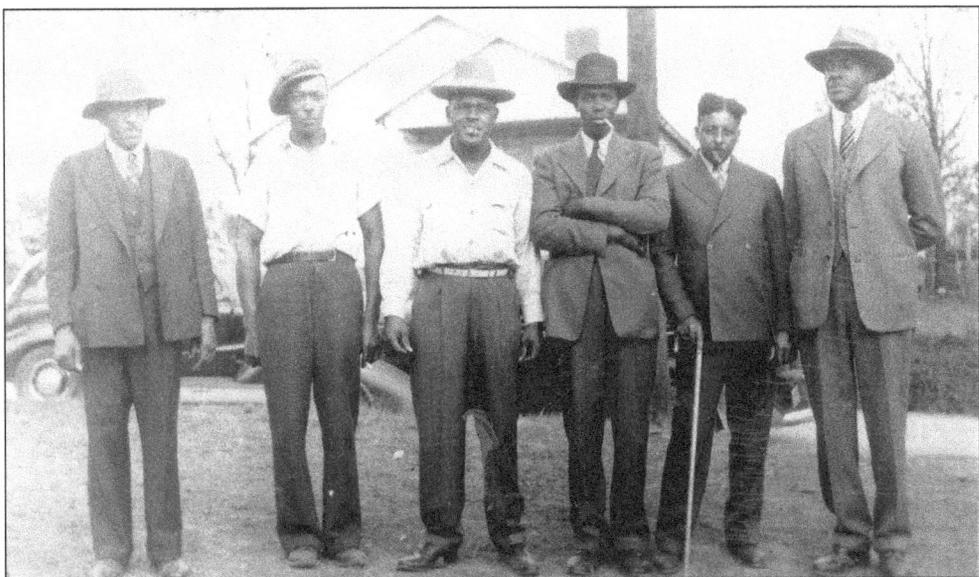

As evident in this 1950s photograph, Fourth Street was no stranger to good-looking men who worked hard and played harder. The words "community" and "family" were held in high regard. Spending time shooting the breeze are, from left to right, two unidentified, Reid Crook, Abraham Martin, Winston Hairston, and Ray Payne. (Courtesy of Alberta Carter.)

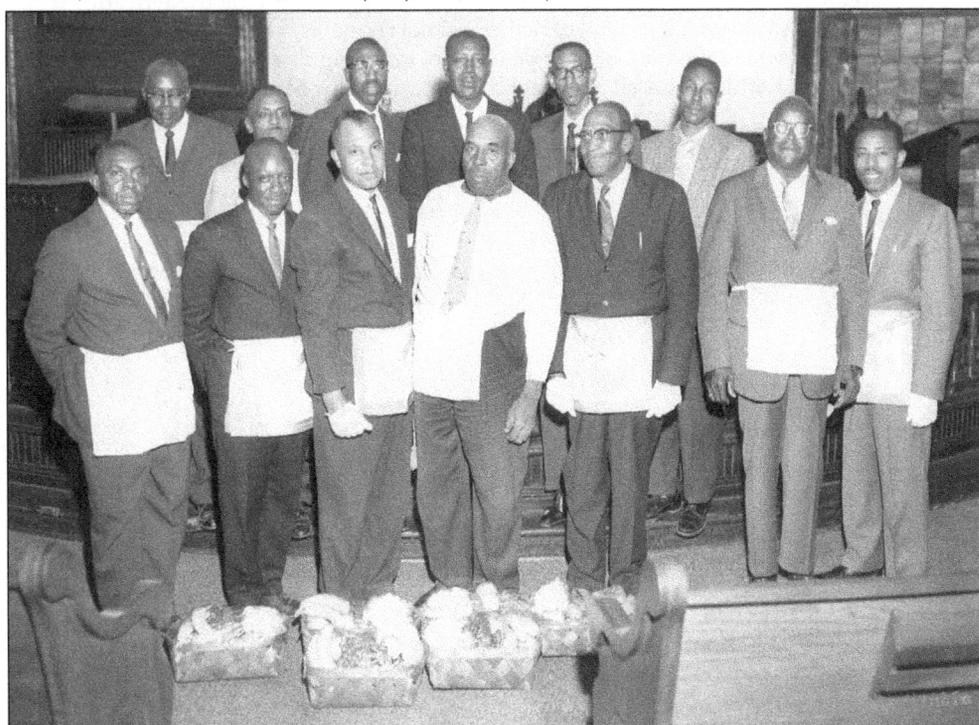

Members of Acacia Lodge prepare for Christmas basket deliveries. They are, from left to right, (first row) Macy Holt, Preston Hargrave, Squire Hairston, Sandy Hairston, Herbert Wright, Rev. Thomas Littlejohn, and Willie Shoaf; (second row) Cliff "Buck" Holt, David Wagner, Theodore Crump, Ernest Perry, Rev. J. L. Stowe, and Verdean Hairston. (Courtesy of H. Lee Waters Collection.)

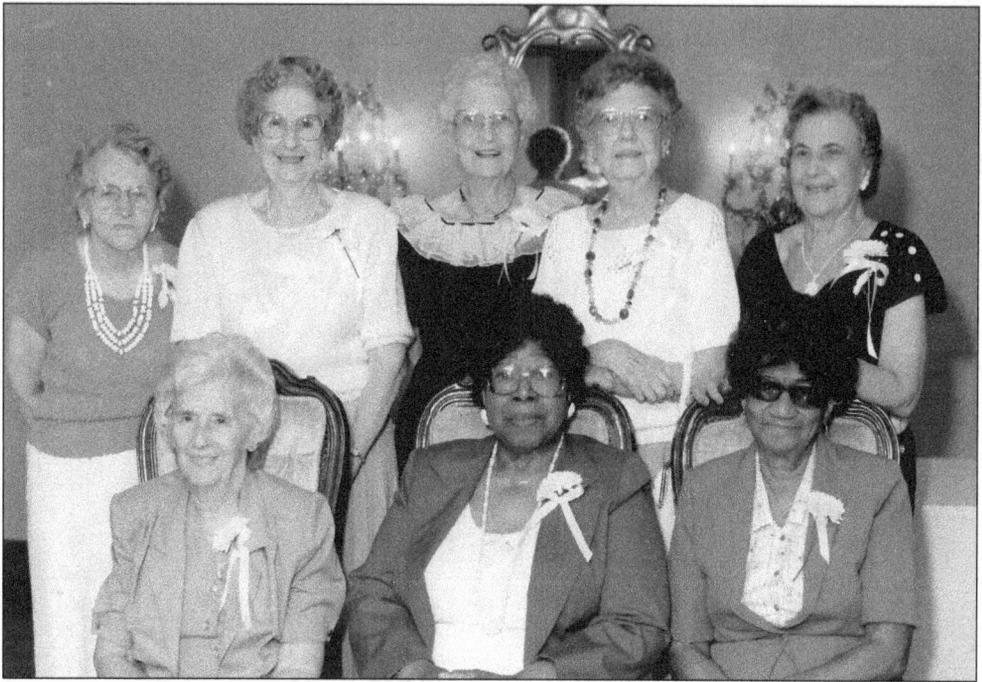

Frances Hargrave and Lillie Mae Evans are among the honorees recognized at the 15th anniversary of the Lexington–Davidson County Unit of Retired School Personnel. These ladies were committed to the educational system. Because of their dedication, many minds were nurtured. From left to right are (first row) Kathleen Russell, Frances Hargrave, and Lillie Mae Evans; (second row) Ada Berry, Frances Rickett, Elizabeth Terrell, Lillian Mabry, and Arline Berrier. (Courtesy of Annette Evans Marshall.)

Samuel "Big Man" Clay, of Hot Springs, Virginia, chats with, from left to right, newlyweds James "Bo" Carter and Alberta Smitherman while friends Sadie and Sonny Craven look on. (Courtesy of Alberta Carter.)

Elvirnia Poole Evans was the mother of Rev. Ananias T. Evans. Born on September 1, 1881, Elvirnia Poole Evans died on May 1, 1958. She had three sons, Jonas, Ananias and Theodore. Her husband died shortly after their last child was born. At 19, Evans was widowed with three small boys. As a strong and determined woman, she was destined to make a decent life out of measly scraps. (Courtesy of H. Lee Waters Collection.)

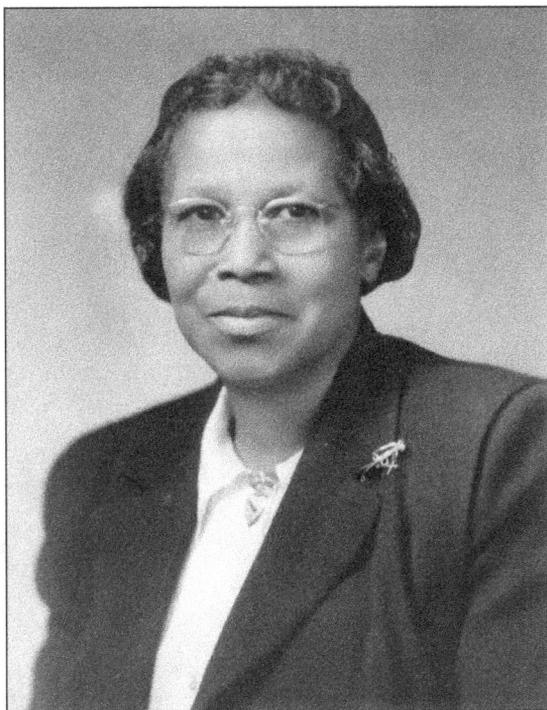

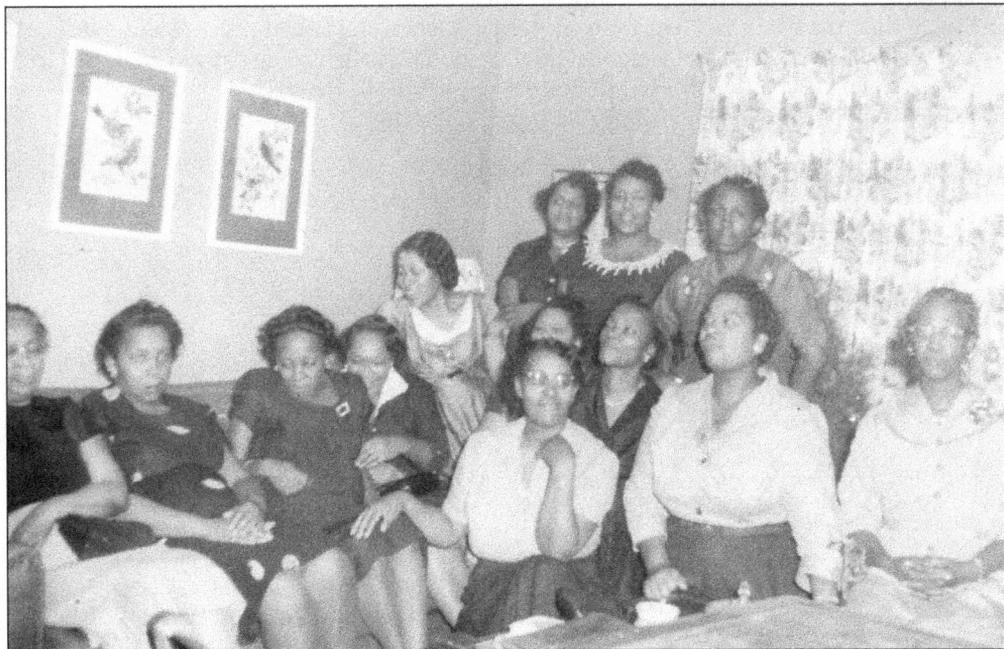

These are the original members of the Nine O'Clock Savings Club, organized in January 1950 by Elizabeth Walker. The purpose of this club was to provide an entertainment outlet for working women while saving them money. Members gathered here include Viola Ellis, Helen Craven, Lucille Holt, Beatrice Reid, Lillian Green, Mamye Singleton, Rachel Koontz, Virginia McCall, Christine Cross, Pat Bailey, Marilyn Holmes, and Mabel Edwards. In the beginning, the ladies met on the second and fourth Friday at 9:00 p.m. (Courtesy of Madie Payne.)

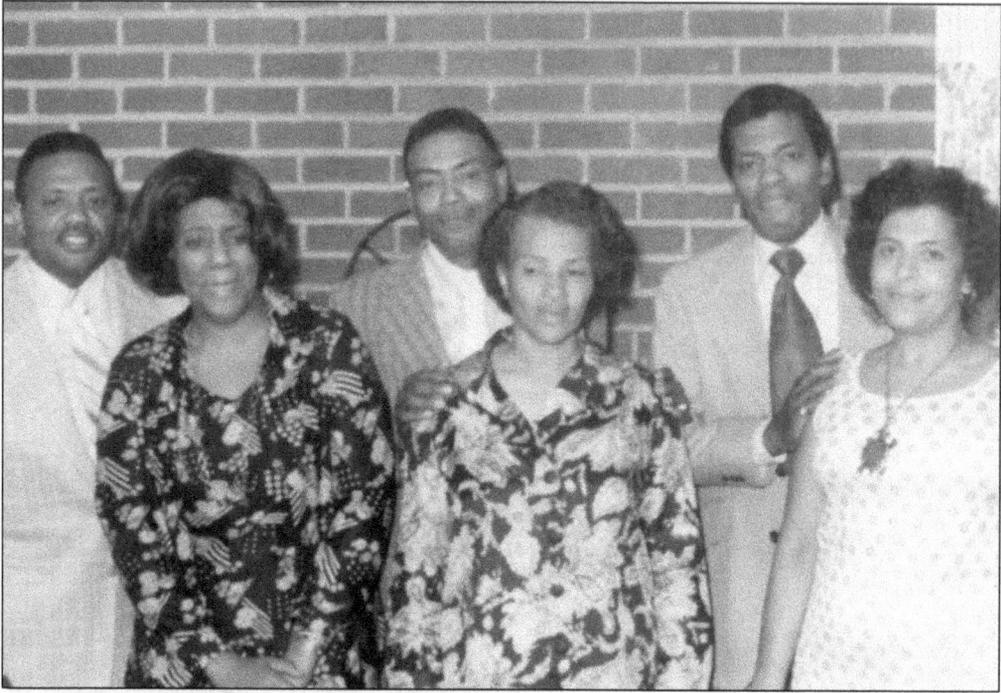

Family gatherings were always special in the African American community. No family demonstrated this more than the Cravens. Here, from left to right, James and Beulah, Walter and Isabel, and Sonny and Sadie—all Cravens—capture another special moment. The Craven crew are close-knit and loyal heirs to their lineage. (Courtesy of Rev. Arnetta Beverly.)

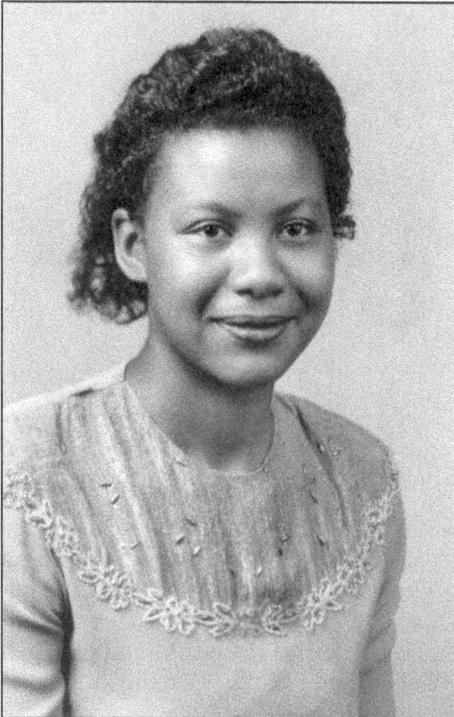

Carrie "Estelle" Mock Walser was born in Southmont to Jules Mock on February 18, 1929. She was educated in the Davidson County school system and actively served St. Stephen United Methodist Church. Estelle was a spiritual person who leaned on God's word during difficult times. She believed in doing good things for all people. (Courtesy of H. Lee Waters Collection.)

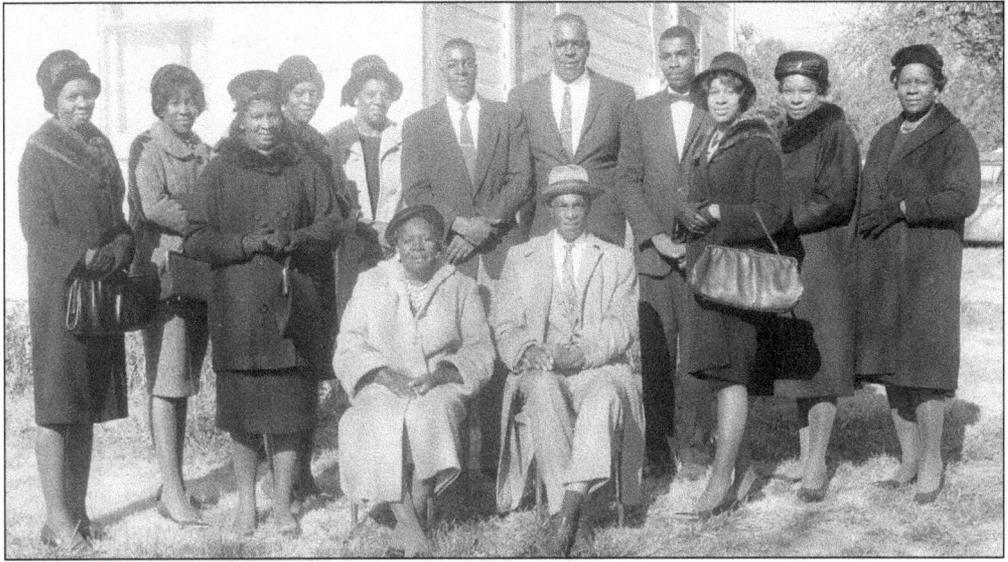

In November 1962, Laura Brown Hoover and Frank Hoover Sr. pose with 11 of their 12 children—from left to right, Ruth Hoover Staplefoot, Pearlene Hoover Moss, Gladys Hoover Holmes, Katy Hoover Evans, Geneva Hoover Peebles, John Gilmore Hoover, Frank Hoover Jr., Baxter Lewis Hoover, Lois Hoover Andrews, Essie Hoover Walker, and Nona Rebecca Hoover. Son Velma Dean Hoover had died as a young child. This photograph was taken at the Hoover homestead prior to the funeral of Essie's son, James Franklin Walker, who had died in an automobile accident. (Courtesy of H. Lee Waters Collection.)

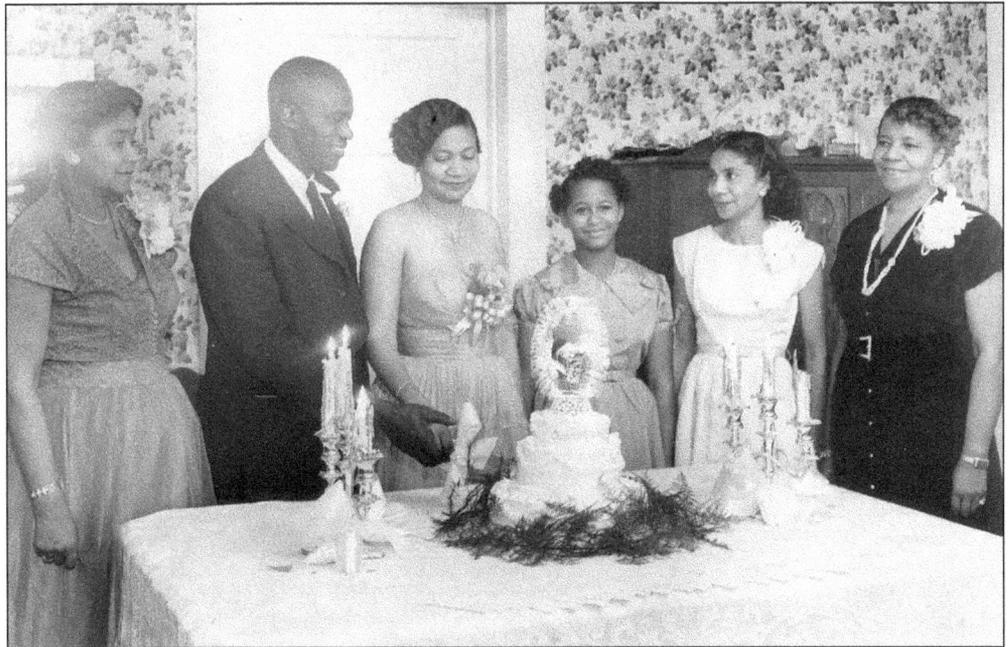

Frances Hargrave served as hostess at a reception in her home honoring the 25th wedding anniversary of Rev A. T. Evans. From left to right are Lillian Bingham Simpson, Rev. A. T. Evans, Lillie Mae White Evans, their daughter Annette, Jessie Miller, and Hildred Moore. The couple had married at Lillian's home in Salisbury. (Courtesy of H. Lee Waters Collection.)

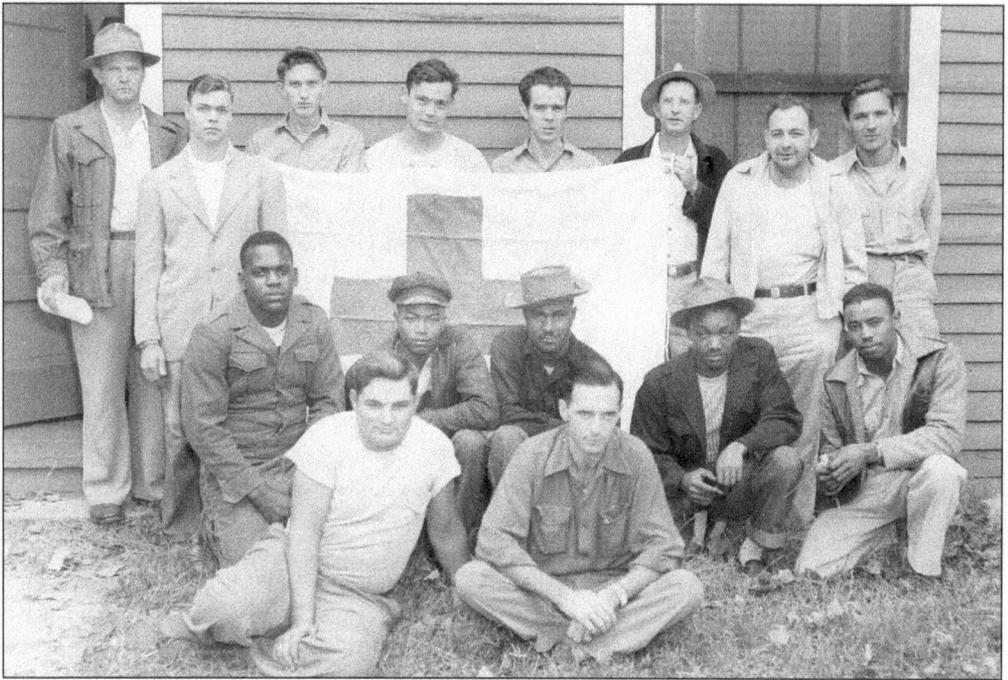

United Furniture sponsored many blood drives for the American Red Cross. In order to secure Negro blood for Negro patients, Julius Hairston, Walt Lewis Craven, Paul Koontz, and Willie Shoaf were recruited to assist. (Courtesy of H. Lee Waters Collection.)

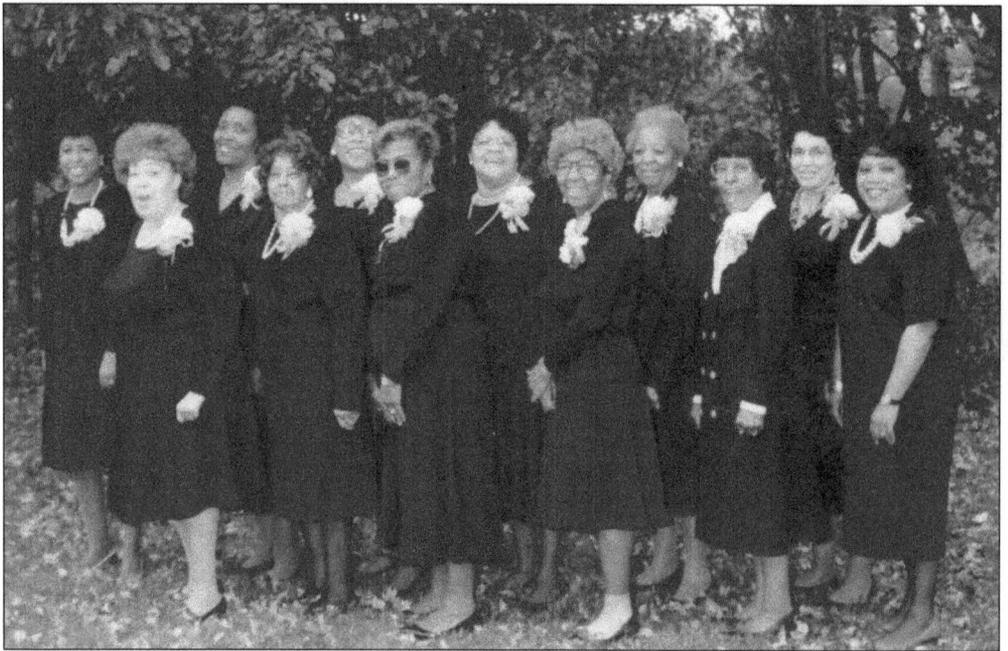

The ladies of the Nine O'Clock Savings Club share a special moment during this 1989 outing. They are, from left to right, Theresa Scott, Betsy Jo Calhoun, Madie Payne, Mamye Singleton, Marjorie Barmore, Cora Hargrave, Molly Mason, Gertrude Reid, Elizabeth Walker (founder), Christine Cross, Rebecca Peoples, and Esther Turman. (Courtesy of Madie Payne.)

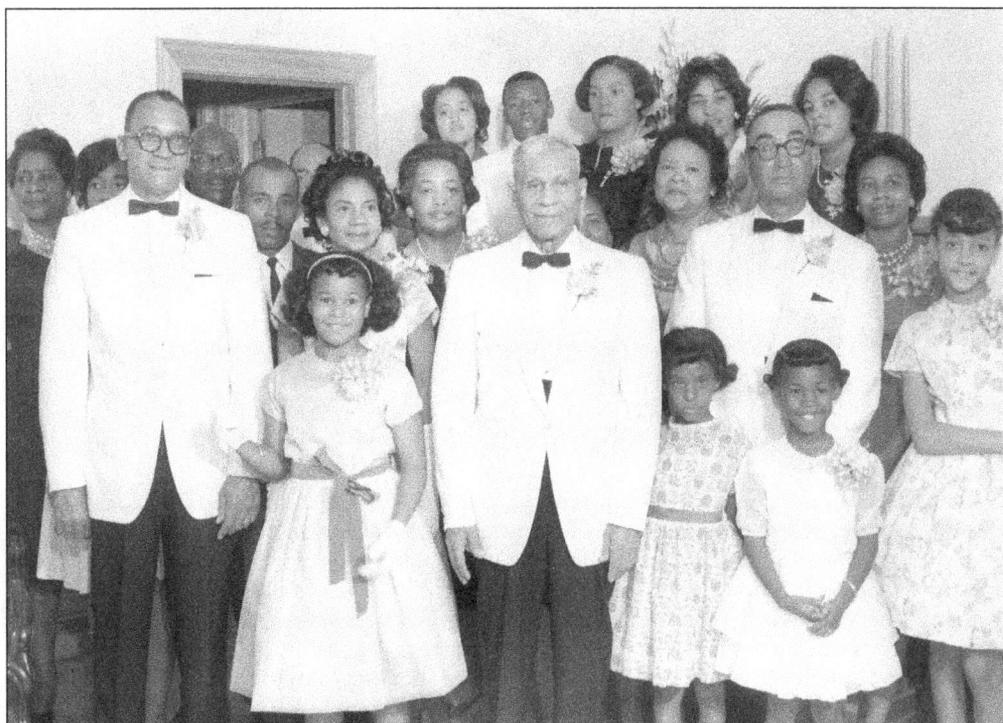

Jessie and Sylvester "Bud" Miller, at left, pose for a memento of their 25th wedding anniversary. Their daughter, Carolice, stands in front of her parents. Also joining the celebration is Isiah White Sr. (center). Cindy and Beverly stand to left and right in front of Richard Stoner (right). Other attendees include Rev. A. T. Evans, Minnie and John Roberts, Martha Michael, Louise Miller, Roland Dusenberry, Gertrude Miller Dusenberry, Anita Hall, Nottie Hall, Mary Noble Miller Stoner, Marlene Stoner, and Donna Hall. (Courtesy of Carolice Graham.)

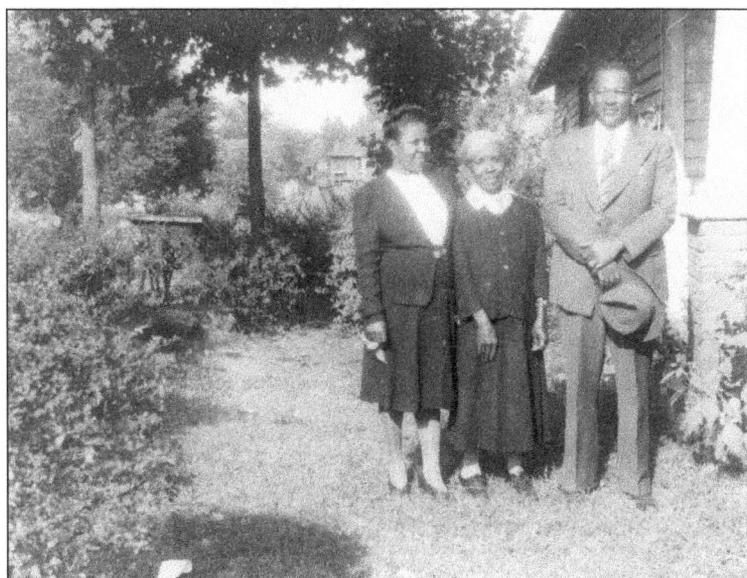

From left to right, Clora Smitherman, Fannie Harrison, and Al Smitherman enjoy a Sunday afternoon in their Elk Street yard. Fannie, like her daughter Clora, was a fantastic cook, and family members were eager to dine at her table. (Courtesy of Alberta Carter.)

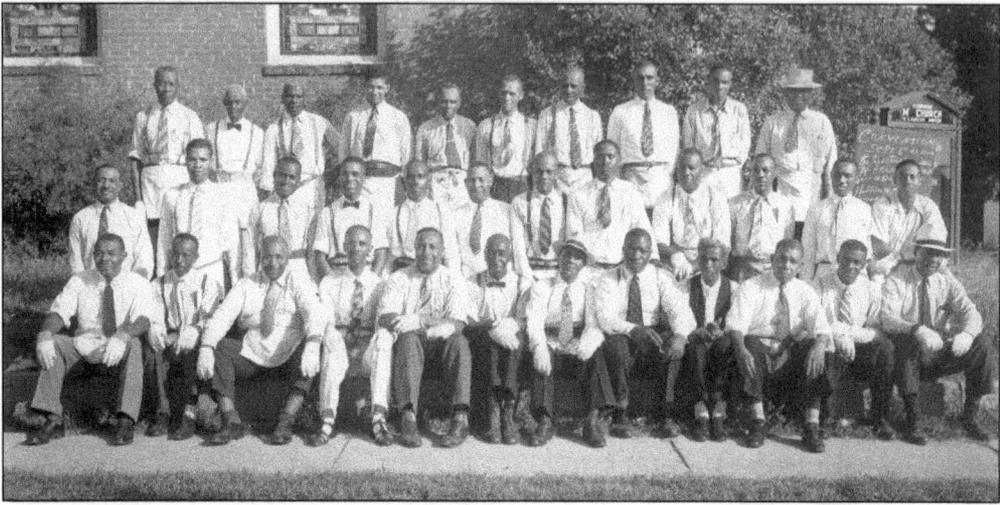

During the early 1940s, Masons from surrounding areas convened at St. Stephen United Methodist Church. This organization, like other fraternal groups, has been known for its peculiar systems and rituals. One of its main priorities, however, is to provide needed assistance to widows and orphans. The Masons also assist churches and others in laying cornerstones. Lexington native R. Baxter McRary was instrumental in expanding the number of Masonic lodges in North Carolina. He would eventually become grand master, a very high honor. Ultimately the Masons' goal is to make good men better and better men the best. (Courtesy of H. Lee Waters Collection.)

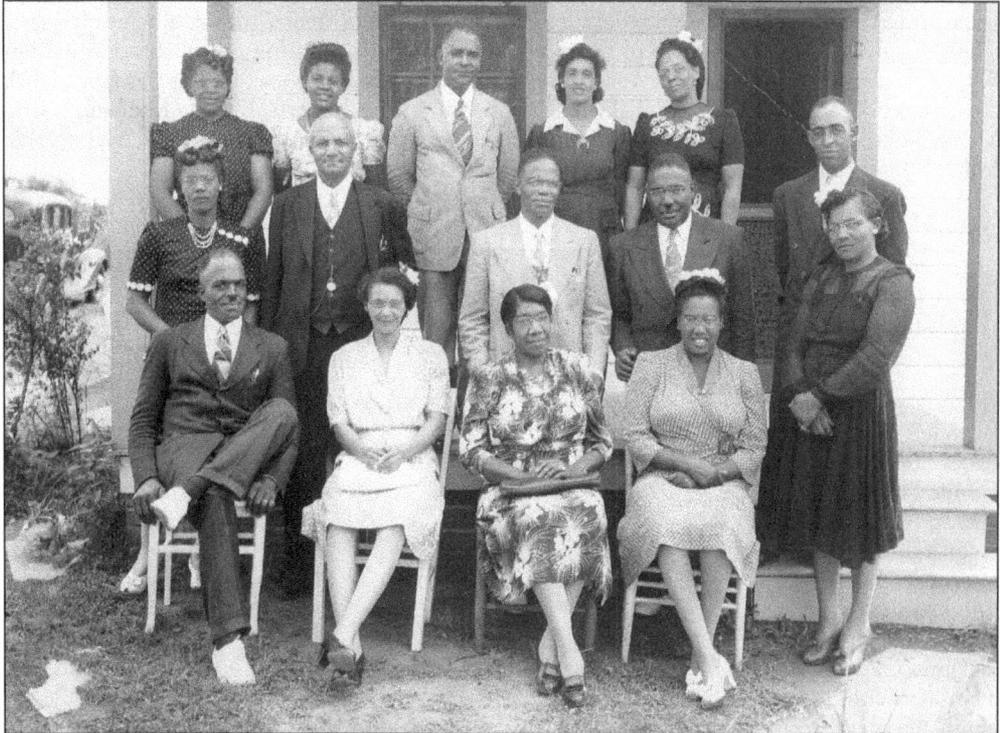

Rev. Baxter Mason and his wife, Edna, seated at left in front, gathered the family one Sunday afternoon. The Mason family valued their time together. Reverend Mason was a highly respected preacher in the Davidson County community and beyond. (Courtesy of H. Lee Waters Collection.)

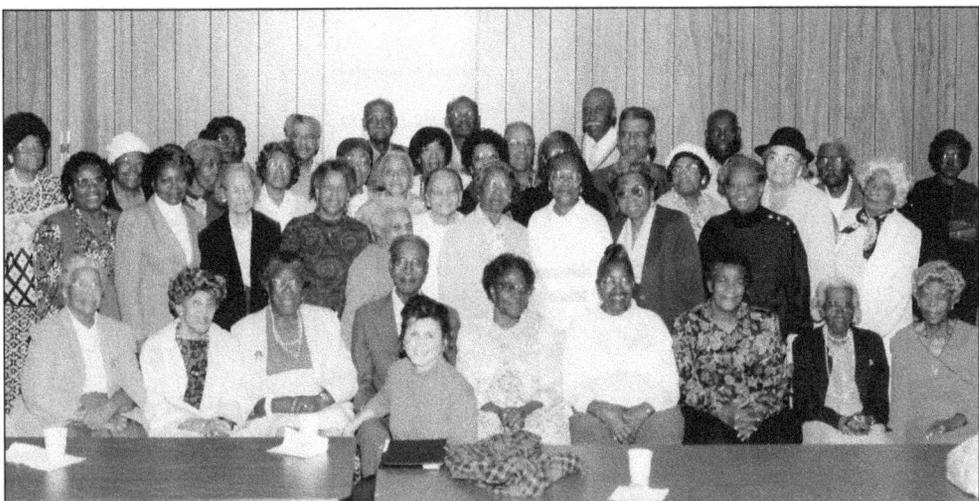

Kathy Everhart, of the Lexington Parks and Recreation Department, smiles proudly with her Southside Senior Citizens group. A monthly meeting always brought out great food, lots of laughs, and wonderful fellowship. (Courtesy of Alberta Carter.)

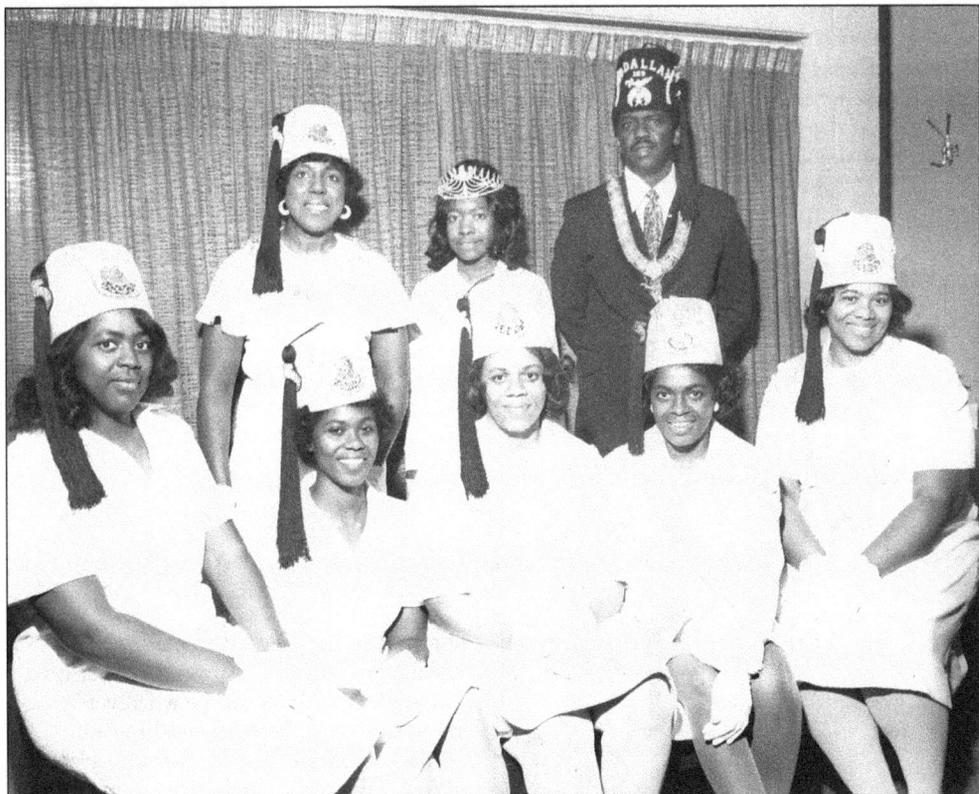

The entrance of five sisters into the Daughters of Isis marked a historical moment. From left to right, sisters Dorothy Talbert, Norma Williams, Irma Bass, Brenda Talbert, and Kiwana Crump were installed into Abdallah Court No. 166. Standing from left to right are Deputy Commander Jacqueline Wright, Commandress Gloria Ramsey, and Noble Wayne Talbert. (Courtesy of H. Lee Waters Collection.)

Miss Sweetheart queen Shirley Lopp (center) shares the spotlight with her court—from left to right, Louise Payne, Mable Smalley, Magelene Hargrave, and Barbara Carson. This photograph was taken at the Dunbar High School football game during homecoming festivities. (Courtesy of H. Lee Waters.)

Throughout her 30 years in education, Adelaid Friday Talbert stressed her personal philosophy that "you can be whatever you want to be." Whether teaching at Dunbar, South Lexington, Robbins, Holt, or South West, she emphasized to her students that there were no excuses. As a young child, Adelaid knew she wanted to be a teacher. She was devoted to making a difference in every child's life. (Courtesy of H. Lee Waters Collection.)

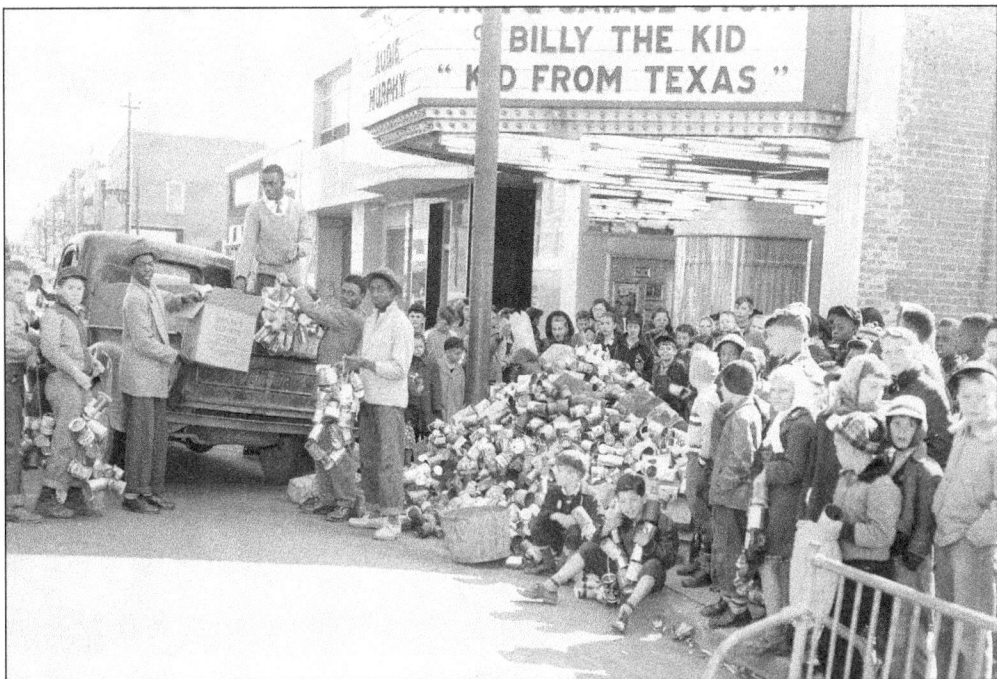

When Lexington boys and girls were invited to a Tin Can Matinee at the Carolina Theatre, they showed up in droves with cans. Manager Dan Austell, who sponsored the show in connection with the city cleanup campaign, estimated that the kids brought around 20,000 cans. (Courtesy of H. Lee Waters Collection.)

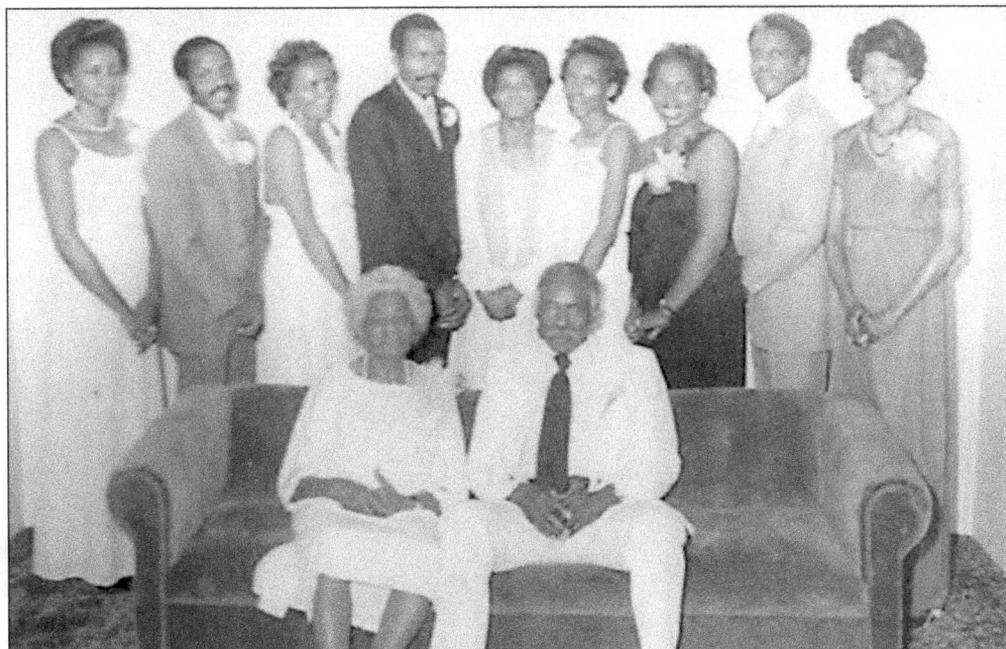

Laura and Clifford Holt pose in front of their children during their 50th wedding anniversary. Present are, from left to right, Elnora, Sylvester, Sylvia, Roy, Josephine, Sue, Ruth, Charles and Mary Ann. (Courtesy of Ruth Holt Small.)

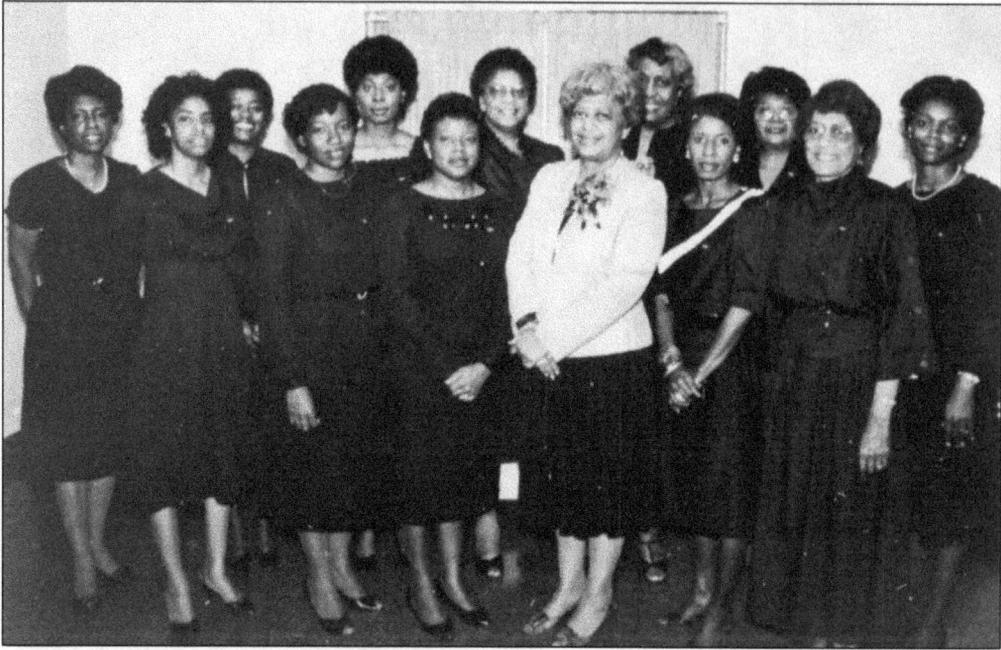

The Lexington (North Carolina) Alumnae Chapter of Delta Sigma Theta, Inc., was chartered on May 28, 1985, with Alice Henderson as the first president. Charter members are, from left to right, Theresa Scott, Cynthia Miller, Margaret Buggs, Debra Norman Hogan, Kathy Y. Wiley, Elaine Rector, Alice Rucker Henderson, regional director Dr. Bertha Maxwell-Roddey, Lucille Dixon Yarbrough, Charlotte Roberts, Arlene Pinnix Morrow, Lillian Foulkes, and Marlena Ricks. Pres. Patricia Ijames stated "the goal of the sorority is to be an integral part of an ever changing society, endeavoring to promote the growth and development of our community by eradicating educational, economic and social inequities." (Courtesy of Delta Sigma Theta, Inc.)

Charles Michael (second from right, front row) represents Troup 210 on "Kings for a Day," held February 13, 1954. Charles, along with other Scouts, was elected to this honor for National Boy Scout Week. Each Scout took over a city or county position for the day. Charles was chosen to serve as principal of Dunbar. (Courtesy of H. Lee Waters Collection.)

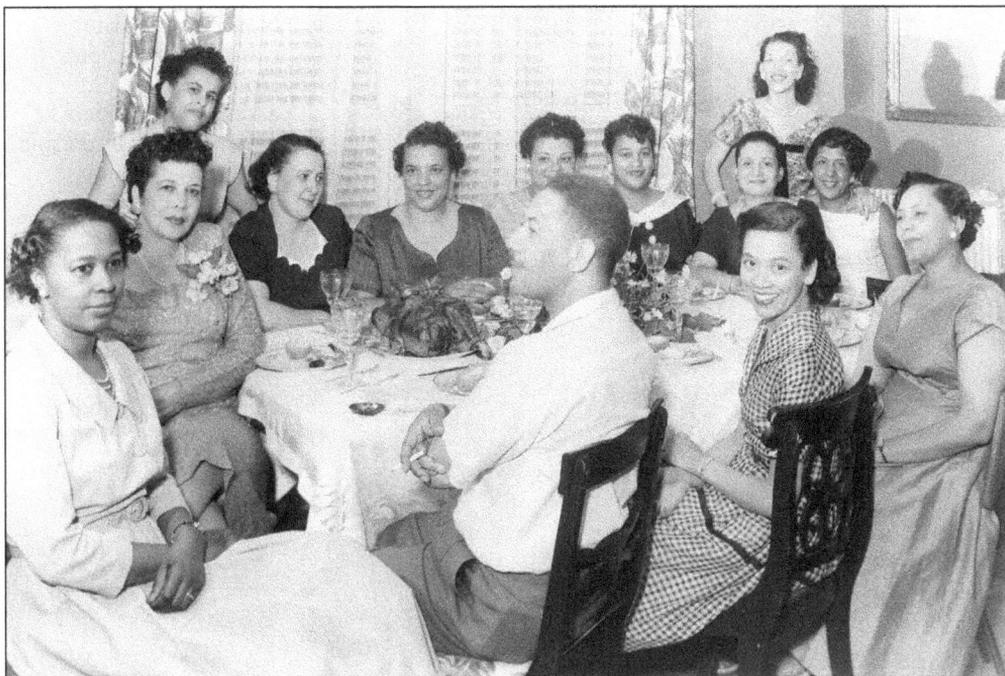

Dinner parties were not uncommon at the Thomason home on Smith Avenue. Althea Dumas Thomason (wearing corsage) moved to Lexington after marrying Walter Thomason. She became one of the town's best-known seamstresses. Althea was a member of several social and civic organizations, including the Pinochle Club and Alpha Kappa Alpha sorority. (Courtesy of H. Lee Waters Collection.)

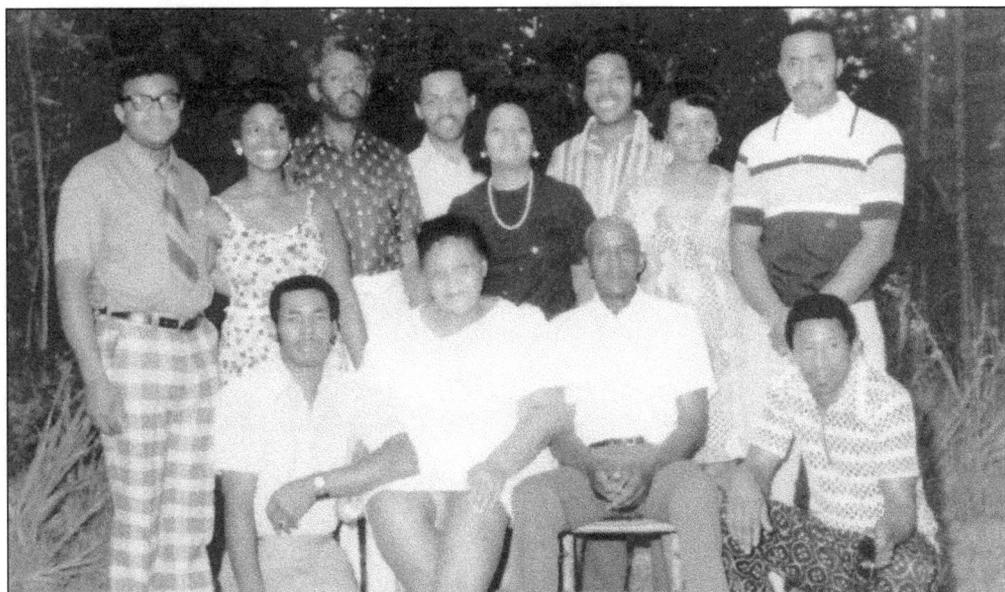

Ineeze Cowan and Raymond Rankin (seated center) are surrounded by their children, from left to right: (first row) Charlie and Chester; (second row) Murray, Terry, Alvie, Carlton, Juanita, Thurmond, Lillie, and Delano. Raymond moved to Davidson County to work at the Belmont Dairy Farm on Linwood Road. (Courtesy of Juanita Rankin Harris.)

No stranger to the classroom, principal Dr. A. B. Bingham addresses his students. Thanks to his leadership, Dunbar can count among its graduates a concert pianist, physicians, ministers, surgeons, lawyers, law officers, pharmacists, college professors, nurses, artists, teachers, administrators, and so much more. (Courtesy of Rev. Arnetta Beverly.)

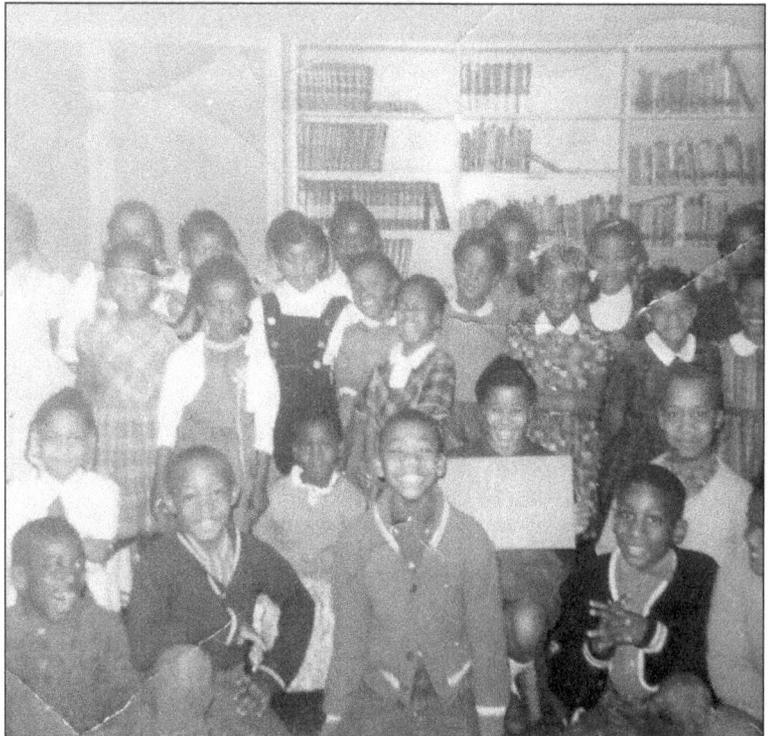

The Lookies Club at South Lexington Elementary School gathers for a group photograph. Reading and enjoying books was the club's primary focus. Librarian Jessie Miller made reading fun. (Courtesy of Carolice Graham.)

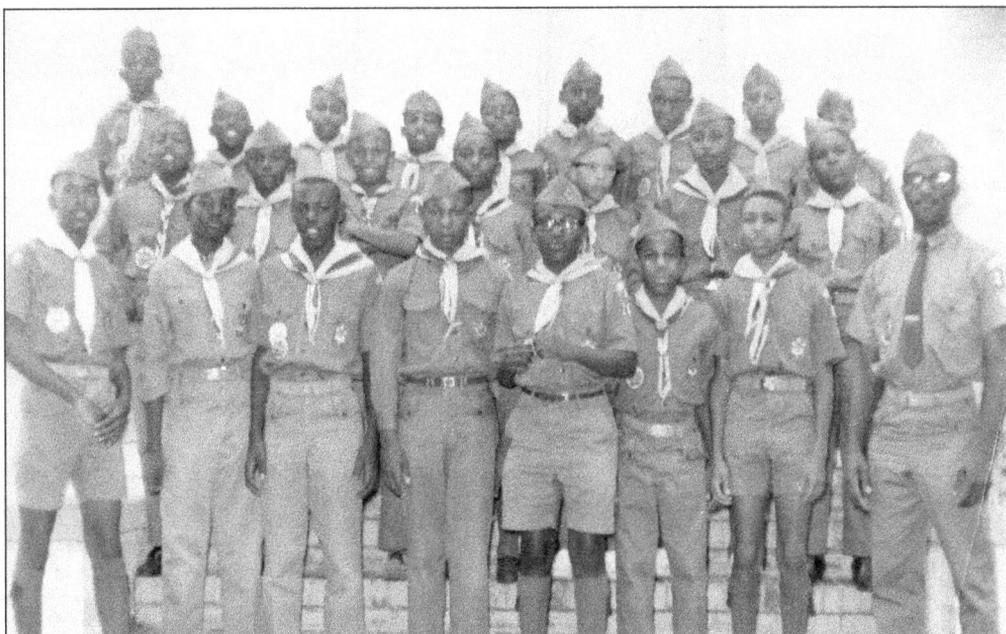

Providing positive outlets for young people was imperative in the early 1950s. Under the direct leadership of scoutmaster George Singleton, assistant scout leader Olin Owens poses with his troop. Among the Scouts pictured here are Hiram Jones, Robert Craven, Buddy Walser, Top Madison, Chick Madison, and Ralph Michael Jr. These boys grew up to be great men. (Courtesy of Alberta Carter.)

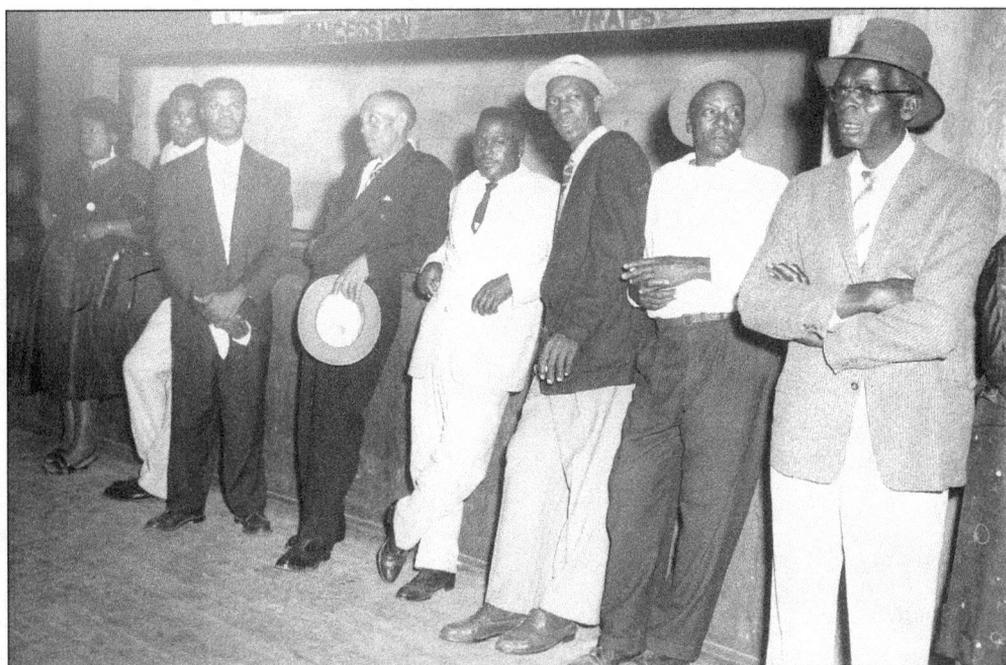

From left to right, two unidentified, Edward Long, Sam Springs, George Cade, Tom Simmons, and two unidentified gather at The Hut, a facility used for dances, meetings, and private events. (Courtesy of H. Lee Waters Collection.)

Frances Jones Mack retired from Forsyth Memorial Hospital after 32 years of dedicated service. She was educated at Kate Bitting Hospital's School of Nursing and continued her education at the former Winston-Salem State College. Thanks to her devoted husband, Dr. Sir Walter Lee Mack Sr., she wore the hat of first lady of Emmanuel Baptist Church for 33 years and a like title for 18 years at Buncombe Baptist Church (Courtesy of H. Lee Waters Collection.)

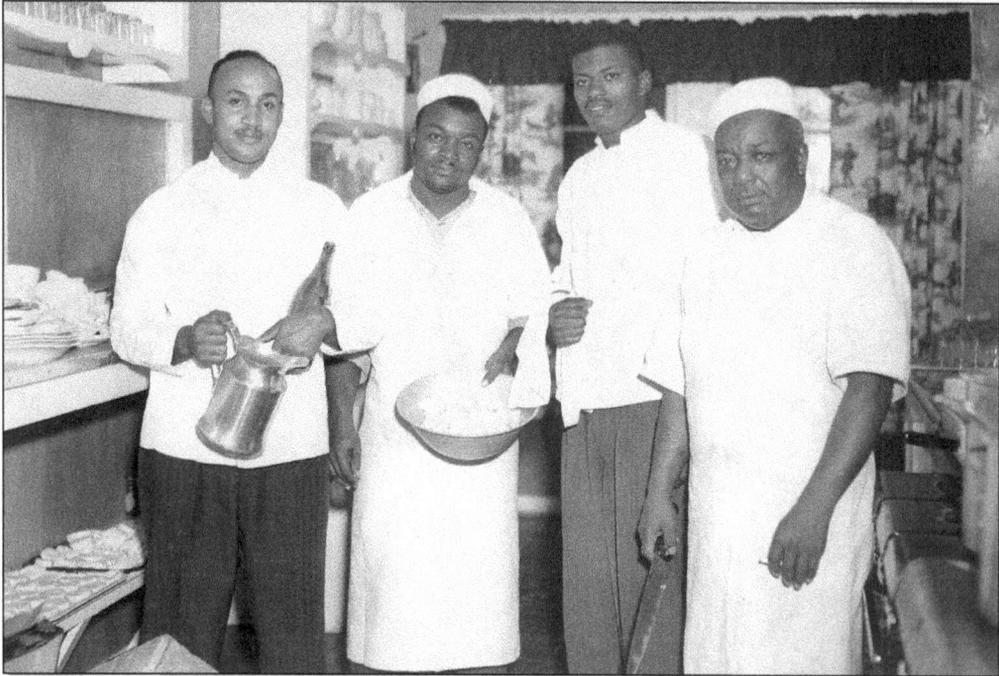

Henry Paul Dula, Robert "Bus" Scott, Sonny Craven, and Gene Scott take a few minutes from their private catering duties to pose for this photograph. Gene had been hired to cook for a Christmas party. He recruited his son Bus to help with cooking, and Sonny and Henry were expected to serve as waiters. (Courtesy of H. Lee Waters Collection.)

As an educator in the Lexington City school system, Helen Roberts Long touched and influenced many lives. The first edition of Dunbar High School's yearbook, *Bluejacket*, was dedicated to Long in 1949. The dedication page states, "May it be a reminder of our sincere appreciation for her fine ability to teach and her enduring faith in helping to make this project a reality." (Courtesy of H. Lee Waters Collection.)

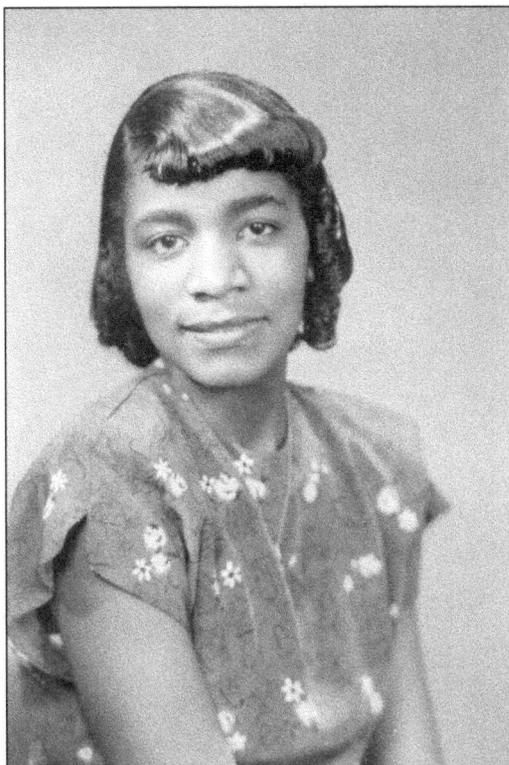

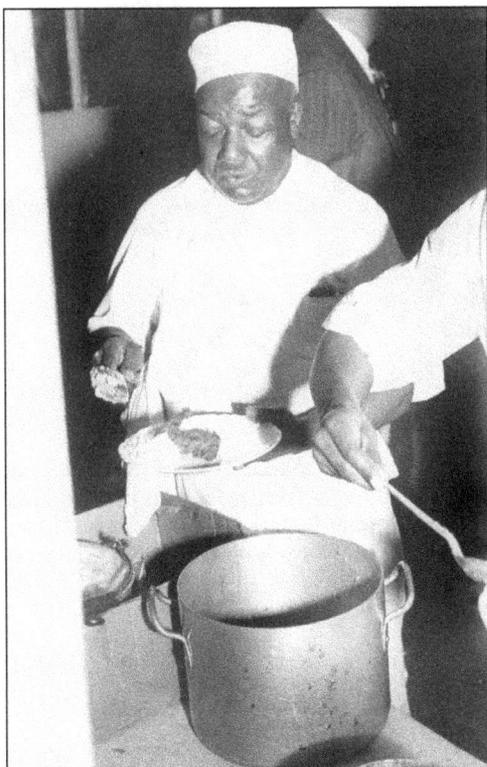

James "Gene" Scott prepares to serve one of his meals at Southern Lunch. He also worked at the Red Pig. Gene loved to cook. He and his wife, Bettie, had five children—Gladys, Bettie Mae, Robert, James, and Eddie. He earned extra money by catering private functions. Southern cuisine was his specialty. (Courtesy of H. Lee Waters Collection.)

109

Tiny Tot Day Care children pose in the basement of Files Chapel Baptist Church, the original center site. Elizabeth Walker cooked balanced meals, and Sally Perkins, Rosa Goodson, Dora Wright, and Vinnie Petty were caregivers. When the new building was built in Southside Village in 1970, Carol Hargrave was hired as the first director. (Courtesy of Marlena Ricks.)

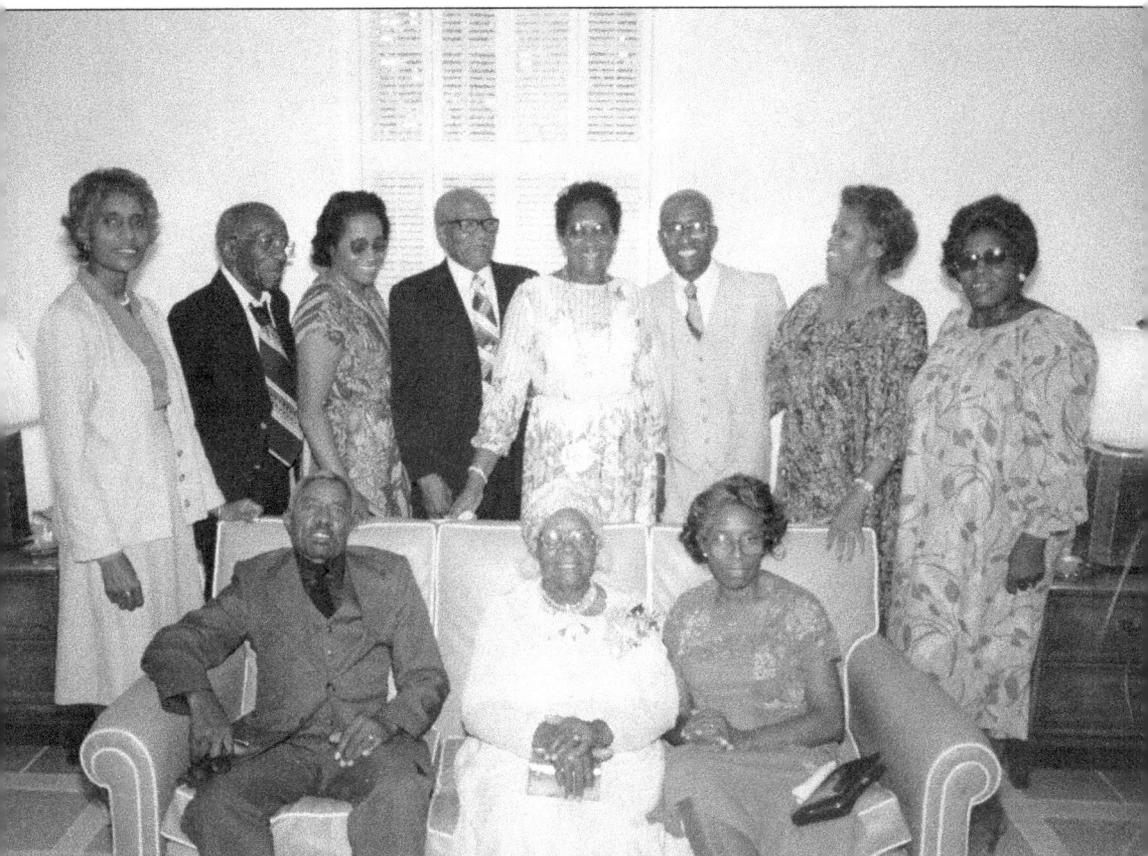

Bettie Owens Cross (center, seated) celebrates her 90th birthday with 10 of her 11 children—from left to right (seated) Robert and Ruth; (standing) Floscene, Wade, Catherine, Sylvester, Mary, Harding, Katie, and Jennie. (Daughter Annie had died years earlier.) Bettie was married to William Cross. As a faithful member of New Smith Grove Baptist, she held many positions, her proudest being Mother of the Church. (Courtesy of Henry Wilson.)

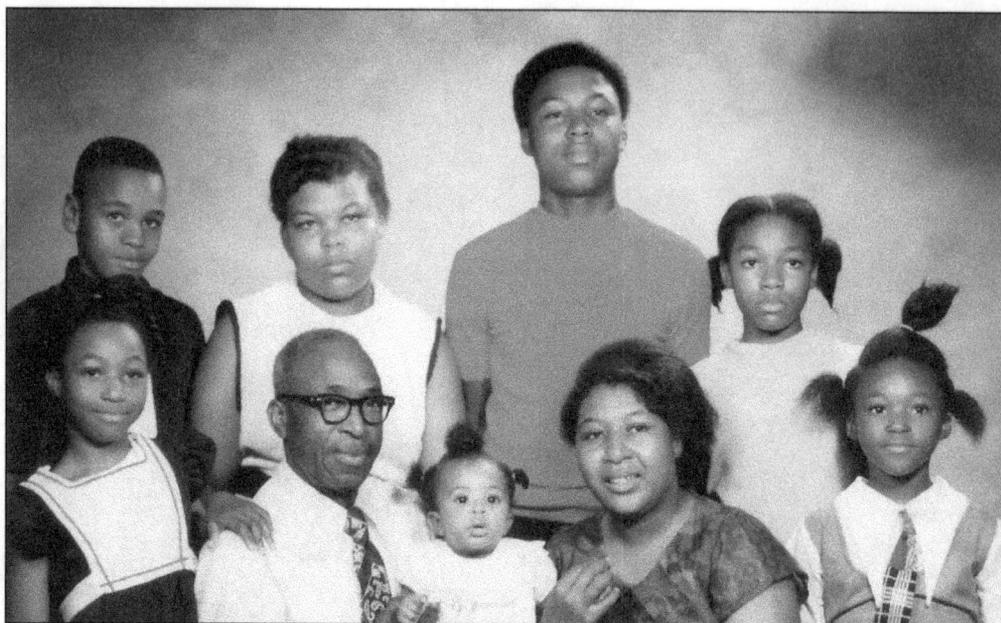

Oscar (second from left in the front) and Mae Ruth Edwards (second from right in the front) share a special family moment with, from left to right, (first row) Toynett, unidentified, and Kim; (second row) Jeffrey Simmons, Victoria, Victor, and LaTonya. (Courtesy of Tonya Lanier.)

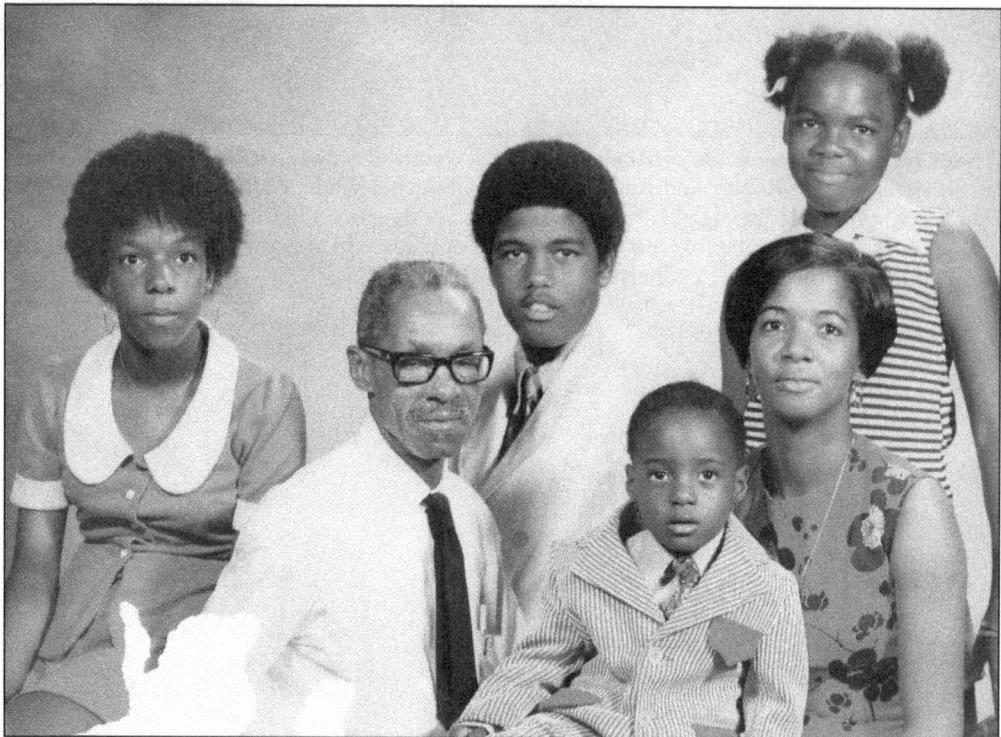

From left to right, Eulah Lanier Petty, James Lanier, Clayton Lanier, Sidney Lanier, Cora Lanier (James's son), and Tonya Lanier pose for a cherished family portrait. (Courtesy of Tonya Lanier.)

# Nine

# LOOSE CHANGE

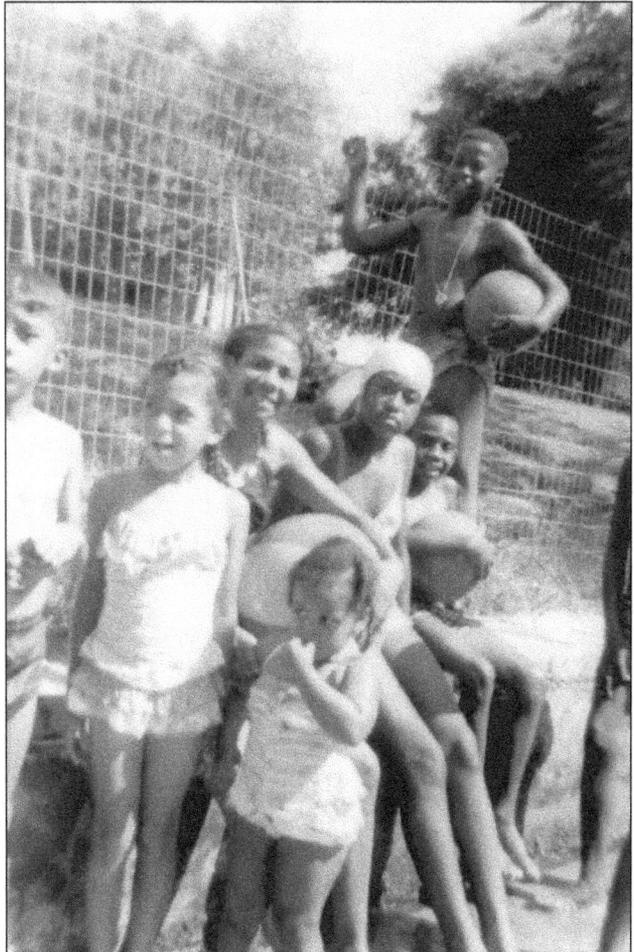

The First Baptist Church swimming pool was a big hit during the late 1930s. During the height of segregation, community leaders realized that children needed a fun, safe place. Children from the church as well as surrounding communities found great times at First Baptist. (Courtesy of Carolice Graham.)

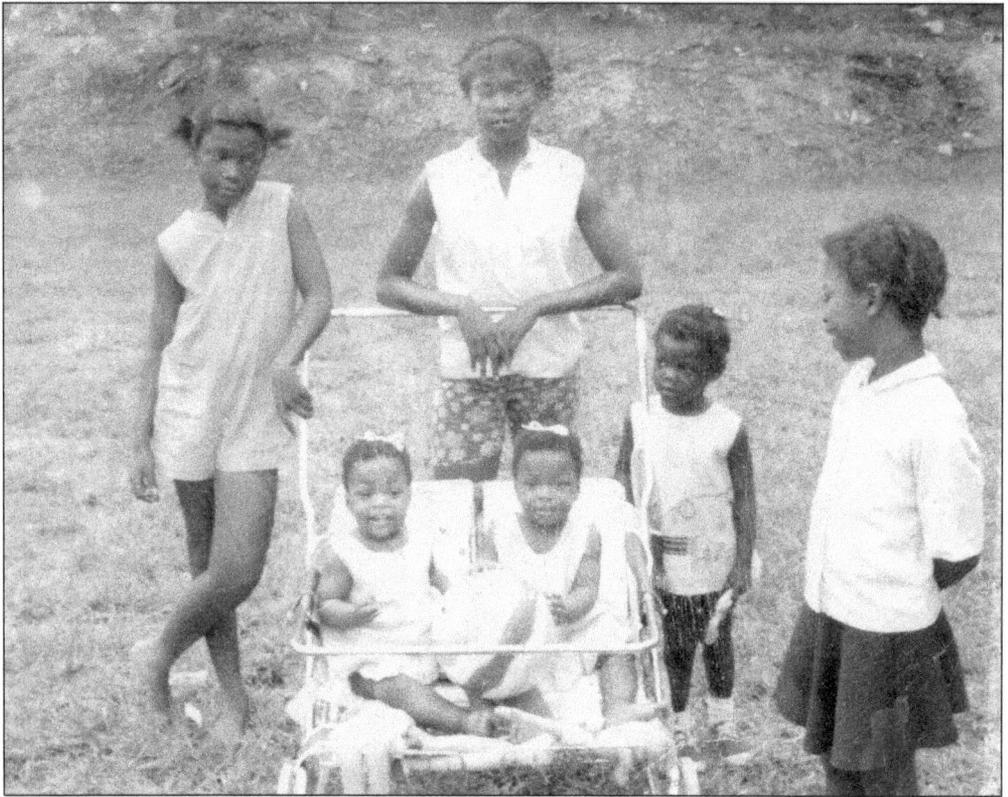

From left to right, Barbara Davis, Karen Davis, Robin Davis, and Vickie Reid closely watch their twin cousins, Arlene and Arlinda Davis (in stroller). (Courtesy of Ethel Parks.)

In 1950, La'Vont Smitherman Madison enjoys playing outside in his Taylor Tot walker. Weeks later, he would be christened in a 100-year-old gown that belonged to Nelly Thomason. This gown was of a very high quality and had been passed down through several generations. (Courtesy of Alberta Carter.)

Tammy Koontz models for her family as she prepares to serve as the last mascot for Dunbar High School. She and Macon England would share this special occasion with the class of 1967. The schools would become integrated in 1968, and Dunbar would become an intermediate school. (Courtesy of Tammy Koontz Craven.)

JESSIE
PAYNE
RECIPES

Jessie Payne loved to cook. Affectionately called "Paynie," she was a caterer in high demand. Because of her exceptional Paynie Parties, her recipes were compiled in this book sponsored by the Club of Twelve, Sorosis Book Club, and the O. Henry Book Club. Jessie Lee Hargrave was born on May 9, 1878 and married Lewis Payne. Although she birthed no children, she was a mom to many. (Courtesy of Jeanne Wall.)

Anytime is a great time for Lillie Cross Koontz to show off her great-grandchildren, Bonnie and Jeffrey. Lillie and her husband, Jessie, lived on Cotton Grove Road. She had a flair for dressing even while working in her garden. (Courtesy of Tammy Koontz Craven.)

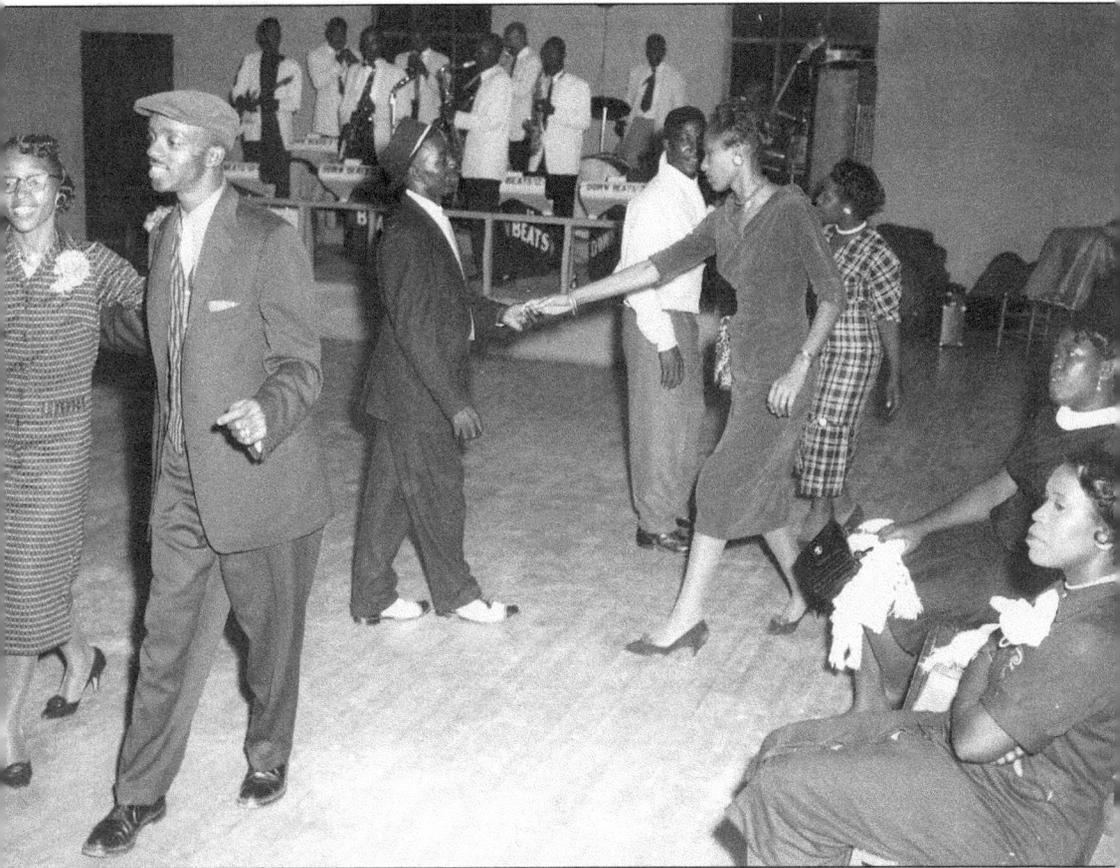

The Hut was the place to go for a good time and great music. John Neely booked many new and exciting acts. William "Warsaw" Anderson and others boogie to the sounds of the Beat Band. (Courtesy of H. Lee Waters Collection.)

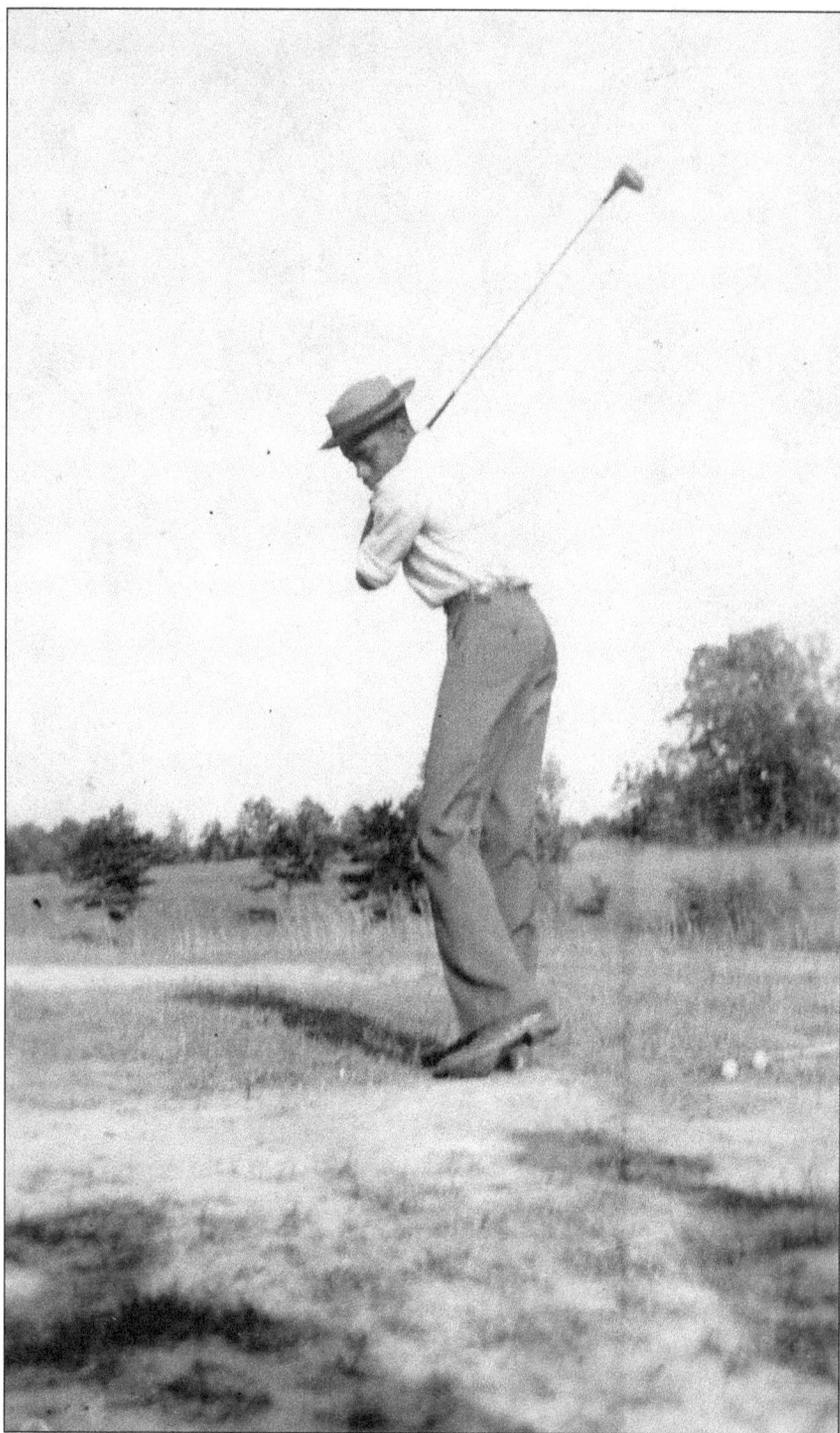

Lewis Michael's friends tried to make a golfer out of him as he practices in this 1940s photograph. The ninth child born to Bud and Estella, Lewis became a Coca-Cola man. He worked for the Coca-Cola Company for 38 years. When not spending time with his family, he can be found doing something for his church or someone in the community. (Courtesy of Lewis Michael.)

Enjoying the summer of 1936, Lillie Mae Evans watches as Jessie Miller prepares to dive into the First Baptist Church swimming pool. Cultural and recreational programs were big attractions at First Baptist. As part of its ministry, the church reached out to serve the needs of the community. (Courtesy of Annett Evans Marshall.)

## VOTE FOR

### ROBERT HENDERSON

### CONSTABLE of Lexington TOWNSHIP

In 1961, Robert "Booman" Henderson ran for constable of Davidson County. A constable was an elected peace keeper. This position and title were abolished by act of the 1969 legislature, with these duties now covered by the sheriff. Although he was not elected constable, Booman would continue to be an advocate for equality and diversity on boards and commissions. (Courtesy of Robert Henderson.)

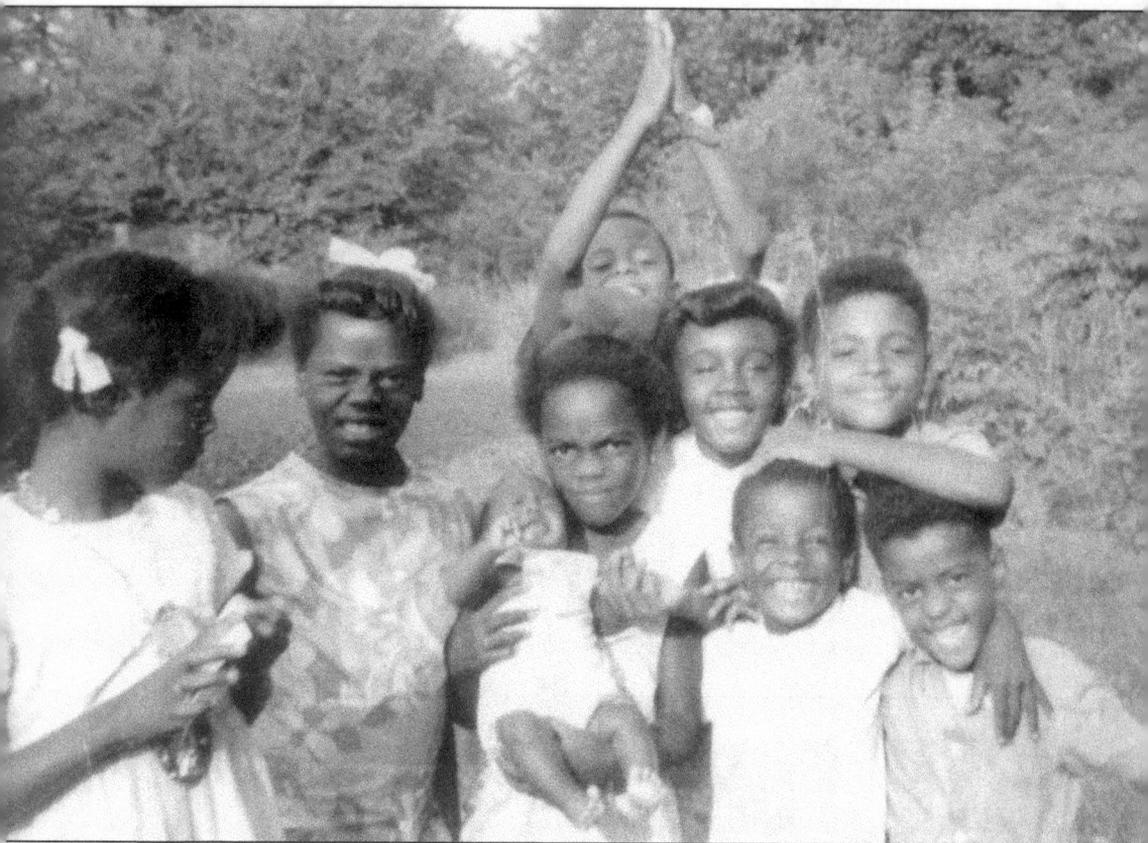

Tonya attempts to show off her new baby brother, Sidney, while, from left to right, cousins Robin Ingram McCorkle, Marjetta Wright, Shawn Saunders, Ella Wright, Johnny Ingram, Engle Saunders, and William Saunders play into the camera. Whether the gathering was in Lexington or Southmont, the families always enjoyed spending time together. (Courtesy of Tonya Lanier.)

Gladys Hoover rests on a stack of sugarcane. Her father, Frank, harvested and cooked this crop. People would drive out to the Hoover farm for Frank's fabulous molasses. (Courtesy of Katy Hoover Evans.)

A 1961 matchbook is a campaign souvenir. The People's Choice candidates are Robert Harmon and Robert Henderson for constable, John Paul Dula for county school board, W. E. Banks for state house, and Johnny Booker and Alonzo W. Gill for justice of the peace. (Courtesy of Robert Henderson.)

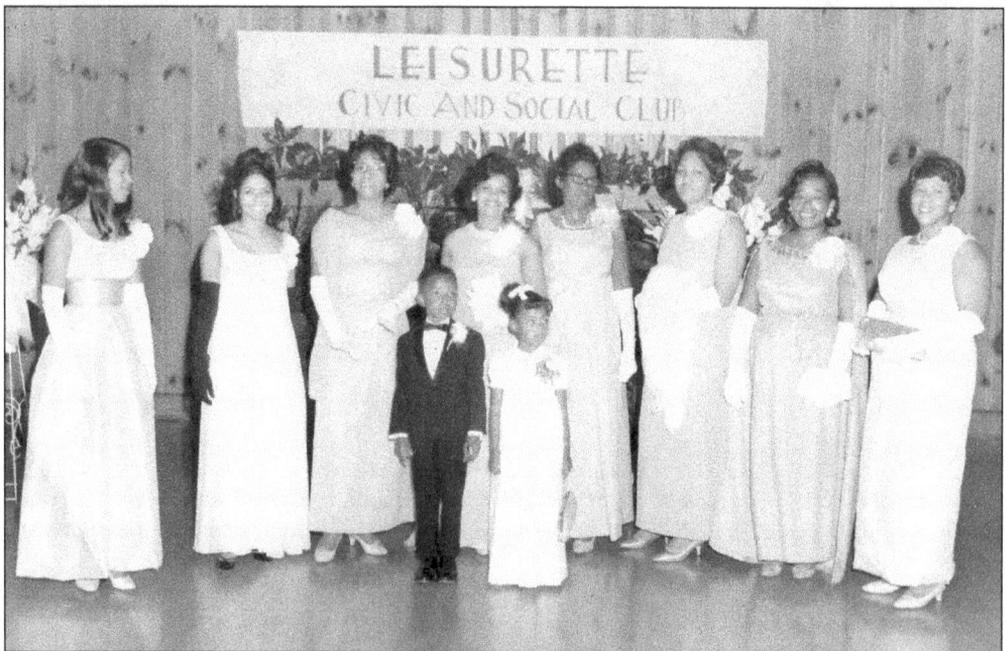

The Leisurette Civic and Social Club presented an annual debutante ball. This formal affair served as a way to recognize young ladies and honor their families. Monthly charm clinics were held on dining etiquette, social graces, current events, and other ladylike topics. (Courtesy of Tonya Lanier.)

Lena "Sally Gal" Perkins plays in the Smitherman yard on Elk Street. "Sally Gal" would become a great cook and a caterer in high demand. Time with her family is considered precious. (Courtesy of Alberta Carter.)

A graveside service was held for Cheryl Ann and Cherry Vann Madison, born September 2, 1955, and died January 29, 1956. They were the daughters of Alberta S. Carter and the late Lee Madison. Lance Crump at Ideal Funeral Home was able to order a double casket, a rarity at the time. (Courtesy of Alberta Carter.)

The Inaugural Committee

requests the honor of your presence

to attend and participate in the Inauguration of

Lyndon Baines Johnson

as President of the United States of America

and

Hubert Horatio Humphrey

as Vice President of the United States of America

on Wednesday the twentieth of January

one thousand nine hundred and sixty-five

in the City of Washington

Dale Miller
Chairman

Often referred to as "Mr. Civil Rights" in the Thomasville community, Dr. Rev. W. E. Banks received this personal invitation to attend the inauguration of Lyndon Johnson and Hubert Humphrey on January 20, 1965. (Courtesy of Rev. George Jackson.)

Drusilla Stephen and Edna McDowell help this Tiny Tot Day Care class take time for a group photograph. Tiny Tot was a licensed day care in Southside Village designed to empower children to develop healthy bodies, minds, and relationships. (Courtesy of Drusilla Stephen.)

Catherine Glen Gilley shares a special moment with her children— from left to right, Larry, Peggy Ann, and Joe Jr. Joel and Catherine would eventually have 10 children whom they loved and cared for dearly. While not much on material things, Catherine left her family a wealth of treasures in character and beliefs. (Courtesy of H. Lee Waters Collection.)

The auditorium at South Lexington School buzzed as parents gathered for this 1963 May Day program. "Rhythms in May" was the chosen theme. This festive, colorful annual event was an exciting way to usher in spring. Carolice Miller Graham had been selected queen. (Courtesy of Carolice Graham.)

Robert Freeman smiles broadly for his second-grade class photograph in the late 1960s. The son of Jessie Mason and the late Jimmie Freeman, Robert enjoyed going to school. After graduating from Lexington Senior High, he joined the U.S. Marines and eagerly began to make a living for his family in Lexington. He and his wife, Tonya, have one son, Tavon. (Courtesy of Tonya Lanier.)

Visit us at
arcadiapublishing.com